ART,
ANTHROPOLOGY
AND THE GIFT

ART, ANTHROPOLOGY AND THE GIFT

Roger Sansi

Bloomsbury Academic
An imprint of Bloomsbury Publishing Plc

B L O O M S B U R Y
LONDON • NEW DELHI • NEW YORK • SYDNEY

Bloomsbury Academic
An imprint of Bloomsbury Publishing Plc

50 Bedford Square	1385 Broadway
London	New York
WC1B 3DP	NY 10018
UK	USA

www.bloomsbury.com

BLOOMSBURY and the Diana logo are trademarks of Bloomsbury Publishing Plc

First published 2015
Reprinted by Bloomsbury Academic 2015

British Library Cataloguing-in-Publication Data
A catalogue record for this book is available from the British Library.

ISBN: HB: 978-0-85785-781-1
PB: 978-0-85785-535-0
ePDF: 978-1-47251-707-4
ePUB: 978-1-47251-706-7

Library of Congress Cataloging-in-Publication Data

Sansi-Roca, Roger, author.
Art, anthropology and the gift / Roger Sansi.
pages cm
Summary: "In recent decades, the dialogue between art and anthropology has been both intense and controversial. Art, Anthropology and the Gift provides a much-needed and comprehensive overview of this dialogue, whilst also exploring the reciprocal nature of the two subjects through practice, theory and politics. Fully engaging with anthropology and art theory, this book innovatively argues that art and anthropology don't just share methodologies, but also deeper intellectual, theoretical and even political concerns, inviting scholars and students alike to look at this contentious relationship in a more critical light. One of the central arguments of the book is that the problem of the 'gift' has been central to both anthropological and artistic practice. This very idea connects the different chapters on topics including aesthetics, politics, participation and fieldwork"-- Provided by publisher.
Includes bibliographical references and index.
ISBN 978-0-85785-781-1 (hardback) -- ISBN 978-0-85785-535-0 (paperback) --
ISBN 978-1-4725-1706-7 (epub) 1. Art and anthropology. I. Title.
N72.A56S26 2015
701'.04--dc23
2014014387

Typeset by Fakenham Prepress Solutions, Fakenham, Norfolk NR21 8NN
Printed and bound in Great Britain

CONTENTS

LIST OF FIGURES

ACKNOWLEDGMENTS

To my colleagues at Goldsmiths, in particular Mao Mollona, Chris Wright, and David Graeber. To my students at Goldsmiths and Barcelona. To my friends in Barcelona, in particular Rosa Pera, Deli Bruset, Pep Dardanyà, Manuel Delgado, Pau Faus, Oriol Fontdevila, Aviv Kruglanski, and Alex Mitrani. But most of all to my son Leo, who was born while I was writing this book.

I INTRODUCTION: AFTER THE ETHNOGRAPHIC TURN

More than a decade ago, a friend invited me to a gallery opening in Barcelona, Spain. This wasn't exactly a conventional "opening": it didn't consist of a display of artworks. It was a proper, total opening: the storage of the gallery, which is normally closed, was opened for visitors to see and exchange the stored artworks. The gallerist was offering to give away all the art in the storage in exchange for *anything*: t-shirts, toys, purses ... This was not exactly barter, but rather a massive act of gift-giving, since there was no apparent equivalence in value between the artworks and the things given in return. The objective of the gallerist was to question public policy on the arts, and this event gave him the opportunity to appear in the media to make his point. I remember I used the term *potlatch:* it seemed to me that the very act of giving everything away was a form of acquiring a public notoriety (a "face," a "name"), which the gallerist could then use to make his voice heard in public. My artist friends who participated in this event immediately recognized the idea of the potlatch: many of them had read Mauss's *The Gift*, and were explicitly influenced by his ideas.

In the years after this event, I started to follow the work of these artists. Many of them worked on site-specific projects that involved something similar to fieldwork, an investigation of a specific place and its social issues, from immigration to urban gentrification, intellectual property rights, labor conditions ... For example, in the project *Insideout: Jardí del Cambalache* "Garden of Barter" (2001),[1] artist Federico Guzmán and curator Rosa Pera built a whole network of reciprocity in the patio of the Fundació Tàpies, a contemporary art museum in a historical building at the very center of Barcelona. The project was the result of an ethnographic research on the *colonos* ("colonists")—people who occupy abandoned plots of land on the periphery of the city and turn them into gardens. Most of these *colonos* are old rural immigrants who came to Barcelona to work in factories. Many of these gardens were threatened by real estate development. One of the *colonos* was invited to transform the patio of Fundació Tàpies into a garden. The vegetables he cultivated were then offered to the public in exchange for some object—whatever they wanted. The project

also included an exhibit on the use of plants, workshops on how to create urban gardens, and an international conference entitled "Revolutionary Plants—Who Owns Plants?," on the illegal trade in plants used as "drugs," with anthropologist Michael Taussig among its participants. The project ended—it couldn't have been otherwise—with a picnic.

THE SOCIAL TURN

By that time I had started to see that the interest of artists in the social sciences, and anthropology in particular, was something more than keen curiosity. I was witnessing the emergence of a generation of artists who defined their work as "social practice": they were less interested in art as a form of self-expression than in working in public spaces and on specific sites, developing research with social groups, and addressing questions of immediate political relevance. In other words, they were almost like anthropologists; some of them even had a university degree in Anthropology! Many of them said that they were not actually interested in "art" itself, but in the things one can do with art. Their frame of reference was not just art history, but also social and cultural theory, and anthropology in particular; they didn't understand their work only in dialogue with other works of art, either following them or reacting against them, proposing "new" art forms and objects, but in dialogue with the world around them.

Often their work took an explicitly political angle. But it wasn't political just in the sense of "denouncing" or "representing" social and political issues through visual media, film or photography; the objective was to produce events with the participation of people from different backgrounds, who may have a stake or something to say about these very issues, from immigrants to elderly people to international scholars. These events took many different forms, from conferences to picnics, and they would be site-specific, sometimes subverting the use of particular spaces, such as turning art museums into community gardens. The objective of these events was not necessarily to generate "Change" with a capital C, but to create unexpected situations, building unforeseen relations, unconventional and unprecedented associations and communities in a particular location—local, specific changes.

From the mid-1990s, many authors have discussed the affinity between art and anthropology. Hal Foster's article "The artist as ethnographer" (1995) was one of the first to address the increasing interest of artists in anthropology and ethnography. Also around that period, some art historians argued for a paradigm shift: W. J. T. Mitchell described the new field of visual studies as fundamentally grounded on anthropology (1996), and Hans Belting proposed an anthropology of

images (2011). Moreover, from the turn of the twenty-first century, there has been a growing literature on the possibilities of cross-fertilization between art and anthropology, essentially discussing the use of ethnographic methods in art (Coles 2000; Schneider and Wright 2006, 2010, 2013).

Fifteen or so years after that gallery opening in Barcelona, the "social turn" in contemporary art doesn't seem to have come to an end (Bang Larsen 2012; Thomson 2012). A recent *New York Times* article argues that social practice art is living a boom, as a reaction not just to commercial art but also to wider political transformations like the debt crisis and the emergence of political movements such as Occupy, in which many of these artists are deeply involved (Kennedy 2013).

Just to give an example: in April 2013, I attended the presentation of the "exhibition" *Todas las plantas del Barrio* ("All the plants in the neighborhood").[2] The project was based at an autonomous art center in a working-class neighborhood of Barcelona, Poble Sec, called the CCCB ("Centro de Cultivos Contemporáneos de Barrio," Center for Contemporary Cultivations in the Neighborhood). It shouldn't be confused with the other local CCCB, the Center for Contemporary Culture in Barcelona, a sleek building downtown, internationally famous for its festivals and exhibits. This second CCCB chose its name partially in ironic reference to the first one. This CCCB is not a big, central public building, but an old house, the last one standing in a scantily illuminated cul-de-sac. Most of the buildings surrounding it have been demolished to make room for the complex of theaters and museums right behind it, "the City of Theater." This art center has a "showroom" called M2, a square meter of wall, on which the artist has to present a project related to the area surrounding the center—one square kilometer around it. This project in particular proposed a documentation of "all the plants in the neighborhood," interviewing local people and asking them about their relationship with their plants. In the presentation event, people were asked to bring their plants together and build an ephemeral garden. In exchange, the artist would give drawings, portraits of the people and their plants. The artist is then also an ethnographer, working in fact on a very popular topic in anthropology these days: human/non-human relations. His intention is not just to build an ethnography or archive, but also to contribute to the construction or "mending" of social relations in the neighborhood—in this case, through plants (Figure 1).

There is a clear continuity between *Jardí del Cambalache* and *Todas las plantas del Barrio*, even if they are separated by more than a decade. And yet, through the years, the vicissitudes of the "social turn" have been many. One of them is the ambivalent relation between contemporary art and anthropology. Some anthropologists feel that the opening of anthropologists towards art has not been fully acknowledged by artists (Schneider 2012: 56). On the other hand, in my discussions with art

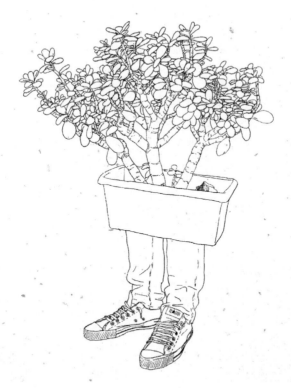

Figure 1 *All the Plants in the Neighborhood*, Zander Januta (CCCB 2013).

practitioners I often found an interest in anthropology, if perhaps not exactly in the ways predicted by most anthropologists. Although the use of ethnography is a very fruitful common ground, art practitioners seem to like anthropology not just because of its methods, but also because they are interested in anthropological theories of exchange, personhood, and the body, to name a few. Further than that, they understand their engagement with anthropology not just as a new form of producing art, but as a form of social and political engagement.

At this point, it may be time to face the reasons for the gap in this dialogue. We could start by clarifying the concerns that anthropology and art are supposed to share. In this introduction I will identify some possible answers to this question: ethnography, the visual, the politics of representation, participation, social practice, and work.

ETHNOGRAPHY

Most of the literature on the relationship between art and anthropology (Coles 2000; Schneider and Wright 2006, 2010, 2013) has discussed the use of ethnographic methods, and how both disciplines could learn and exchange ideas about the uses of ethnography. Schneider and Wright's groundbreaking volume, *Contemporary Art and Anthropology* (2005) focused on the collaboration between artists and anthropologists at the level of "practice," confronting artistic and anthropological methodologies in representing others. One of the main objectives of these authors was to encourage experimentation and creativity in anthropology itself. Practice, for Schneider and Wright, is understood mainly but not exclusively as visual practice— the use of visual and other media in anthropology:

> For anthropologists to engage with art practices means embracing new ways of seeing and new ways of working with visual materials. This implies taking contemporary art seriously on a practical level and being receptive to its idiosyncratic processes of producing works and representing other realities. (Schneider and Wright 2005: 25)

These edited volumes are made of contributions that take two forms: either anthropologists or art critics addressing the work of particular artists and looking at the ethnographic and anthropological themes in them, or artists describing their own practice and/or the outcomes of interdisciplinary collaborations. Many interesting themes emerged in these contributions, from Schneider's complex understanding of "appropriation" (in Schneider and Wright 2005) to Kuchler's subtle reflections on how the theme of the gift informs Sophie Calle's work (Coles 2000). And yet, perhaps because of its fragmented form, these edited volumes can't fully develop an argument on what Schneider and Wright have called the "deeper affinities" (Schneider and Wright 2005: 2) between contemporary art and anthropology at full length, beyond the common use of ethnographic methods. In fact, there are a number of notions—from "practice" and "method" to "experimentation," "expertise," or "skill"—that may need to be discussed further, addressing not just fieldwork, but also what is the "work" that contemporary artists and anthropologists do: it may be necessary to discuss their "practice" beyond the strict framework of art and anthropology as academic disciplines, to understand it in wider terms, as social practice. But before that, we should start by acknowledging that the use of fieldwork by artists and anthropologists alike is just one aspect of their commonality, and that we should discuss a bit further these "deeper affinities," which may not just be methodological.

THE VISUAL

Could these deeper affinities reside not only in the *use* of visual media as a method, but also in the common theoretical concern with "the visual" and "images"? Or even in a wider sense, the media and the senses? In the last decades, the fields of visual anthropology, the anthropology of media, the anthropology of the senses, and visual cultures have been blooming. Approximately at the same time that the "ethnographic turn" emerged, "visual culture" studies started to challenge the autonomy of "Art" as a specific field of study, proposing to expand from art to the totality of the visual. Beyond the elite culture of "Fine Art," Visual Cultures studies proposed a non-hierarchical approach to visual production, founded on a more anthropological notion of "culture" (Mitchell 1996) as the totality of human practice. The growth of this new paradigm also resulted in an expansion of the theoretical discussion on media and mediation (Mitchell 2005; Belting 2011; Pinney 2011).

And yet, can we subsume contemporary art practice under a general rubric of the visual, the media, or the sensual? A lot of artistic production in the last decades resists the frame of reference of "visual art" or "media art." The curator of a recent show defined the very notion of "video art" as "totally obsolete" (Fontdevila 2012). This was said in reference to a group show in which he had asked a number of artists to produce a video answering two interrelated issues: the exponential growth of "domestic video" production in the last years, and to what extent video-making has become more associated with "leisure" than "work." Most of these artists had no specific training in video-making; in fact many contemporary artists do use video, but they don't define themselves as video artists—they would not accept to be defined by the use or the theory of certain media (visual, related to any other senses, or digital), first of all because most of them are not professionally trained in these media. Many artists may relate to the medium as "users" or "amateurs"—as most people in our society use different forms of media without being professionally trained. One of the key aspects of contemporary art is the simultaneous use of multiple media, as one can often read in galleries' "mixed media." But more than the "mixture" of media, these processes show that many artists are not necessarily constrained by the use of a specific medium to produce their work, because they don't define themselves by their professional training in this or that medium: sculpture, painting, photography, or video. Some artists not only use multiple media, but also multiple "hands": they often produce their work with the help of skilled, professional workers who are actually able to materialize their projects, or they sample, or re-make. Rather than being professional practitioners of visual media, they often use ready-made objects, images, or techniques, or use the skills of others to make their work.

In many cases, the use of media is not an end in itself, but a means to an end: "art" is not just in the medium. Beyond the use of different visual or sensual "media," a lot of contemporary art isn't defined or particularly constrained by the senses. About a hundred years ago, Marcel Duchamp explicitly proposed a "non-retinal" art (Tomkins 1997: 158), in reaction to the formal experimentation that preceded him, from impressionism to cubism. This "non-retinal" art would not be directed just to the senses, but aimed to produce a critical reaction and a response beyond immediate sensory experience. Following Duchamp, in the second half of the twentieth century conceptual art was defined precisely by a "withdrawal from visuality" (Crow 1998: 213). Many contemporary art practices—"conceptual," "relational," "contextual," "situational," etc.—cannot be characterized mainly, or essentially, as practices of image or sound production, or seeking a visual or sensual engagement from the public, even if they may use visual or other media.

From this perspective, it would be misleading to collapse "art" and "the visual," "art" and "the senses," or "art" and "media." This is not to deny that these are areas of great interest where extraordinary work is being produced, and with direct relevance to the themes we discuss in this book; but many questions being asked in contemporary art practice and in anthropology today escape from this framework.

THE POLITICS OF REPRESENTATION

Perhaps these "deeper affinities" of art and anthropology, beyond methods and media, are more "conceptual" than "sensual"? For art scholars like Hal Foster (1995) and Miwon Kwon (in Coles 2000), anthropology and art shared a common theoretical and political concern: the politics of representation. Foster coined the expression "the ethnographic turn," pointing to the growing interests of artists in issues of identity and its representation in the 1990s. For Foster, ethnography and anthropology are essentially "the science of alterity" (Schneider and Wright 2006: 19). He described the relationship between artist and anthropologist as a kind of mirroring, in which both look at each other as an image of what they would want to be—an "envy": anthropologists want to be artists, they envy their freedom and openness; while artists want to be anthropologists, they envy their critical perspective, and direct access to cultural alterity. And yet the fact that these images are constructed out of desire prevents each from seeing what the "other" really is. The mutual attraction of artists and anthropologists from the sixties onwards was born out of institutional critique in both disciplines. Institutional critique—the questioning of art as an institution—was paralleled in anthropology by the "crisis of representation" in the eighties (Marcus and Fischer 1986); anthropologists were

becoming increasingly aware of the controversial nature of their own methods, and started to wonder how much the "cultures" they were studying were not the result of their own construction, and/or if it was really possible to reach the real cultural "other" in its own terms. As Foster pointed out, one of the initial reactions of a generation of anthropologists in the eighties was to seek for new, more creative, experimental forms of writing ethnography, partially inspired by the idealized figure of the artist (Marcus and Fischer 1986; Clifford 1988).

The "ethnographic turn" in art was the mirror image of the "literary turn" (Scholte 1987) in anthropology. As a generation of artists reacted against the autonomy of art and its institutions, Foster argued, they started to seek inspiration in anthropology because it was perceived as self-critical, counter-hegemonic, and based in cultural alterity. And yet, Foster also argued, by disguising themselves as anthropologists, artists often take for granted what anthropologists had been questioning for decades: their own authority. From the perspective of artists, it seems that becoming an anthropologist is critical enough; the artist does not take a critical approach to her or his position as an anthropologist—the relation with the "other." Thus artists may end up projecting their own vision on the community "other," building a representation that appears as authentic and politically engaged, without ever having had a critical understanding of who this "other" really is.

It is difficult to assess the extent of Foster's criticism, since he didn't make specific reference to projects that involved fieldwork. In fact, for Foster, the "ethnographic" question was one of representation: he was making reference to ethnography as text. This was indeed the central contention of the "literary turn" in anthropology. The paradox of this move, as some of its own proponents later observed (Marcus 2010), was that the "experimental" moment in anthropology focused on writing the ethnography, rather than in fieldwork itself.

Foster's article was also published as a part of an influential edited volume by anthropologists Fred Myers and George Marcus, *The Traffic in Culture* (1995), which addressed contemporary art as "one of the main sites for tracking, representing, and performing the effects of difference in contemporary life" (Marcus and Myers 1995: 1). This drift of art towards cultural critique paradoxically implied, according to these authors, the need for art to accept its loss of autonomy, and its progressive merge with anthropology and other forms of cultural critique (Marcus and Myers 1995: 24).

The appeal of anthropology in the mid-nineties was based on the hope that it would provide a critical approach to the politics of representation, proposing a more democratic, transnational approach to "culture" against the autonomy of hierarchy of "Art" as a Western construct, even in spite of Foster's skepticism of the ethnographer's envy in art. Yet this new announcement of the death of "Art," as a Western

institution, seems to have fallen short of what actually happened in the following years: rather than imploding, "Contemporary Art" has flourished. Art centers, festivals, events, and practitioners have multiplied around the globe on an unprecedented scale (Gielen 2010), engaging new publics. Beyond the reflection on identity and representation that was at the center of Foster's "ethnographic turn," many art projects from the turn of the twenty-first century engage with social practice at large, experimenting with participative methods (Bishop 2012). Rather than showing works that discuss identity politics, they enact specific social events and situations; from art practices that talked about stuff to people, to art that actually does stuff together with people.

RELATIONS

The work of Félix González-Torres can exemplify the beginnings of this shift. Being gay, and classified by US ethnic categories as Latino, he nonetheless resisted being identified as a token or representative of any community. "Who is going to define my culture?" González-Torres asked once; "it is not just Borges and García Márquez, but also Gertrude Stein and Freud and Guy Debord" (Rollins 1996: 90). The politics of culture and gender were unquestionably important for González-Torres, and they were an integral part of his work. But his work also had a strong focus on what he called "everyday life": "It is very exciting to take something that is there in everyday life and create from it something out of the ordinary, to give that ordinary object or situation a new meaning with a great economy of means" (Rollins 1996: 92). Some of González-Torres's more emblematic works are piles of candy in geometrical shapes, rectangular carpets or pyramids leaning against a wall, all "Untitled." They were left "in process": the aim of González-Torres was that the audience took the candy, and then the pile has to be filled up again by the gallery or the museum. These pieces were made as "portraits" of people he loved and who had died (including his partner, and his father), but two are also a double portrait of him and his lover. This work is often read as a reflection on death, and more specifically in relation to AIDS; both González-Torres and his partner died of AIDS. But together with what his work represents, the very process they enact seems to be central to the "portraits"— the process by which they are constantly being deconstructed and reconstructed back to their original weight[3] in an endless act of gift-giving.

Rirkrit Tiravanija's work has raised similar questions. An artist of Thai origin, Tiravanija was born in Argentina, lives in New York, Berlin, and Thailand, and has no specific claims to represent a "subaltern" or non-Western culture. Tiravanija's first shows basically consisted in cooking meals for the people who visited the gallery.

The aim was to bring people together, participating in a meal. For Tiravanija, "It is not what you see that is important but what takes place between people."[4] Or in other words, his aim is to *do* something with art beyond the art object itself.[5] For example, in the workshop "Disruption" at the art production center Can Xalant, on the outskirts of Barcelona, he spent a week with young artists, who shared their work, hung out and cooked together with Tiravanija. The outcome of the workshop was meager in material terms: some pictures of the event, at most. One of them shows the group of young artists wearing masks with Tiravanija's face next to Tiravanija himself (Figure 2). The main objective of the workshop was not to produce an exhibit, but precisely to generate an ephemeral community.

More than what they *represent*, what is interesting about González-Torres's and Tiravanija's work is what they make happen: a situation of encounter, a social relation. Both Tiravanija and González-Torres were central to Nicolas Bourriaud's arguments in *Relational Esthetics* (2002). Bourriaud described the "relational art" of these artists as "taking as its theoretical horizon the whole of human interactions and its social context, rather than the assertion of an independent and private symbolic space" (2002: 14). The real object of González-Torres's or Tiravanija's work is to invite people to eat and talk to each other, to construct a (perhaps ephemeral) social relation. For Bourriaud, relational art is a situation of encounter (Bourriaud 2002: 18): "All works of art produce a model of sociability, which transposes reality or

Figure 2 *Disruption,* workshop with Rirkrit Tiravanija, Can Xalant (Can Xalant 2009).

might be conveyed by it" (2002: 18). The form of the artwork is in the relations it establishes: to produce a form is to create the conditions for an exchange. In other words, the form of the artwork is in the exchange with the audience. In these terms, the artist becomes more a mediator, a person who fosters and provides situations of exchange, than a creator of objects. For Bourriaud, these art practices establish particular social relations for particular people; the artist tries to keep a personal contact with the public that participates in the exchange, fostering what he calls a "friendship culture" (Bourriaud 2002: 32), in contraposition to the impersonal, mass production of the culture industries.

The relational aesthetics that Bourriaud describes is in many ways familiar to anthropologists. From Marilyn Strathern's work in *The Gender of the Gift*, anthropologists have been discussing ontologies in which relations take precedence over entities: "it is at the point of interaction that a singular identity is established" (Strathern 1988: 128). From this perspective, people are constantly being made and re-made through relations, and things are constantly being created not in contradistinction to persons but "out of persons" (Strathern 1988: 172). Through gifts, people give a part of themselves. They are not something that stands for them, a representation, but they are "extracted from one and absorbed by another" (Strathern 1988: 178). This continuity between people and things is what she called a "mediated exchange," as opposed to the unmediated exchange of commodities, which is based on a fundamental discontinuity between people and things (Strathern 1988: 192).

In this book we will question to what extent the concepts of "relation" used by Bourriaud and Strathern are really the same. But at this point, it is interesting to note how the gift, a central concept in anthropology, is also very important in contemporary art. In his seminal essay *The Gift*, Mauss famously said that "*On se donne en donnant*" (Mauss 2003: 227), "one gives one's self while giving." With that expression, Mauss implied that social persons may not be just single minds in single bodies, but they can be constituted by an assemblage of elements, including bodies, things, names, that may be physically detached from one another while remaining the same.

Strathern's notion of the "partible person" is partially grounded on the work of Mauss in *The Gift*. Alfred Gell developed further this idea of the "partible" or "distributed person" in *Art and Agency* (1998). There, Gell argued that works of art can be seen as persons "because as social persons, we are present not just in our singular bodies, but in everything in our surroundings which bears witness to our existence, our attributes, and our agency" (Gell 1998: 103). For Gell this is not an exotic belief of Hindu priests and voodoo sorcerers—on the contrary, he affirms that works of art are some of the more accomplished objectifications of human agency.

Gell was not looking at art as a social text; he was looking at works of art as actors, as participants in social action. He didn't think that the task of anthropology was just to decode what objects represent, how they can be read to understand a social "context," but their effects; not what they stand for, but what they do. In this sense, he was not simply saying that the artwork is a "distributed person" of the artist. He went further than that: artworks can contain several different agencies, from the artist, to the person represented or the person who commissioned it, to the person who bought it, to the curator who is displaying it. An artwork can be a "trap of agencies," sometimes contradictory, sometimes complementary (Gell 1999).

The examples used by Bourriaud could be easily applied to Gell's arguments. González-Torres's candy pieces are candid traps, part of the "distributed person" of the artist, but also "portraits" of other people—and sometimes of other people and himself: double portraits of the artist and the person "portrayed." They are also engaging the public, by making them contribute to the work; the audience becomes a part of the work—"portrayed" by their very act of taking candy, "extracted from one and absorbed by another," as Marilyn Strathern would say. Rirkrit Tiravanija's events are equally textbook examples of the theory of the "distributed person"; the in-joke of the young artist residents wearing Tiravanija's masks next to Tiravanija is a direct example of the very notion of the "distributed person." It looks like Gell elaborated his theory in perfect synchrony with the art of the time, to a greater extent that he may have actually imagined.

But at this point one could ask, whose "distributed person" is this? Tiravanija and González-Torres include audiences and workshop participants into their work, but it is still their work: they have the power to decide what constitutes art, they are the authors, while the participants seem to be a part of the process of production. It looks like the "friendship culture" of these artworks is not necessarily based on a premise of absolute equality between artist and public, and even less the cancellation of the distinction of one and the other, art and everyday life, but rather a play between them. Still, as we will see, this does not necessarily question the utility of notions of the gift and the distributed person to describe these practices; anthropological theories of the gift are not a celebration of egalitarianism and community-building, but they also underscore the aspects of hierarchy and the relations of power that these practices may entail. On the other hand, what may be interesting about these forms of art from an anthropological perspective is how they propose a kind of experimental laboratory of the minimal elements of everyday life, the basic forms of social relation, like an act of gift-giving, with all its ambiguity, by putting them into play in unexpected ways.

SOCIAL PRACTICE

"Relational aesthetics" has been questioned from different perspectives. One of the more immediate criticisms was that it enclosed "social relations" in the sphere of art spaces, galleries, and museums, where these ephemeral events took place; its criticism of mass culture appeared as an elitist reaction (Thomson 2012; Kester 2011). As opposed to the enclosure in the art space, many art collectives and activist groups in the last decades have been working in specific sites: a neighborhood, a town, a "field." Stepping outside the gallery space, these artists have proposed explicitly social and political forms of work. The aim of their projects is not just to enact social relations, but to intervene in actually existing contexts—to have a social and political effect.

These practices have been described in different terms: contextual (Ardenne 2002), dialogical or collaborative (Kester 2011), socially engaged (Thomson 2012), social practice (Jackson 2011), situational practice (Oliver and Badham 2013)—different denominations that are not exactly synonymous. As I mentioned before, these forms of practice have often adopted a rather instrumental approach to the institution of "Art," using it for other ends; "Art" can be a particularly well-suited means to actually do things other than artworks, including many other kinds of exchanges and social events from conferences or workshops to parties and demonstrations, refurbishing parks and schools, or providing legal documents to illegalized immigrants. Moving further than relational aesthetics, one could say that in these practices, artists are not just generic mediators in an art event, but they are proposing an actual intervention in the thread of social life.

Anthropology can be important for these practices not just because it provides a method, ethnography, that can help to establish these relations of participation, but also important in relation to their ends. The objectives of these projects are often explicitly political, not just in the sense of representing a particular community, but also in order to challenge the existing forms of the social in a particular site. The problems addressed can be of many kinds: from labor, to the commodification of social relations, to citizenship and immigration, real-estate speculation and gentrification, ecology, gender roles, etc.—all issues that constitute the fabric of everyday life in the context in which they are working. These projects can question or unveil the hidden reality of these existing relations, but they may also propose unprecedented relations between different actors, generating new alliances and communities—in other words, help re-imagine and rebuild the social at a local level. The function of anthropology in these projects would go beyond giving the tools to represent "the other" through ethnography, but it could also provide conceptual tools to question existing relations and imagine other possibilities. This interest in questioning and

re-imagining the social may take artists to anthropological theories of exchange and the gift, for example, as forms of relation based in participation and collaboration, in opposition to commodity exchange and the alienation of labor.

But of course, these projects can also raise many questions, just like the "relational aesthetics" that sometimes they criticize. What is the agency of the artist in these processes? What does local participation or collaboration entail? To what extent are the artists imposing their program on the participants? Why would artists have the privilege to help, or inform, others? What are the effects of these practices? What "changes" are being brought about? These are not just practical, but also conceptual questions: ultimately, what do terms like "social practice," "exchange," "participation," "relation," and, finally, "gift" really mean in these situations?

Indeed art as social practice is a contentious issue. In their last volume, Schneider and Wright (2013) explicitly question the use of terms like "participation" and "collaboration," which have been subject to much critical scrutiny in anthropology (Schneider and Wright 2013: 11). But precisely, this explicit engagement with questions that were traditionally the domain of the social sciences is what makes these practices interesting for anthropology—not just because anthropologists can teach art practitioners to be more reflexive on their own practices, but also in the opposite sense: the expanded field of art as social practice appears as a field of experimentation, where all these concepts, from practice itself to participation, collaboration, work, relation, gift ... are put into play. Social practice art is interesting for anthropologists not just as a field of study, an object of fieldwork, but also a form of work that can help anthropologists think about, or perhaps better tinker with, these issues from a different perspective; perhaps it can even help anthropology play with its own work from a different point of view. The objective of this book is precisely to explore these possibilities of play.

WORK

This last point on work is related to an argument recently proposed by Tim Ingold. His book, *Making: Anthropology, Archeology, Art and Architecture* (2013) starts with the provocative statement that what renders art practice compatible with anthropology is precisely what makes it incompatible with ethnography. For Ingold, art practice is speculative, experimental and open-ended. Ethnography, on the other hand, is committed to "descriptive accuracy" (Ingold 2013: 8). In other words, Ingold understands ethnography as a text, a document, rather than a process; ethnography should be compared to art history, as a retrospective objectification of art, rather than art practice. But anthropology cannot be reduced to ethnography.

Anthropological fieldwork—what Ingold calls simply "anthropology"—is a kind of learning whose aim is not so much to provide us with facts *about* the world as to enable us to be taught *by* it (2013: 3). Anthropology is a studying *with* and learning *from*, as a living process that transforms the researcher (ibid.). As opposed to anthropology, ethnography would be a study *of* and learning *about,* as a document separated from the researcher.

Art practice, as a living, on-going engagement with the world, letting oneself be affected by this world, would be more akin to anthropology than ethnography. In these terms, Ingold thinks that art practice could help anthropology in rethinking its practice in different ways from ethnography—in doing anthropology differently. For Ingold, the results of anthropological research could include drawings, paintings, works of craft, musical compositions, perhaps even buildings … (Ingold 2013: 8).

It is clear that Ingold's understanding of "art" is a bit different from what we have been discussing: art projects that involve social processes rather than the production of objects—either paintings, crafts, or buildings. But on the other hand, it could be said that engaging with art as social practice could only contribute to Ingold's ideas; these are speculative and experimental art processes, which result in a direct involvement with a world of life, have transformative effects, and often remain open-ended, "in process," without any final, definitive outcomes. In fact, Nikolai Ssorin-Chaikov (2013) has recently asked very similar questions, if starting from a very different place: conceptual art. Ssorin-Chaikov proposes an "ethnographic conceptualism" that explicitly constructs the reality it studies, as opposed to claiming to represent an already existing reality. In this sense, ethnographic conceptualism takes a performative and transformative approach to the social field, like conceptual and social art practice.

Ssorin-Chaikov's proposal parallels George Marcus's recent interest in rethinking experimental forms of ethnography beyond the textual emphasis of the "literary turn" in anthropology in the eighties. For Marcus, experimentation has shifted from the textual outcomes to fieldwork practices themselves; these practices today are not only multi-sited, but participative and collaborative, and their outcome may not be the traditional ethnographic monograph, but it may take many other, more ephemeral and indeterminate forms (Marcus 2010).

Ingold, Ssorin-Chaikov and Marcus start from very different approaches to art and ethnography—in fact they don't seem to use the terms in the same way. But still, the three of them are interested in how experimental and performative forms of work in art can inform anthropology. Paradoxically, these proposals could be read as going back to where we started: one could say that they are not so far away from earlier discussions on the relation of art and ethnography as experimental practice. Perhaps the difference is mainly of degree: these last authors are asking similar

questions, but more widely, not just in terms of proposing an interdisciplinary engagement, but questioning what constitutes the practice of anthropology, in general—what constitutes the work of anthropologists.

But on the other hand, most of these authors haven't engaged with the discussions on the very question of "work" in art practice and theory in the last few years, in the context of a wider intellectual and political debate on the new forms of labor at the beginning of the twenty-first century, from discourses of the "creative economy" to theories of "immaterial labor." The interest of some contemporary art practitioners in intangible social relations and open processes, as opposed to the production of finished objects, can be seen as the result of a conscious critical approach to the division of labor and commodification in the modern world, the separation of work and play, commodities and social relations. If anthropologists want to engage with artistic forms of work, they can't step aside this critique, and the wider political discussions on the changing conditions of labor in general. The last chapters of this book will focus on these issues.

AN ANTI-DISCIPLINARY APPROACH

Perhaps at this point one could ask, to what extent are all these really *new* issues? Participation, the fusion of art and everyday life, the division of work and play, have been long-standing questions in art for most of the twentieth century, even if in the last decades they have taken a particular shape (Bishop 2012). In the same way, the relationship of art and anthropology has been intense and contentious for a long time. The concept of the "gift," in particular, as we will see in this book, has a long history of exchanges and misunderstandings between both fields. For Marcus and Myers, "Art and Anthropology are rooted in a common tradition, both situated in a critical stance toward the 'modernity' of which we are both a part" (Marcus and Myers 1995: 6). Both emerged not just as academic disciplines but as critical forms of knowledge that challenged classical Western notions of exchange, personhood, production, and the relation of people and things. The gift, as a concept, a practice, a prototype, is at the center of this challenge.

Anthropology and art have a very specific common historicity, which at many points has exceeded the framework of the institutions that contained them. This introduction has started from the immediate past, the last couple of decades, but in the next chapters we will take a larger historical perspective, behind the "ethnographic turn," taking us back to the origins of both modern anthropology and avant-garde art at the beginning of the twentieth century, and at some points even to the origins of what Rancière (2004) has called "The Aesthetic Regime."

In this sense, this book has no particular claim at proposing what is "new" in the relationship of art and anthropology, as opposed to the past; it is true that in the last years, after the so-called "ethnographic turn," this relationship has become more intense and has been the object of more close attention than before. But many of the core features of this relationship should be described in their long historical trajectories.

Having said this, it is inevitable that such an approach across the borders of art and anthropology may seem to address some questions superficially from a disciplinary perspective. This book has been designed as an attempt to build a bridge between different publics, with different traditions of thought which often use different terms, or use similar terms in different ways. One of the common problems of the dialogue gap between artists and anthropologists is the use of misnomers: sometimes when referring to "aesthetics" or the "gift," we are not exactly talking about the same things, or at the same level of engagement. Sometimes we can't take things for granted, and because of that, in this book I will have to spend some time addressing notions that may look obvious to some, but less clear to others.

To illustrate these topics, I will use different cases, ranging from well-known examples of contemporary international art to projects from my own research in Barcelona. But this is not an ethnography; my objective is not to describe a particular field site. Neither is it to write an art history or geography of art, or to propose a genealogy or cartography of Art–Anthropology exchanges through its more representative artworks and/or ethnographies. Even further from my intention is the idea of giving a critical assessment of what would be "good" and "bad" examples of these exchanges. My objective is more specific: to look at this relationship from the particular perspective of questions like participation, the relation of art and life, work ... and in particular, the gift, with all its ambiguities.

The task of writing this book, trying to maintain its intellectual rigor while keeping the argument open to different publics, has not been easy, but I hope it achieves its objective: to propose a common ground from which the dialogue between art and anthropology can be brought forward. One of the main things I have learned, while doing research for this book, is that interdisciplinarity should not necessarily start from defining one's own field of expertise, but by questioning the very notion of expertise and the "ownership" of certain ideas, and daring to think from scratch—starting from our ignorance, rather than from our expert knowledge. Perhaps better than an "interdisciplinary" approach we should start from an anti-disciplinary approach.

THE BOOK

The chapters of the book are organized around questions rather than case studies. After this introduction, Chapter 2, "Art as Anthropology," offers a very general introduction to how artistic practice has dealt with anthropological questions, and conversely, how it has been influential in anthropology. The chapter is not an exhaustive history, but rather it concentrates on three periods or cases: Dadaism and surrealism, situationism and performativity, and the "ethnographic turn" at the turn of the twenty-first century. This chapter will frame many of the issues that the next chapters will address: representation, aesthetics and politics, the gift and participation, work and life, fieldwork and everyday life.

Chapter 3, "Traps and Devices," starts with the claim formulated in this introduction, that art and anthropology have moved beyond the "politics of representation." It starts by discussing the anthropological approaches to art in the last decades, culminating in the work of Alfred Gell, who proposed a way out of the framework of "representation," looking at what art does, rather than what it stands for. But as we will see, his approach has some drawbacks. The second part of the chapter looks at how Gell's approach can be complemented by theories of the device in contemporary art.

Chapter 4 discusses the contentious question of "Aesthetics." Since the nineties several anthropologists (starting with Gell) proposed to go "beyond aesthetics" in the study of art. Western aesthetics was subject to different criticisms: too culturally specific, elitist, and intellectualist. Gell proposed a "methodological philistinism": to study art beyond aesthetics. On the other hand, art theory and practice by the nineties was also very critical of aesthetics: "institutional critique" was the dominant paradigm. In the last decades, all these criticisms of aesthetics, both from art and anthropology, have been partially re-evaluated through the work of Rancière, who postulates that aesthetics is always political, and that politics always implies a particular distribution of the sensible. This chapter emphasizes how Rancière's argument is grounded on the very origins of modern aesthetics. But it also points out the limitation of Rancière's vision of politics, which essentially maintains a division between people and things as subjects and objects of political action that contemporary anthropology and artistic practice may bring into question.

This argument will lead to Chapter 5, "Participation and the Gift." This chapter compares anthropological and artistic approaches to the question of the gift, in particular in relation to contemporary practices of participation in art. In most cases art practice sees the gift as an expression of individual freedom, while the anthropological literature has often underscored the agonistic aspects of the gift, as a form of building hierarchy, fame, people, and things. And yet beyond these contrasting

perspectives, there is a third, critical understanding of the gift as a form of transgression. These multiple understandings of the gift as a social relation can offer a wider perspective on contemporary debates on participation in art.

The question of the "gift" in anthropology is inextricably linked to the discussion of the notion of the person. One of the central points of gift theory in anthropology is, precisely, the reversibility of people and things as objects and subjects of exchange. In the following Chapter 6, "Work and Life," I propose to address the notion of the distributed person in relation to theories of artistic production in contemporary art, including recent discussions on immaterial labor, and the bio-politics of the "project" in the "new spirit of capitalism." From there, the chapter will move to more general considerations on work, expertise, improvisation, and skill both in art and anthropology.

Chapter 7, "Fields and Labs," brings the discussion back to anthropology, starting with the question: what can participative and experimental art practices teach anthropologists about their own work? This question will be addressed within the larger framework of collective experimentation, and the questioning of traditional divisions between experts and lay people, laboratories and everyday life.

The final chapter of the book, "Ethnography and Utopia," brings together the themes discussed in the previous chapters, in the context of the economic and political "crisis" of the Western world in the last years, and the intense political and cultural mobilization around movements like 15-M or Occupy, which not only respond to this crisis, but also propose alternatives to the society that generated it. The question of "utopia" will have appeared previously in the book in a more anecdotal form, but in this chapter it will be central.

2 ART AS ANTHROPOLOGY

The relationship between art and anthropology did not start at the turn of the twenty-first century; this is a long story. And it is not simply based in a common interest in the cultural "other," exotic peoples and faraway places, but in something more profound in the constitution of their own forms of practice, as both art and anthropology were in a process of reinventing themselves. Since the nineteenth century, both avant-garde artists and anthropologists were seeking a radical change in their form of work—a radical break with the "academy" that had confined them to their armchairs and libraries, in the case of anthropologists, and their workshops, in the case of artists. They needed a breath of fresh air: to encounter the world directly, without mediations or acquired truths. It was in this mood that some anthropologists (not all of them) left their libraries and some artists (not all of them) left their workshops to find the world outside—the "field," as anthropologist called it, or "everyday life," as many artists did. This world outside became their experimental laboratory, from which a number of problems and questions emerged, around concepts of exchange, personhood, work, and the relation between people and things.

This chapter will focus on art *as* anthropology; that is to say, how some forms of art throughout the twentieth century have engaged with ideas and questions that anthropology has also been interested in. I take this expression from the conceptual artist Joseph Kosuth, who wrote on the "Artist as Anthropologist" (1975). For him, both the work of the anthropologist and that of the artist consist of "cultural fluency." Anthropologists need to gain fluency in other cultures, while the artist does the same work in his own culture. For the artist, this cultural fluency is a dialectical process, because he is trying to affect the culture that affects him; the artist tries to change his own society, he is an anthropologist engaged (Kosuth 2008 [1975]: 182). There are a number of problems with this definition, from the point of view of anthropologists. First, the notion that anthropologists work in other societies, and not in their own; second, the assumption that anthropology is not "engaged" and doesn't try to change society, while art does. But for now, what is interesting about Kosuth's idea is less

the differences between one and the other, than what art and anthropology have in common: "cultural fluency" as a critical exercise of everyday knowledge. Both artists and anthropologists would ask questions about everyday life, questions about things one normally takes for granted: the value of commodities, the relation of people and things, work and play, people and the city ...

This is not to say that *all* modern and contemporary art in the twentieth century has been influenced by anthropology; this chapter is not a history of twentieth-century art. It is not even an exhaustive history of all exchanges, confusions, meetings, and separations between art and anthropology,[1] but it will focus specifically on how different questions have been raised at different times by different movements, artists, and collectives, in close relation to anthropology: from the decentering of artistic agency and the surrender to chance in Dadaism and surrealism, through the different attempts at reuniting art and everyday life in the mid-twentieth century, in particular through situationism, to the "ethnographic turn" and "site-specificity" at the end of the century. At some points, artists were directly inspired by anthropologists in raising these questions; at other points their relationship was more contentious and ambiguous. In any case, the objective of this chapter is only to trace these issues in very general terms, as a general context to open a wider discussion in the next chapters.

THINGS AND CHANCE

James Clifford defined the paradoxical relation between surrealism and anthropology in his now classic book, *The Predicament of Culture* (1988). If the task of the anthropologist is to describe the exotic as familiar, and show how strange and exotic rituals and beliefs are part of everyday life for people in other parts of the world, the objective of the surrealist was in many ways its diametrical opposite: to render evident how our own culture can be incredibly strange. This inversion of positions, from the extraordinary to the familiar and the familiar to the extraordinary, makes both processes, in many ways, complementary. In fact, the ultimate aim of anthropology, like surrealism, was not just to describe other cultures, but to put them in comparison with our own culture; to develop a critical attitude towards what our own culture takes for granted, make us aware that things we take as "natural," like the family or the market economy, may not be so "natural" for people elsewhere.

We can find an excellent example of this point in a short article by the anthropologist Marcel Griaule, entitled "Gunshot." The article was based on a picture of an African drum with a carving representing a man with a gun. This representation was shocking to a European public looking for "authentic" African art. But

Griaule argued that for Africans, European guns were what African masks were for Europeans: exotic and interesting objects. "If a black cannot without debasing himself use an exotic element, namely a European one familiar to him, what is one to make of our blind borrowings from an exotic world one of colour about which we must in self-defence declare to know nothing?" (Bataille 1995: 65). Griaule was proposing to take the inverse position: to look at things from the African perspective, as if the French were the exotics.

Griaule's article was published in a journal called *Documents*. In that journal, one could find ethnologists like Griaule publishing together with writers like Georges Bataille and Michel Leiris, who eventually also became an anthropologist: years later, both Leiris and Griaule were involved in the Dakar-Djibouti ethnographic expedition (see Leiris 1996; Clifford 1988). The name of the magazine was itself a manifesto: they were not interested in "art" as manufactured objects of beauty, but they looked at objects as documents, traces, remainders of events. They were interested in ethnography: documenting the events of the everyday and the extraordinary, the familiar and the distant. These documents were to be used as weapons to shake the deepest foundations of Western culture. They were interested in other cultures also as a means of questioning their own culture, its institutions, its beliefs, its values.[2]

Clifford (1988) described the surrealist process, the confrontation of the familiar with the exotic, in terms of juxtaposition and collage. Collage "brings to the work (hence the ethnographic text) elements that continually proclaim their foreignness to the context of presentation"(1988: 146). Or we could say it shows the irreducibility of one culture to the next. The model of collage is based on appropriation, taking things from one context and putting them in a different one. But in the end, it seems that all is left in a game of mirror images, reflecting each other, but not really producing any effects: things remain different, irreducible, perhaps impossible to understand.

But we could say that surrealist processes went further than collage: they didn't just play games of mirror images. André Breton often made reference to Lautréamont's line: "beautiful as the chance meeting on a dissecting table of a sewing machine and an umbrella" (Lautréamont 2011). This chance meeting is not just the superposition of two radically different things, but the chance *meeting* between them, an event that we can only be left to imagine with a shriek. That is precisely its objective: to shock, to shake, not just to compare or critique. Breton rephrased it thus: "Beauty will be convulsive or will not be atall " (Breton 1999: 160), meaning *we* have to be convulsed by the experience. Walking down the street, in shops, in flea markets, the surrealists found the extraordinary, the insane, the uncanny in everyday things. Louis Aragon's *Paris Peasant* includes long, quasi-ethnographic descriptions of the

city, broken at points by unexpected magical events. In *L'âge d'homme*, Leiris talks about some of the events that marked his childhood and adolescence. One of them was the discovery of the infinite: sitting at the breakfast table when he was a small kid, every day he was confronted by a pot of cocoa with the drawing of a girl with a pot of cocoa under her arm, with the drawing of a girl with a pot of cocoa ... This image immersed little Leiris in a cosmic panic for an instant: the sudden awareness of the possibility of the infinite (Leiris 1993 [1937]: 36). The "convulsive beauty" of this image is based, precisely, in its dynamism, it questions and resets the limits between the self and the world, bodies and things (Figure 3).

The image of the "peasant" and the child are important here, as a marker of the "primitive." But the "primitive" is not just the exotic African or the free "wild" man of unrepressed passions. It is something more generic and abstract: Dadaism, the direct precedent of surrealism, started from this very notion. "The word Dada symbolizes the most primitive relation to the surrounding reality; with Dadaism a new reality comes into its own," said the *Dadaist Manifesto* (1918). Dadaists were not simply interested in the "primitives" but were trying to be "primitives" themselves, unlearning civilization and academic art, and opening themselves to quotidian things. Marcel Duchamp, first of all, made an effort to "unlearn to draw," forget

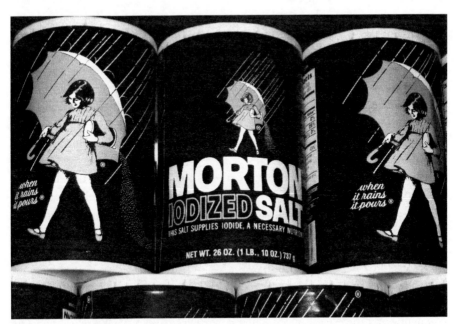

Figure 3 The idea of the infinite in everyday life. These pots of Morton Salt convey the same message as the Dutch Cocoa pots of Leiris: A girl with a pot of salt with a girl with a pot of salt with a girl with a pot of salt (Roger Sansi 2000).

his academic skills, his "hand" (Tomkins 1997). This notion of the "primitive" is connected with the fascination with mechanical movement, machines, and insects: movement without consciousness, intention, expression. For the Dadaists, the projects and agency of the artist should be replaced by chance: Hans Arp tore scraps of paper, dropped them on a larger sheet of paper on the floor, and pasted them where they landed. The machine, and chance, become co-authors in the process.

From the perspective of this "primitive" gaze, one had to look at everyday life as if seeing it for the first time, as a marvelous and unexpected encounter. In everyday life, the surrealists met the "*objets trouvés*," "found objects." These were objects found by chance, which by virtue of this encounter produced a particular vision, revelation, or awakened a specific memory. Leiris's cocoa pot would be a good example. "Found objects" are not things one can look for, since in many ways it seems to work the other way round; it is as if the object found the person, rather than the reverse. The surrealist goes out in the streets of Paris like a hunter goes to the forest, where hunter and prey are sometimes reversible; everyday life in the city is a "forest of indices" (Breton 1937: 22), of signs that point towards us, waiting for us to appear. The power of the "found object" does not reside so much in their condition of objects, but the act of encounter; because in this particular encounter, in that place and point in time, they produce a radical change in the person who has found them. It may be that the same object would not have produced the same effect in another person, at another time, in another place. In Leiris's words, they provoke "these crisis moments of singular encounter and indefinable transaction between the life of the self and that of the world become fixed, in both places and things, as personal memories that retain a peculiar power to move one profoundly" (Pietz 1985: 12). It is a matter of asking, in fact, who found who, the person or the object? And in the end, who has power over whom? Who is the object and who is the subject? The found object is a fetish (Pietz 1985), an object with a particular power over the subject.

The surrealist "found object" is inspired by Duchamp's ready-mades (Lütticken 2010). One of the central issues raised by the ready-made is the abolition of the distinction between production and appropriation. For Duchamp the word "art" meant to make, but then, "to make is to choose and always to choose."[3] And yet, Duchamp's ready-mades were not just an act of conscious appropriation, or an affirmation of the power of the artist to decide what is art and what is not. The ready-made, in Duchamp's terms, was "a rendezvous" (Duchamp 1973: 32), an encounter between an object and an author (Duve 1994: 71). This encounter had two conditions: the first one is to choose the object. But this choosing, Duchamp said very explicitly, was not motivated, but based on indifference and total lack of responsibility (again to quote Duchamp: "I object to responsibility"[4]). So that choice

is actually chance: Duchamp's choice was totally unintentional. To the question "How do you choose the ready-made?" he responded: "he chooses you, so to speak" (Duve 1994: 72). The second condition of this encounter was that it has to be inscribed (Duve 1994: 73), registered, documented. Duchamp wrote down the place and time of encounter. This encounter then becomes an event, a memorable point in the past, and the object would be a document of this encounter. "Art" is to be found in the encounter rather than in the object, which is more a trace than a work of art itself.

One could read the work of the ready-made and the found object as taking commodity fetishism to its ultimate consequences, by explicitly unveiling the fetish character of the commodity in the found object (Hollier 1992). For they don't disavow the power that objects had over them, but they embraced this power. One could also say that by embracing fetishism, they were paradoxically subverting it; they recognized the power of commodities, but they turned it into a personal power—a use value, as it were; the value of the object was a radically personal value, not an exchange value. In other words, they turned commodities into gifts: they used them to build persons, instead of being objectified and alienated by commodity fetishism.

The found object is not an art object per se, but an event with revelatory effects, which uncovers the "magic that surrounds us" in everyday life, under the "thin layer of civilization" (Leiris in Bataille 1995: 95)—even at the apparently rational modern city of Paris. Interestingly enough, it could be argued that surrealists and anthropologists developed similar theories of magic. In *Witchcraft, Oracles and Magic Among the Azande* (1937), Evans-Pritchard described how the "magical thinking" of the zande, an African people, is not an "irrational" thinking, ignorant of the laws of nature. The zande does not question that tree branches do fall all the time. But if the tree branch falls on my head, the zande will ask, why now? Why on my head? It is precisely from the understanding that this is an exceptional fact that the zande starts to look for a social cause for a natural phenomenon: *who* caused the tree branch to fall on my head?

Almost at the same time that Evans-Pritchard published his book on the zande, Breton defined "objective chance" in *L'Amour fou* (2003 [1937]) as a correspondence between the natural and the human series of causality, the recognition of the arbitrary as necessary: events that happen by chance, but seem to have been made to happen with a purpose, the purpose of unveiling a truth that was there all along. For Breton there is nothing supernatural or mystical in this truth: it is just a correspondence of the inside and the outside, our unconscious desires and the objective conditions of our world. Objective chance brings together Freud and Engels, psychoanalysis and historical materialism (Breton 1937: 31). Events of objective

chance have a revelatory condition, which bring together the world outside and the world inside of us; and this synchrony between the inside and the outside produces a transformation—it marks a before and an after, they bring to light something that wasn't clear before.

The question of objective chance itself is very important for anthropology, in particular through Claude Lévi-Strauss. In *The Savage Mind* (1966) Lévi-Strauss introduced the metaphor of *bricolage* to address how the limits of our knowledge correspond with the limits of our world. We can only work with the things we find in our way; the elements with which we organize our world are necessarily "pre-concrete," subject to contingency. This contingency forces us to adjust our project to our possibilities. "Once it is done," said Lévi-Strauss, the project "will be inevitably in disproportion with the initial intention (which is always, in any case, just a project); an effect that the surrealists rightly call 'objective chance'"(Lévi-Strauss 1966: 35). In other words, human practice is always limited by the given world: our intentions and projects are always conditioned by it; they are "pre-concrete"; and the realization of our actions will always be a result of the encounter with this externality. What is important for Lévi-Strauss, following the surrealists, is that this external contingency is not understood in terms of a determination, as it were, an objective "nature," ruled by laws that we can't contradict, a limitation to human agency; but an objective chance, in which we can only make do with whatever is there at a given time.

One common misreading of Lévi-Strauss and structuralism is that it opposed structure to agency (Ortner 1984), when in fact what Lévi-Strauss was distinguishing was structure from event. "Structure" for Lévi-Strauss was not just an imposed "system" that didn't allow any margin of agency to individuals. For Lévi-Strauss, the savage mind (or the "mind" in general) is constantly trying to encompass events into structure; it does so through a mechanism, a device—the unconscious—that orders and gives meaning to events according to structure. The unconscious, for Lévi-Strauss, was an empty organ, a "stomach" that digests events. The "mind" s was less the will, consciousness, intentional agency, than an empty receptacle processing and digesting experience (events) and transforming them into meaning (structure). This process is not driven by agency or intentionality, but by objective chance.

The influence of surrealism on anthropology has gone far beyond Lévi-Strauss. Perhaps its more evident and brilliant expression can be found in the work of Michael Taussig. His main referent in this regard is not Breton, but Walter Benjamin, who developed a very similar notion to objective chance, the "dialectical image." The notion of the dialectical image is based on filmic montage: the capacity of film to bring together different images, coming from different times and spaces,

in a single sequence, and even switching object and subject by changing points of view. For the surrealists, film appeared to be a perfect technical means of reproducing dreams. Think, for example, of the initial sequences in Buñuel's *L'âge d'or*, which starts as a nature documentary on scorpions, and then suddenly becomes the dreamy image of a shepherd from the top of a cliff, staring with surprise at a group of cardinals praying by the sea. This sequence is not just a collage of images, but a dialectical image, in which the time illusion of montage—putting the sequence of the scorpions next to the sequence of the cardinals—forces the viewer to establish dynamic connections between them. For Taussig,

> [...] such images defamiliarized the familiar and shook the sense of reality in the given order of things, redeeming the past in the present in a medley of deconstructive anarchical ploys. Unlike current modes of Deconstruction however, the intent here was to facilitate the construction of new forms of social life from the glimpses provided of alternative futures. (Taussig 1984: 88)

For Taussig, however, the dialectical image does not result in the organization of a meaningful structure and order, like "objective chance" for Lévi-Strauss, but in disorder (Taussig 1984, 1991); and the device through which the dialectical images are articulated is not just the mental unconscious, a symbolic function that attributes meaning, but bodily mimesis (Taussig 1993). Taussig radicalized the appropriation of surrealism of Lévi-Strauss—moving from Breton to the side of Benjamin and Bataille—and yet the notions of "objective chance" and the "dialectical image" clearly belong together.

Surrealist film-making and its "dialectical images" were also very influential in some forms of ethnographic film. One clear example would be Jean Rouch's *The Mad Masters* (*Les Maîtres fous*, 1955), an account of the Hauka possession cult in Accra, in which Africans are possessed by the spirits of the colonial elites. The film was extremely polemical both with colonial authorities and African nationalists (Stoller 1992). One of the central scenes of the film shows the Hauka breaking an egg on the altar of the Governor, a coconut-shaped piece of wood with glasses, one of the Hauka spirits. "Why an egg?" asks Jean Rouch in voice-over. The next scene is a military parade of the British army, with the governor wearing his helmet covered in feathers. The broken egg on the spirit effigy looks exactly like the helmet. The magic of cinema, jumping from one place to the other, one time to another, taking the point of view of different people, allows Rouch to duplicate the experience of spirit possession—jumping out of the here-and-now into other bodies. In this process, Rouch's film could not but be a scandal—not just because of the gory images of the spirit possession cult, but also because he was showing a reality that was neither

African nor European, but the encounter of both through the techniques of spirit possession and filmic montage.

Notions of the found object, objective chance, the dialectical image, and montage show that the surrealist process does not operate just by producing a collage of images, of superposing different objects, different cultures, to develop a critical perspective on both; much further than that, surrealism stresses the dynamic dimensions of encounter, the convulsions, the transformations that this encounter between people and things produces. In any case, these notions anticipate discussions on the relation between people and things that have taken place in the social sciences in the last few decades, as we will see in the next chapters. For the surrealists this was indeed a revolutionary practice, one that questioned the bourgeois separation between people and things to its very ontological foundations. The convulsive, and subversive, effects of encounter were central to another artistic movement that in some ways took surrealism to its ultimate consequences: Situationism.

SITUATIONS AND EVERYDAY LIFE

Bringing Dadaism and surrealism further, in the fifties and sixties, some art movements started to focus more explicitly on the event of encounter itself rather than the found object. These encounters took different forms and were defined in different terms: "performance," "installation," "assemblage," "action," "intervention," "situation," "event." Some art critics like Michael Fried questioned the "theatricality" of these forms of art (Fried 1967). For Fried, "good art" should negate the presence of the beholder (Pinney 2002: 159): art is a self-contained, absorbed representation; artworks tell a story, independently of the context and the public. Fried was reacting against the emergence of forms of art like minimalism, which promoted an interactive experience from viewers—asking them to "enter" the artwork, consider its materiality, experience it in space, in relationship to its context: these were some of the first installations, settings or stages, scenarios, "theaters" rather than self-absorbed representations. For Fried, this was "anti-art," first of all because it was "literalist"—it didn't distinguish art and object, container from content, the artwork from what it represents. In fact, minimalist sculpture did not represent anything: art and object, art and artifact were the same thing. The objective of the minimalist installation was not to produce a distance, but to immerse the public in the artwork.

Much more radical in its ends and form than conceptual installations were the "happenings" of Allan Kaprow (1993), which did not only include the public in the artwork, but immersed the visual arts in performance, in an ephemeral event that just "happened," aiming to bring together art and life. The encounter, in this

case, was first of all a social event that was bringing people together, rather than an individual finding an object. The international movement Fluxus promoted happenings, performances, and events which were not defined by any media, or signed, or dated, or sold—at least in principle. In fact Fluxus did not define itself as an "art" movement, but more as a philosophy of experience (Friedman 1998), a form of life, that aimed to abolish the distinction between art and everyday life, "making art" and just living. However, in the long run, the work of many members of Fluxus, such as Joseph Beuys, became canonical references in contemporary art: their work became objectified. During the same period, Jean-Jacques Lebel used the term "happening" for the first time in France to promote his ritualized perfor-mances. Sexualized and transgresssive, Lebel's happenings were directly influenced by surrealism, Artaud's theater of cruelty and anthropological descriptions of ritual; for Lebel, they were "critical anthropology in action."[5] In fact, anthropology was directly and explicitly influential on the new forms of theater that proliferated in the sixties and seventies, and central to the emergence of performance studies (Schechner 1988). Particularly important were the writings of anthropologists working on ritual, especially Victor Turner (Schechner 1985).

I introduced these very general examples just to point out the eruption of performative practices in art in the fifties and sixties. This interest in performance was not exclusive to art but also new forms of philosophy and new schools in the social sciences shared the insight that performative actions in everyday life have the potential to create or undermine social reality (Klimke and Schaloth 2009). In this section I will discuss situationism, one of the more radical examples of this shift to performativity, bringing together art practice, social research, and political activism, and I will put it in comparison to some new forms of practices in the anthropology and social sciences of the time, such as *cinéma vérité* and ethnomethodology, which also worked with performativity as a method.

Situationism was an uneasy offspring of surrealism. In the first issue of the *Situationist International* (1958), an article on "The bitter victory of surrealism"[6] argued that capitalism had co-opted the surrealist interest in the unconscious, with managerial techniques like "brainstorming." In fact, the subversion of the commodity form in the found object can be double-edged: commercial advertising has attempted to develop techniques to manipulate the unconscious, and convince consumers that they desired the objects of consumption they were offering. To overcome the limitations of surrealist practice, the situationists replaced the personal found objects of the surrealists with one very big collective object: the city itself. The city for the situationists was the world of everyday life, as opposed to the dead world of art galleries, museums, and ateliers. Following the surrealists, they abandoned the art world to engage with the world outside; but they did not intend to collect bits

and pieces of this world and bring it back to galleries as "art"; they did not intend to produce art as a commodity for the art world. Situationists did not even seek to encounter particular things, but their objective was the encounter itself, promoting events, situations, that would challenge the established order of society.

The *Situationist Manifesto* proclaims: "against unilateral art, situationist culture will be an art of dialogue, an act of interaction."[7] In these terms the situationists shared a similar discourse to contemporary movements like Fluxus or the practice of "happenings." But their objective was much more radical: happenings, actions, and performances are still forms of practice produced and consumed by the art world, and came to become events in the narrative of contemporary art. They refused to produce any "events" for the art world, works that could be objectified and commodified: their "situations" disappeared in their own practice.

The final objective of their "situations" was the subversion of everyday life. For the Marxist philosopher Henri Lefebvre, who was a strong influence on the situationists, there is a fundamental contradiction in what we call everyday life: on the one hand it's our "free time," out of the regimented spaces of labor, a time when we stop being alienated workers with a specific task and knowledge, who sell their workforce in exchange for a wage, to become just people in the street, with the time we have left to be ourselves, to play, to do what we want. But on the other hand, as our life in general becomes more regimented, our free time also becomes more organized, catered, and provided for—in other words, alienated. Lefebvre was witnessing the birth of mass consumption society and new mass technologies of cultural production like the television. Everyday life then is at once a space of liberation and alienation (Lefebvre 2002 [1961]).

The objective of the situationists was to unleash the liberatory potential of everyday life, make people recover the control of their own lives. And to do so, they had to redefine everyday life from a space of alienation, dedicated to the consumption of commodities, to a place of liberation: "The point is to produce ourselves rather than things that enslave us."[8] They were taking to its last consequences the critique of capitalism that was implicit in the surrealist practices of unveiling the fetish of the commodity: they were proposing to subvert commodity fetishism through everyday life. They did not only question artistic production, or their own life, but the social division of labor and the organization of life in general terms, the division between work and leisure, formal, specialized activities and informal play: "situationist theory supports a non-continuous conception of life" (Debord 2006 [1958]: 41), constituted by situations that may not have a lineal trajectory, and that therefore do not constitute unified, but plural subjects. "In a classless society there will no longer be 'painters,' but only situationists who, among other things, sometimes paint" (Debord 2006: 41). The objective was "quantitatively increasing human life"

(Debord 2006: 39), by questioning the very division between work and leisure, and putting play at the center of life.

Mauss's writings on the gift, through Bataille, were also extremely influential on situationism. Bataille's *The Accursed Share* (*La Part maudite*) proposed no less than "a general economy, in which the 'expenditure' (the 'consumption') of wealth, rather than production, was the primary object" (Bataille 1993 [1949]: 9). In his model, excess replaced scarcity as the general condition or nature of economic behavior. The main example and inspiration of this economy of excess is Mauss's description of the potlatch, a Native American ritual of massive gift-giving and conspicuous consumption. But together with the potlatch, Bataille also talked about the Marshall Plan, showing how the principle of excess is common to both apparently "primitive" cultures and the massive program of economic help launched by the US after the Second World War. Bataille's emphasis on consumption, rather than production, mirrors the shift from the manual production of objects to the encounter with objects in avant-garde art, after Duchamp's ready-made. And after Bataille, for to the situationists the potlatch and the economy of excess prefigured a form of exchange radically different to commodity exchange; in Jorn's terms, "Art is the invitation to expend energy, with no precise goal other than what spectators themselves can bring to it. This is prodigality …"[9] One of the first situationist journals was named *Potlatch*. The journal itself was given for free, as a gift.[10]

The situationists envisioned different ways of subverting everyday life. One of them was *détournement*: the act of subverting street signs, logos, and slogans of mass culture in public space. Through juxtaposition, combination, rearrangement, reappropriation, and plagiarism of words, sentences, images, *détournement* generates yet new images, messages, texts that subvert the original message. According to the situationists, the practice of *détournement* was not just an attack on artistic notions of inspiration, creation, and originality, but questioned the very notion of property on which art practice was based (Debord, Wolman 2006 [1956]).[11] It could be said that it was the generalization of the "ready-made" to everyday life; its objective was to puzzle people in the street, make them question the foundations of everyday life, turning the city itself into one big "found object."

Besides *détournement*, psycho-geography is the situationist practice that more effectively resembled anthropological fieldwork. Psycho-geography was defined by Debord as "the study of the precise laws and specific effects of the geographical environment, consciously organized or not, on the emotions and behavior of individuals"[12]—in other words, an application of objective chance, well beyond the encounter with objects, to encompass the whole of social life in the city. In practical terms, it consisted of exploring the city by drifting through it—letting oneself be taken or affected by the city—so it would often be called simply "drift" (*dérive*). In

this sense perhaps we could say that it was complementary to *détournement*, and its opposite at the same time: instead of appropriating the city, psycho-geographers would allow themselves to be taken by the city, in ways that were not predicted by the impositions of rationalist urbanism. The objective was to question the rational organization of the modern city, divided in separate spheres of life—one area to work, one area to rest, one area for leisure—forcing its inhabitants to commute between these imposed "rational" spaces. Through the "unitary urbanism" promoted by psycho-geography, the situationists proposed to subvert these symbolic borders, which was the same thing as subverting the compartmentalization of life in work, leisure, and rest. One example of a psycho-geographical research could be Abdelhafid Khatib's "Attempt at a psycho-geographical description of Les Halles" (1958), an area in the center of Paris at the junction of many travel routes, back then known for its food markets, cafes, restaurants, and nightlife, including prostitution in some areas—a rather chaotic and lively assemblage. Les Halles was (and still is today) an area where locals and foreigners, people from the center and the periphery, working-class and bourgeoisie meet in transit. Khatib noted how the area was delimited physically and symbolically from the richer, more residential neighborhoods to its west and north by a series of buildings that operate as a clear border. Khatib's "Attempt" included an outline of a proposal to transform Les Halles into a sort of situationist park for the education of workers. Yet the study remained an "attempt" nonetheless—as is shockingly pointed out in a footnote—because Khatib was detained several times, as a result of the curfew imposed on North Africans.[13] And yet, one should acknowledge that most situationist psycho-geographies were "attempts"; Ralph Rumney's project to produce a systematic psycho-geographical account of Venice failed; he was "vanquished" by Venice, he "disappeared" in the "Venetian jungle."[14] There was always an element of incompleteness in situationist research practices.

The activities of the *Situationist International* became progressively more theoretical and political: in the late sixties Debord published *Society of the Spectacle* (1970 [1967]), a sharp critique of the contemporary society of mass consumption, which according to Debord was witnessing the complete colonization of everyday life by commodity fetishism. The same year, 1967, Raoul Vaneigem published *The Revolution of Everyday Life* (*Traité de savoir-vivre à l'usage des jeunes générations*), which described the foundations for a situationist revolution. Central to this revolution for Vaneigem was a shift in the forms of exchange in everyday life, from the exchange of commodities to the exchange of gifts.

It is often claimed that situationism was extremely influential on the events of May '68 in Paris. Even if that is difficult to ascertain (Clark and Nicholson-Smith 1997), it is undeniable that many pamphlets, slogans, and graffiti of the time seem

to have a situationist inspiration. Perhaps precisely because of its dissolution in the revolution of everyday life that was May 1968, situationism as a movement didn't have much sense after the event. In fact the *Situationist International* was dissolved a few years later, in 1972.

The situationists were at the same time artists and activists, but also researchers: they adopted the language and rituals of the social sciences (see Jorn 1957); they developed theories, terms, methodologies; they made research and organized conferences. It has been argued that situationism has been almost ignored by scholars for decades (Plant 1992; Clark and Nicholson-Smith 1997) precisely because it was too close to them. In fact, they questioned professional scholars in the same terms that they were questioning "professionals," in particular professional "artists," and the division between work and life in general. The "incompleteness" of their work should also be understood in these terms of resisting formalization.

In order to discuss the relationship between situationism and "professional" scholarship in the social sciences, one should take into consideration that at the same time as the situationists, in the general context of explosion of different forms and notions of performativity in the sixties, some anthropologists and social scientists were developing methods that were very close to the "situations" that they proposed. One could think of at least two examples: *cinéma vérité*, or "truth cinema," and ethno-methodology.

Garfinkel's ethno-methodology (1967) is probably the best example. The central objective of ethno-methodology was to understand the formation of social rules through everyday practices or methods. These methods or procedures index—point to—these social rules. These social rules would not be learnt before and independently from these methods, but everyday life constantly indexes—points to—these rules, making sense of the world around us, defining our respective roles and positions. One of the ways through which ethno-methodology proposed to unveil these rules was breaching experiments. These experiments would consist in creating small contradictions in the flow of everyday life, shaking the distribution of roles and the relations between social actors: for example, asking for seats on public transportation; treating customers as waiters in a restaurant; tipping your friends or parents for their kindness; saying hello instead of goodbye … To sum up, small twitches or breaches in everyday life, aimed at revealing the very fabric it is made of. Like "situations" and "*détournements*," breaching experiments were by very specific, simple acts and interventions, changing the direction of the signs. But interestingly enough, breaching experiments are much more aggressive and disruptive than the practices of situationism, since they involve direct engagement with people, while *détournements* only seemed to challenge everyday perceptions through interventions in the cityscape and the media. On the other hand, the intended outcomes

Figure 4 An example of *détournement*, found at the corner of my street. As with any works of *détournement*, it is almost imperceptible, and always anonymous (Roger Sansi 2013).

of *détournement* are much more radical than ethno-methodology: the latter only pretended to generate research data on the formation of social order through everyday life, while the former envisioned their practice as the first steps toward a revolution.

In any case, situationism and ethno-methodology seemed to develop independently, without any knowledge of each other. But that was not the case with *cinéma vérité*, or "truth cinema." *Cinéma vérité* presented itself as a form of documentary cinema based on the explicit interaction between filmmaker and subject, as opposed to documentary film that pretended to hide the presence of the camera, like direct cinema. *Cinéma vérité* was conceived by sociologist Edgard Morin and anthropologist Jean Rouch, whom we mentioned before in connection

with surrealism. Their film *Chronique d'un été* (*Chronicle of a summer*) is the study of "this strange tribe living in Paris": it follows a hand-held camera wandering through the streets of Paris in a hot summer, without a clearly determined path. As the camera goes, we can see the researcher asking passersby an inchoate question: "êtes-vous heureux?," "Are you happy?" The shock of unmediated interaction was meant to unveil the truth of everyday life, beyond appearances and social conventions. The subject is questioned directly, to the point of provocation, allowing the camera to film his hesitation and discomfort. The very act of filming and the direct, even aggressive intervention of the filmmaker were meant to be a catalyst for this process of unveiling, precisely by not allowing the subject to hide beyond a ready-made answer. This emphasis on the moment of encounter, the situation, shifts the focus of the documentary or the ethnography from an activity that not merely reflected, but produced a new reality. In Stoller's terms, "the camera does not capture reality, it creates reality—or cine-reality—a set of images that evokes ideas and stimulates dialogue among observer, observed, and viewer" (Stoller 1992: 193).

But *cinéma vérité* was not well received by the official "situationists," essentially Guy Debord, who thought it was pointless to pretend to get to a real understanding of everyday life in Paris by filming "out there" (McDonough 2007). And yet, one could argue, from an inverse perspective, films like *Chronique d'un été* are excellent examples not just of the methods, but also of the ideas of the situationists: the film was not just based on the production of situations, but the themes that emerged from these situations were precisely the contradictions of everyday life: the relationship between work and life, the use of free time, boredom, play ... Perhaps Debord's critique of *cinéma vérité* is less interesting in itself, than as a revelation of the contradictions of situationism as a movement, in the constant debate between developing new methods and forms of life, and focusing on the discursive critique of capitalism.

SITES, COMMUNITIES, ETHNOGRAPHIES

Situationism has been a direct inspiration for many of the most radical cultural movements of the second half of the twentieth century, from its influence on punk to the more specific practice of culture jamming and subvertising in anti-consumerist movements. And yet, paradoxically, some of its methods have ultimately been also re-appropriated by the society of the spectacle: "situations" have become "flash-mobs"; "*détournement*" is used as a method of aggressive counter-advertising ... Even some situationist prophecies, like Khatib's idea of transforming Les

Halles into a "situationist park," seem to have come true, if in a twisted form: it has become a shopping mall with a cinema and a big, international art center nearby—the Centre Georges Pompidou. Just like in the case of surrealism, it could be said that situationism and the radical performativity of the sixties have been re-appropriated by the very society they were seeking to overthrow. This re-appropriation has inevitably also affected art practice in the last decades: the art movements we have mentioned were seeking a dissolution of art in everyday life, which meant essentially, for the situationists, a disappearance of art as a commodity form, and the artist as a professional. This, as we know, hasn't happened. On the contrary, contemporary art has grown exponentially. Still, this doesn't mean that after May 1968 artists have renounced the critical ideas that guided surrealism or situationism. Take for example Nicolas Bourriaud's influential formulation of "relational esthetics" in the late 1990s. Bourriaud explicitly defined relational art in terms of encounter and mediation, personalized and ephemeral situations of exchange that could offer an alternative to the impersonality of the society of spectacle. Relational art, on the other hand, would not see the public as a passive consumer but as an active partner.

The situationist genealogy of these ideas is quite clear, starting with Bourriaud's direct reference to Debord's *Society of the Spectacle*. But it could be said that this is a rather cautious reading of situationism. "Relational art" doesn't pretend to lead a general revolution, but modest, local interventions: "social utopias and revolutionary hopes have given way to everyday micro-utopias and imitative strategies" (Bourriaud 2002: 31). Contemporary artists using situationist techniques would not be delegitimized because these techniques had already been used or even re-appropriated. What is important is where and how these techniques are effectively used, how and where they are applied: their practice makes more sense in relation to the here and now, to form an ephemeral community, an "everyday micro-utopia," as opposed to the big, macro-utopia of revolution as a universal narrative, History with a capital "H."

Regardless of the many criticisms to Bourriaud's approach, and what he really means by "everyday micro-utopias" (we will come back to that!), it could be said that in the last decades, many art projects work with the immediate problems of today, in specific places, with specific communities, rather than towards a general revolution of the near future, like the situationists before them. Everyday life has become a particular place, rather than a general problem. The site-specificity and participatory direction of many forms of art in the last 40 years has made anthropology yet again key to contemporary art practice (Coles 2000; Kwon 2002; Schneider and Wright 2006, 2010). Fieldwork techniques such as participant observation, field notes, interviews and life histories have become common methods through which artists

produce their work. Anthropological questions about exchange, personhood, and identity figure prominently in many of these projects.

A question that is often raised in relation to this last "ethnographic turn" is to what extent the practices of these artists meet the anthropological standards: if they result in the faithful representation of a community or if they engage with anthropological questions. These are an important questions, but also inevitably frustrating ones; if anthropologists are interested in what artists do with anthropology only as "experts" assessing "amateurs," they will always find the work of artists lacking. Perhaps it is more interesting to ask or see what use artists make of anthropology. That would imply a different question: rather than asking if they are using anthropology properly, one could ask what are they using it *for*.

To address this last question, we have to come back to how the "reunion" of art and everyday life is envisioned. The forms and ends of this process can be very different—from professional, international artists who turn everyday life into art, to politically engaged collectives and activists who seek to use art to produce local change within the communities they work with. This drifting territory certainly conditions the uses of anthropology—from using anthropological methods and ideas as a means of artistic production, to using anthropology as a means to intervene in a specific social situation. In the following pages we will consider some examples of this unstable territory in order to outline some general questions, but without any ambition to be exhaustive or describe a general art history of these practices. In the next few chapters we will present many other cases and engage more deeply with the questions they generate.

Consider first a couple of well-known examples of artists working with everyday life. Sophie Calle's work is often based on studies of particular places and situations, where she compiles information through field notes, photographs, and interviews. In *The Hotel* (1984) project, she meticulously recorded her activities as a chambermaid in a hotel—registering how her relationship with the guests was mediated by the objects and trash they left behind; in *Double Games* (performed in 1994), she took the persona of a book character, living for a week in a phone booth in Tribeca, lower Manhattan. From there she listened to conversations and talked with passersby, offered cigarettes and sandwiches, and recorded everything that happened, every exchange, including smiles. In all these situations, the evocative power of images and objects, the encounter with the unexpected—in other words, "objective chance"—is central (Calle 2007). In Susan Kuchler's words, in Calle's work "the ethnographic is found in situations which are born out of chance and yet become the platform for recollections whose documentation and installation turns the project into an artwork" (Kuchler, 2001: 98). This ethnography is always, to a certain extent, an auto-ethnography, a reflection on Calle and her social

person: in *Take Care of Yourself* (2007), she took an email she received from her former partner, telling her "it is over," and asked 107 women, chosen for their profession or skills, to interpret this letter. The resulting work is an installation that includes photographs, videos, and texts with these "interpretations." In *Birthday Ceremony* (1998) she presented thirteen cabinets with the presents she received from the people she invited for dinner on her birthday—the same number of people as years she had lived. For Kuchler, this work's reflection on the theme of the gift and the mutability of subject and object (Kuchler 2001: 101–2) inevitably connects with anthropological discussions of the concept in Mauss, Strathern, and in particular Gell—the notion of the distributed person, how we are present not just in our body, but in the objects that come from us or that we receive as gifts. What is interesting for our current argument is that Calle's work in these issues— the person, the gift, the relation between people and things, chance—is deeply informed by a long-standing tradition of dialogue between art and anthropology since surrealism.

Francis Alÿs would be a good example of the developments of situationist practices and ideas as an art form. A Belgian living in Mexico, many of his works document performative events that consist, basically, of futile practices in everyday settings. Or in other words, one could say "non-events," acts without consequence, but which become meaningful precisely because they are recorded, documented, through pictures and video. One of his pieces, *Sometimes Making Something Leads to Nothing* (*Paradox of Praxis 1*) (1997),[15] is a walk through the streets of Mexico City with a big cube of ice, which melts as Alÿs goes along. The walk can be seen as psycho-geography and *détournement* at the same time, since it not only proposes a walk through the city but also involves an incongruent praxis, something that leads to nothing, questioning the limits of everyday life, work, play, production, and the city. One of his best-known and most spectacular works is *When Faith Moves Mountains*. This was a participative project in the outskirts of Lima, Peru: Alÿs, with the collaboration of curator Cuauhtémoc Medina and film-maker Rafael Ortega, mobilized university students as a voluntary workforce to displace a 500-meter-long dune. The students worked with shovels in a line of 800, and little by little, moved the sand of the dune forward by 10 centimeters. A lot could be said about what this work "represented" (in relation to Peru, urbanism and underdevelopment), but what seems to be also interesting, in connection to Alÿs's previous work, is that this is a totally futile enterprise that generates, according to one critic, "'conviviality', or the founding moment of a community" (Medina et al. 2005: 118): the group of people who participated in the action. This is an act of collective waste of labor that, because of its very obvious uselessness, ends up taking the form of a celebration, like in the "potlatch" of Bataille and the situationists.

The work of Calle and Alÿs clearly makes reference to a modern art tradition interested in everyday life, the relation of people and things, chance, work and play, a tradition that runs through both art and anthropology. Kuchler has noted, for example, how Calle's work engages with questions of memory and the relation of objects and subjects that are also at the center of anthropology. Alÿs's work, on the other hand, touches upon the relationship between the body, work, play, ritual, and the city. Both include participants into their practice, acting as mediators in social relations, more than as producers of objects; both allow the chance of their encounters with objects and people to shape their work, withdrawing their agency. And yet these artists firmly remain within the field of art; they don't try to disappear in the everyday, perhaps they don't even pretend to change it, but they use it as raw material through which they produce their work, which is objectified in the form of films, photographs, installations, archives, notebooks, and books of their authorship. Their authorship, in fact, is not questioned, even in participatory projects like Calle's *Take Care of Yourself* or Alÿs's *When Faith Can Move Mountains*; the agency of these authors may be distributed, but this distribution is still under their direct control. They may allow chance to shape their work, but they have the final word in deciding which form this work takes. Alÿs himself explains how distribution actually works: "The second part (the film) belongs to me clearly ... Whether the first part, the day itself, belongs to me, to the volunteers ... to Cuauh and Rafa ... to the dune itself, I would personally find it difficult to tell" (Medina et al. 2005: 143).

Grant Kester has pointed out the ambiguities of this "participation": while the event or action itself is participatory, its outcome—the artwork, the document, the video, that will be shown in art venues around the world—belongs to the artist. At another level, as Kester also points out, Alÿs and his collaborators seem to have decided to involve middle-class students in the action, rather than the residents of the shantytown near the dune, to avoid being too literally "activist," too obviously related to the problems of the shantytown, or the opposite, to avoid being accused of exploiting shantytown dwellers for his art project. Alÿs's project remains in this sense at a safe "poetic distance" from the actual site of the dune, its immediate realities (Kester 2011: 72).

In opposition to these processes of aesthetization or artistification of the everyday, Kester defends collaborative projects that subsume art in social practice. In his recent book (2011) Kester discusses several examples of this "collaborative art," among them the Dialogue collective, working in central India, with an Advasi ("indigenous") community. In Kester's words, the art collective "analyzed the spatial choreography of village, life, the protocols governing the movement and aggregation of bodies, and the distribution of power, labor, and access among men, women, and children" (Kester 2011: 79). In other words, they did fieldwork. Out of this

fieldwork, "the water pump quickly emerged as a central nexus of meaning in village life." So they developed plans for restructuring the pump sites. Their intervention was rather simple: building smooth concrete pads, more efficient pumps, and decorated enclosures. More than the symbolism of the decoration, Kester argues, what is important about the project is that it provided women (who are in charge of water in the village) with a protected space of interaction. As opposed to Alÿs's work, Dialogue would have chosen to engage directly with the tensions, problems, and divisions of the community they work with, rather than stepping aside from them, looking for a metaphorical image that may be effective on screen, like a line of people moving a dune (Kester 2011: 95).

It is quite clear that the work of Dialogue operates from a practice that anthropologists could readily identify as fieldwork, while that would be much more difficult to say of Alÿs's projects. And yet Dialogue's work can also open up many questions—such as, for example, what process was their "fieldwork" following? Was the "analysis of the spatial choreography" of the village just an act of observation, or did it involve asking people in the village what they wanted from them? It is clear that the art collective had a complex understanding of the internal tensions and differences within the community, but what about the tensions and differences that were created by their presence in the village? And what about the power they seem to attribute to themselves of affecting certain "changes" in the life of the village? That is less clear from Kester's description. In other words, the problems of "agency" that one could identify in Calle's and Alÿs's work could also be found, if at another level, in long-standing, community-oriented ethnographic projects, like Dialogue's.

The complex "network of agencies" involved in participative art projects are also at the center of a recently published historical ethnography of a "community arts" group in Great Britain: Free Form, by anthropologist Catherine Crehan (2012). Free Form started in the late sixties, like many collectives of what in Britain came to be known as "community arts." These collectives started from the premise of abandoning the autonomous realm of art and work in projects that could be useful to local communities. At that time, community arts were the avant-garde of art practice in Britain, and Free Form received support from public institutions like the Arts Council for more than a decade. The use of ethnography in these collectives was almost a given; they were, after all, developing their projects with communities. Originally presenting themselves as "visual experts" willing to share their knowledge, they progressively came to understand that their form of relating with the communities could not start from a top-down imposition of their expertise, but through a process of collective decision-making. Their work shifted with time, from performances and festivals, to environmental projects, often involving the redecoration of housing estates, for example with murals. These larger, permanent projects involved

a longer process of negotiation and collaboration with the local communities. After the eighties, with the neoliberal policies of Margaret Thatcher's conservative governments, "community arts" in the UK became increasingly marginalized from public funding, something separate from artistic production, between education and social services. Since then, Free Form became specialized in getting funding for social projects. In the long run, they have become experts in delivering "community participation" (Crehan 2012: 186).

In the long historical trajectory of several decades, the very identity of the group has changed, in relationship to all the different kinds of agencies they have had to deal with—from changing governments, to changing local communities, to an art world in transformation, with a quite uncertain result. From the perspective of the art world, in the end, Free Form is a rather marginal player; this group, like the Dialogue collective discussed by Kester, stands miles away from the international fame of art stars like Alÿs or Calle. Their form of work—small interventions in villages and neighborhoods: murals, water pumps, or ephemeral events like carnivals—subsumes their practice in the everyday life of these communities, and may have no immediate repercussion in the international world of "Art." On the other hand, the work of international artists like Calle and Alÿs is clearly separated in two phases: first, the subsumption in everyday life, through "events"; and second, the "redemption" of these events for the art world, in the form of documents that travel through different art venues as instances of the "distributed person" of the artist. This separation is in many ways parallel to the anthropological distinction between fieldwork and ethnography; the actual process of working in the field, and the written (or visual) account of this process. And yet there are substantial differences between artwork documentation and anthropological ethnographies. The former are normally presented as an archive, open and unfinished, rather than in the academic form of an article or monograph, with a clear organization and conclusion. Artistic documentation is left voluntarily open to keep it close to the "process" of production, as a trace, or leftover, of this process. In fact, this documentation has become the very work of art, the commodity that is sold in the art market, an objectification of the ephemeral event that can't otherwise be grasped, because of its ephemeral specificity. At the turn of the twenty-first century, the "document," which for the surrealists seemed to be the revolutionary antonym to the artwork, has become its ultimate instance; the new form of commodity fetishism in art.

In the end, however, similar problems seem to emerge in both kinds of "collaborative" projects: questions of agency, objectification, and control over the project and its outcomes appear in different guises and at different levels, but they are still common to both. Miwon Kwon addressed these questions in her exhaustive account of the history of site-specificity in contemporary art (2002). As Kwon showed,

artists working with communities have two opposite kinds of risk: one, turning the community into a ready-made object of their own work; and two, disappearing as artists and becoming social service providers (Kwon 2002: 117). This, in itself, perhaps wouldn't be a problem—if these social services actually worked—but the problem, as Kwon notes, is that as with many other kinds of public service, these projects can "exacerbate uneven power relations, re-marginalize (even colonize) already disenfranchised groups, depoliticize and re-mythify the artistic process, and finally further the separation of art and life (despite claims to the contrary)" (Kwon 2002: 19).

To sum up, this is precisely the opposite of what they wanted to achieve. Of course that is not to say that all collaborative art projects do that; but it simply affirms that this form of work does not have the results it pretends to have just because of its methodology. Even if the division between art projects that take a "poetic distance" (like Calle's and Alÿs's) and "collaborative art" that works with specific sites with specific objectives is quite clear, both can end up "reinforcing the separation of art and life." Perhaps we could also look at it in the opposite direction: asking what both kinds of project actually "do," without pretending to be able to assess their "social benefits" in positive terms.

Community arts or collaborative arts have a hands-on "useful" approach, which can show visible material results for a particular community: Dialogues' water pumps, Free Form's murals, etc. But the invisible, immaterial side of this collaboration (empowerment, or on the opposite, creating new power relations etc.) is more difficult to assess, because they work at the level of the discourses, ideas, or "representations" of this given site at that time. The effects of big, flashy art projects like Alÿs's or Calle's are, on the other hand, probably totally unaccountable, besides counting the visitors to their exhibits or the price of their works. But if we attend to the testimony of the students who participated in Alÿs's *When Faith Can Move Mountains*, it seems that indeed something more happened: a community of sorts was formed. One can question the scale, outcomes, and purpose of both kinds of project, but still, one can't deny that both kinds of project "do" have effects. It is not so easy to divide these projects between "poetic" and "political" art, an art that "represents" social questions versus an art that "transforms" society, an "aesthetic" versus an "ethical" art. All these practices, inside or outside the museum, can be approached as social practices that have social effects.

According to Kwon, one possible way out of this conundrum is to question the very notion of "community," as a pre-existing entity that the artist has to confront and/or represent. As an alternative, she suggests that we should rather think of the collective artistic practice, out of which the community may emerge—as an outcome, rather than a premise, of the artistic process.

In more general terms, perhaps we could shift the discussion from how artists represent the people they work with to how artistic practice may be a tool for constituting social relations. In these terms, we may understand these artistic projects as laboratories of experimentation with social relations, establishing unprecedented connections between different agents and collectives; they could be described in relation both to situationist practice and to ethno-methodological "breaching" experiments. The outcomes of these experiments are not necessarily empowering or liberating; they may also result in conflict and even generate new inequalities and hierarchies. This insight may also be useful for anthropologists—for example, by shifting the discussion from how anthropologists represent the people they work with, to how fieldwork, as a form of practice, constitutes social relations.

CONCLUSION: THE ARTIST AS ANTHROPOLOGIST

At the beginning of the chapter I proposed to discuss the parallels between art and anthropology at different points of the twentieth century from the perspective of the "Artist as Anthropologist"—that is to say, looking at how artists have engaged in formulating similar questions to anthropologists. In the first section, I discussed how Dadaism and surrealism questioned the relation of people and things, through particular encounters that sometimes reversed the subject/object relation, disavowing the authorship of the artist through chance encounters with objects and techniques. This attention to the "magic" of the everyday brought the surrealist close to theories of magic and the gift, like those proposed by Evans-Pritchard and Mauss, and is at the foundations of a radical critique of commodity fetishism in everyday life. Reciprocally, surrealist theories of objective chance and the dialectical image were very influential in the work of anthropologists like Claude Lévi-Strauss or Michael Taussig.

In the mid-twentieth century, the situationists brought surrealist ideas of the magic of everyday life to its final consequences, by exploring the ambiguity of this magic: capitalist commodity fetishism could be reversed into a tool for the liberation of people and things through the "methods" they developed: *détournement* and psycho-geography—methods that extend the interest in chance encounters beyond objects to the social life in the city. Their interest in the performative effects of everyday situations and events, and their capacity to form or change social reality at large, was part of a larger interest in performativity in the arts, philosophy, and the social sciences, for example in the case of ethno-methodology.

The situationists also brought surrealism full circle in their embrace of the "primitive" as an unskilled outsider, and the rejection of specialized knowledge

and work; they renounced being professional artists, and rejected the distinction between work and leisure. The final objective of the situationist revolution was the disappearance of art and the cancellation of the separation between work and life, by the same token. The "potlatch" and the gift were key to this revolution, as subversive forms of exchange that could overthrow the fetish of commodities.

The influence of situationism and anthropology in some forms of contemporary art after the sixties is as big as contradictory. The revolutionary ambitions of situationism are often reduced to the production of small, local "changes" at a local scale, "everyday micro-utopias." The site-specificity of these projects often relies upon ethnography as a method, in what has come to be called the "ethnographic turn." Many of these works engage with issues that anthropology has been discussing all along: the gift, the distributed person, the relation between people and things, work and play, etc. In many of these cases, ethnographic research leads to the production of documents and archives, but often without a particular narrative or conclusion, unlike traditional anthropological ethnographies; they are open works in process. And yet, this "process" has an author, and the documentation many times ends up being displayed as "artworks" for the art world, returning to the circuit of the commodification of art that the situationists had rejected.

On the other hand the situationist project of abandoning the professional autonomy of art has endured in the practice of many art collectives, who have left museums and galleries to work in non-artistic spaces, with communities far away from the world of art. Again the need to use ethnography to articulate this encounter is key to their practice. And yet, community arts and collaborative projects have also generated several contradictions, as these collectives, while disappearing from the art world, many times end up becoming professionals in "delivering community participation," perhaps reproducing the inequalities that they themselves wanted to challenge.

According to Kester, the changes in artistic practice throughout the last century enact a "relentless disavowal of agency" (2011: 4), from allowing chance to guide the process of production of artworks, to working with social situations and in collaboration with people. But as we have seen, this disavowal of agency seems to have its limits, even in explicitly collaborative projects; ultimately, it is difficult to overcome the distance between the "authors," or mediators, or facilitators, of these projects and those who participate in it. Going further in this direction, we could also question to what extent one can really make a strong distinction between projects "inside" the space of art and "outside" in the "real world." In both cases, beyond how they "represent" the communities they work with, we could address these participative art projects as tentative, experimental social processes, with all their contradictions and shadows.

These arguments leave open many questions: from the relation between art as "representation" and art as "action," to art and politics, or aesthetics and politics; from the relation of people and things, chance, and everyday life, to the "social relations" established through practices of participation; from the notion of the primitive, to the politics of artistic practice and anthropological fieldwork. In the next chapters, we will address these questions in more detail.

3 TRAPS AND DEVICES

What does it mean to go "beyond the politics of representation?" What is the problem with representation after all? To put it in very simple terms, the "problem" stems from the identification between "art" and "representation" in most of the anthropological literature until today. Art objects are deemed to "represent" something; they stand for something else, like images or texts, in figurative or symbolic form—that is to say, either as iconic representations that have a physical resemblance to the object, or as abstract representations which make reference to the object through a shared code (language, writing, etc.). As representative objects, they appear in opposition to objects of use in everyday life: artifacts. But contemporary art in many cases does not represent anything; it does not stand for anything, it is not just a text or image on some already existing reality. As a matter of fact, often art is precisely made of everyday artifacts, starting with Duchamp's ready-mades. And like artifacts, many contemporary artworks are supposed to *do* things, not just to talk about or stand for other things.

This is a key issue in contemporary art, but for anthropology it seems that it only became evident with the work of Alfred Gell. For Gell, anthropology should not approach art only in terms of representation, but also in terms of action—looking at what art does, not just what it stands for. But in spite of starting a critique of the representational approach, we could say that Gell still remained within its scope, by organizing his analysis around an anthropocentric concept of agency, which inevitably goes back to a theory of representation.

In this chapter, we will look at the shift from understanding art in terms of representation to address it in terms of action. I will start with the much-debated distinction between "art" and "artifact" in the anthropological literature of the last few decades. From there, I will move to Gell's proposal for an approach to art based on action, looking at both its advantages and drawbacks. In the second part of the chapter, we will look at the wider context of theories of action in both art and anthropology, showing how notions of encounter, event, or device may be more appropriate than "agency" in order to describe the shift away from representation in art.

FROM ARTIFACTS TO TRAPS

In 1984, at the exhibition *Primitivism in 20th Century Art* at MOMA in New York, the curator William Rubin proposed an investigation on the influences of "Primitive" or "Tribal" art on Modern art, showing them side by side. The cover of the exhibition catalogue showed a Picasso painting next to a Kwakiutl mask. Rubin was explicitly reacting against the "aesthetic blindness" of anthropologists, who, according to him, brought back from their fieldwork objects with no artistic interest since they wouldn't distinguish art from artifact, objects of artistic quality from mere instruments of everyday life (Rubin 1984: 21). This generated a strong reaction not just from anthropologists, but also from a younger generation of art historians, who questioned the assumption that the value of "primitive" art should be predicated simply on its formal affinity to modern art. The show presented these objects without reference to their original meanings and value, and it didn't question the legitimacy of the appropriation of this primitive art by modern artists, which in many ways could be seen as an extension of the colonialism that brought these "primitive" works of art to Western museums. In more general terms, it could be said that the exhibition didn't have a critical approach to the very distinction of "art" from "artifact" (see McEvilley 1984; Foster 1985; Clifford 1988; Price 1986, 1989; Flam and Deutch 2003; Myers 2006).

Susan Vogel took this debate as the thesis for yet another exhibition, *Art/Artifact*, in the Museum of African Art in New York. The show was distributed over five spaces. The first space, called the "contemporary art gallery," was a white, impersonal room—a white cube in the manner of many art galleries. The room contained a few selected objects, carefully highlighted, but without any titles or tags by their side, just a number that the viewer could check in a separate paper sheet. One of these objects was a zande (African) hunting net. Another was a nineteenth-century sculpted head from Abomey. Both were African objects; but were both art objects? One should think about it: that was the objective of the exhibition. After this space, the public was led to other rooms: a forest of commemorative posts from some African culture with a video that didn't explain much; a curiosity cabinet (a room full of random things with no apparent order); "a natural history museum" where the previous forest of commemorative posts was recreated as a diorama. The final fifth room showed an "art museum" with "consecrated" works of art with comments by their side.

The exhibition was asking visitors to draw their own conclusions about what was the limit between art and artifact. These limits depended largely on the context in which these objects were presented. The Abomey bust, for example, could be seen as a work of art because presented in an art gallery. If it were in an ethnographic

museum, it may not be seen as such, but as a religious object. The exhibition was a direct response to Rubin's show. Rubin was not interested in the objects' cultural or ritual meaning, but in their value as artworks. But what about the hunting net? Is the hunting net a work of art too or just an artifact? Sitting side by side with other works of art in an art gallery, it becomes a work of art. In fact, it was reminiscent of the work of contemporary artists like Jackie Winsor, who also works with knots and nets (Farris 1988: 776). The comparison that Rubin was establishing between masks and Picasso was mirrored in the cover of the *Art/Artifact* catalogue, by showing the zande net next to the Abomey bust.

But is "context" enough to call the zande net "art"? One of the authorities who contributed to the exhibition catalogue, the art theorist Arthur Danto, didn't think so. For Danto there is a fundamental distinction between art and artifact, not just in our culture, but in all cultures. This distinction does not depend on the crafts-manship or technical quality of works of art, as opposed to artifacts: it does not depend, either, on their beauty. "An artifact is shaped by its function, but the shape of an artwork is given by its content" (Danto 1988: 31). In other words, an artifact has a use, while an artwork has a meaning.

The meaning of artworks, for Danto, is attached to the core values of the cultures that produce them: "artworks have some higher role, putting us in touch with higher realities" (Danto 1988: 31). Artworks tell us fundamental things about notions of the person, identity, life and death. They are symbols of these higher notions. In these terms, the head from Abomey may be an artwork, but the zande hunting net probably not, since for Danto it is difficult to understand what a net may symbolize. Or maybe they can be highly symbolic? That would depend on the relevance and meaning that the "Wise Persons" (Danto 1988: 29) of that culture give to them.

Danto's argument was criticized by Farris (1988), who questioned the authority Danto gives to the "Wise Men" of the tribe. In fact, if we are suspicious of the criteria of Western "Wise Men"—art critics and curators like Rubin—why should we accept the opinion of the "Wise Men" elsewhere? Danto seemed a bit too zealous to preserve the supposed "original meanings" of objects displayed as art in museums, just as many anthropologists have been for a long time. But as Farris argues:

> Anthropological orthodoxy is interested in ensuring that any possible "measures" that might be used in exhibiting African materials out of context give full attention to the richness of local function and the specific demands of the aesthetic product. The motives for this insistence, while perhaps honorable [...] could be argued to deny objects of the Other any potential of their own – any freedom from the security of context – almost as if in their emancipation they might be revealed as, well, primitive. (Farris 1988: 779)

Indeed, do we need to justify the presence of these objects in a display? Are they not able to justify their presence themselves? Aren't they enough? Or are we afraid that they are too insignificant, too menial, too primitive? Do objects need to be protected, or should they be "emancipated"? Should we be afraid of the ways in which they can be interpreted or appropriated?

The discussions on appropriation, ownership, commodification, and the politics of representation dominated most of the literature on anthropology and art in the eighties and nineties (Clifford 1988, 1997; Steiner 1994; Marcus and Myers 1995; Phillips and Steiner 1999), and are still very much at the center of attention in the anthropology of art (Schneider 2006; Sansi 2007; Svansek 2007). The work of Nicholas Thomas (1991, 1999) on the colonial Pacific was particularly influential. Thomas stressed that appropriation was not just in one direction, from native to Western, but it could also be the other way around—from Western to native. This literature developed alongside a growing anthropological interest in processes of objectification (Miller 1987) and the "social life of things" (Appadurai 1988), which argued that the trajectories and "biographies" of objects are particularly well suited to understand transformations in social value: the "life" of a commodity that becomes a gift and then perhaps a religious object can give particular ethnographic insights into how the different systems of value it crosses through (markets, temples, etc.) are articulated. The biographies of objects could also be interesting ways of addressing not only transformations in value, but also cultural exchanges; the appropriation of an aboriginal object by a Western colonizer could give particular insights into how the relations between aboriginals and colonizers were established. Art objects made particularly good examples of these processes of cultural exchange and appropriation (Myers 2001; Sansi 2007), being particularly valued and meaningful objects. All this literature showed that beyond questioning their legitimacy, these very acts of appropriation should be addressed ethnographically, because they gave relevant information on processes of formation of value and cultural exchange in general.

On the other hand, besides the histories of colonial and postcolonial appropriation of non-Western art, Schneider has noted (Schneider 2005, 2006, 2012) that the appropriation of other cultures has been at the very core of modern art practice all along. For Schneider, the use of appropriation should not be understood simply as a process of decontextualization and theft, but as a hermeneutical process of learning and understanding the other (Schneider 2006: 40; 2012: 62), akin to ethnography.

Like Schneider, Gell also pointed out the necessity of addressing discussions on art and appropriation in anthropology not just in reference to "primitive" and "tribal" art, but in direct dialogue with modern and contemporary art. For Gell, most of

the anthropological discussions of art were surprisingly out of synch with the art of the twentieth century. In a rather cruel but funny paragraph, he denounced that:

> Art for the anthropology of art consists of those types of artifacts one might find on display as "art" only in a very sleepy, provincial town which (as most of them do) boasts a "gallery" where one finds folksy ceramics, carvings and tufted woolen tapestries, not to mention innumerable still-lives and palmeresque rural idylls. (Gell 2006: 210)

Modern and contemporary art for Gell would be very different from this "middle-brow" tradition. As we saw in the last chapter, ready-mades and found objects can replace the skilled production of images; in the place of manual craft and mimesis, since Dadaism and surrealism, art can be made of entirely arbitrary objects as far as they are presented as art. And these objects can include from manufactured commodities to "primitive art."

From this point, Gell's argument went much further than most discussion of appropriation and the politics of representation of non-Western art before him; he "acknowledged but bypassed the much-debated issues of the fetishization and deval-uation of the 'primitive', together with a host of other questions around collecting, appropriation, exhibitions, and representation (Thomas and Pinney 2001: 3). He was interested, in wider terms, in building a general theory of art.

The first formulation of this theory of art was articulated in an article on the *Art/Artifact* exhibition and its commentators, "Vogel's Net" (Gell [1996] 2002). Gell went back to the zande hunting net, asking: why should traps be seen just as artifacts, not as artworks? Why shouldn't a hunting net put us in touch with "higher realities" as artworks are supposed to do? As Gell showed, traps may be not only objects of beautiful and imaginative manufacture, showing the craft of the hunter, but also complex case studies on the agency and power of the prey: hunters have to know their prey very well to make them fall into the trap; different animals require totally different mechanisms of entrapment. There can be a very complex metaphysics attached to these mechanisms, by addressing the question: how do different kinds of prey bring themselves to death?

Traps could indeed be seen as touching upon complex and "higher" realities, and therefore they could be artworks, according to Danto's definition. But Gell was using Danto's definition precisely to subvert it; in his text for the *Art/Artifact* exhibition, Danto refused to think that a trap could have a meaning beyond its use. Gell argued the opposite, showing that Danto's apparent respect for the "Wise Men" of other tribes and their interpretations and "higher" realities was actually grounded in a quite narrow understanding of what could be a meaningful object. Gell's answer

was clear: any object can tell a story. There isn't a necessarily "right" or "authentic" interpretation of what an object means. In that sense, he seems to agree with Farris's arguments on appropriation and the "liberation" of objects from their "right" cultural interpretation. Following that, Gell moved on to propose an eventual exhibition that could include not only actual traps, but also contemporary artworks that look and act like traps. Gell made reference to Damien Hirst's famous shark in a pool of formaldehyde (*The Physical Impossibility of Death in the Mind of Someone Living* [1991]) as an example; he argued that the strength of this artwork lies in the shocking contrast of the bestial force of the shark, which looks alive to us, with the aseptic, technological formalism of its cage/trap, a minimalist sculpture, a model of "art." The net, the trap, is indeed a very powerful model. According to Gell:

> [...] the trap is [...] both a model of its creator, the hunter, and a model of its victim, the prey animal. But more than this, the trap embodies a scenario, which is the dramatic nexus that binds these two protagonists together, and which aligns them in time and space. (Gell 2002: 202)

The trap incorporates the prey, which has fallen into the trap by its own means, and the hunter, who has built the trap as a scenario. Both are in a way present in the trap, in a complex setting that Gell calls a network of "complex intentionalities" or agencies. Couldn't this metaphor of the trap be extended to reappropriated artworks like African masks? In Gell's words:

> Every work of art that works is like this, a trap or a snare that impedes passage; and what is an art gallery but a place of capture, set in what Boyer calls "thought-traps" which hold their victims for a time, in suspension? (Gell 2002: 213)

Indeed. Hirst's work appears here as a perfect example: the savage beast in the white cube, like "primitive" art in a modern art gallery. The violence of the object is trapped in another form of violence—the understated violence of rationalist modern space, in a complex game of forces, powers, agencies.

Playing with the idea of an exhibition on traps, Gell brought the argument of appropriation to its last consequences, and precisely because of that, it opened a path to move well beyond it. The trap, as a model, cannot be reduced to discussions of appropriation and the politics of representation; the trap is not only an empty repository or vessel that "represents" human agencies or culture, which can be appropriated in different ways. It seems to be proposing a subversion of the very distinction of subjects and objects, the appropriator and the appropriated; in the trap, these are only relative positions that can be reversed or entangled through the

very mechanism of entrapment, the scenario of the trap. Any theory of appropriation needs first a clear distinction between a subject who appropriates and appropriated objects; a clear distinction between who represents and what is represented. The trap, on the other hand, seems to propose a way out of discussions of appropriation and representation towards a relational approach, in which it is the situation, the scenario that constitutes its subjects. However, Gell didn't follow the consequences of this model to its very end. In the next section, I will address Gell's art theory in more detail, alongside its criticisms, to discuss the possible consequences, and the different forms that this relational approach can take in art and anthropology.

REPRESENTATION AND ACTION

Gell developed his theory of art further in *Art and Agency*. Gell's proposal was to look at all works of art, and objects used by humans in general, as indexes of agency. Indexes of agency are the result of intentions: "Whenever an event is believed to happen because of an 'intention' lodged in the person or thing which initiates the causal sequence, that is an instance of 'agency'" (Gell 1998: 17). To have intentions means to have a mind. The "life" we attribute to things, and works of art in particular, is the result of a process of abduction or indirect inference of a "mind" in a thing.

Artworks don't just index the agency of the artist, but of all the agents that have been "entrapped" by the artwork; they contain their distributed person, or distributed mind, which for Gell were the same thing. Artworks have power, but for Gell this power is always bestowed upon them by people with "minds," whose intentions are distributed in art objects. The entities represented in artworks would be "prototypes" of the index—models distributed in the artwork. At this point, we should explain in more detail Gell's terminology: what do "index," "agency," "intention," "distributed mind," and "prototype" actually mean?

Gell defined art as a nexus of complex intentionalities. But there are lots of artifacts that could also be defined as a nexus of complex intentionalities and are not necessarily presented as artworks. A car could also be seen in these terms; a car is used by people, who nonetheless may be trapped in it when they are in a traffic jam. A land mine could also be seen as a trap that embodies the agency of the soldier, the general that orders the soldier to hide the mine, and the person who steps on the mine. In fact, Gell used these very examples to expose his theory. Therefore, this may not just be described as a theory of the agency of art objects, but of objects in general. Some authors have questioned Gell on these grounds; Richard Layton, for example, argued that there is a substantial difference between the efficacy, or

the agency, of a land mine and an artwork; one would be like a powerful electric shock, and the other like the sign on the fence depicting a person falling back from an explosion. The first would be "brute energy," while the second "conveys a message whose stylistic conventions must be understood if it is to do its job" (Layton 2003: 460).

Layton defined artworks as images or representations: a sign of an electric shock, not the electric shock itself. Signs need to be understood according to certain codes of communication, through symbolism. For Layton, art would be "a culturally constructed medium of visual expression" (ibid.) that can only be decoded through the codes given by a culture. In this sense, he is going back to Danto's definition of art objects as symbols. But the examples that Gell was using do not exactly comply with this distinction. Duchamp's urinal does not "represent" a urinal: it *is* a urinal. Hirst's shark in formaldehyde is not a representation of a shark: it *is* a shark. Anyone who has seen a shark or a urinal before can see this is what they are, without any need to be told by a Wise Man what it means, or to be aware of the symbolism of the shark or the urinal in Western culture. That is precisely key to the argument that Gell was making—the urinal and the shark are not just artworks that symbolize or represent some message that can only be understood by those who participate in the "culture," those who share the code: they are the things themselves.

Walking through contemporary art museums, one can often hear the pious question of the random visitor: "what does it mean?", as if the meaning of art was something outside the very object that appears in front of the public, as if an expert opinion was required. But perhaps there is no need for an expert, a symbolic decoding of the hermetic text: that's it. These works are not giving answers, but asking questions: they are asking the public to *do* something with it, like tracing back the connections that have taken these things to that context in the first place. They are a provocation, they "mean" to generate a reaction from the public.

In these terms art is not a sign on the wall, or a text that has to be decoded, but a trap, a machine, a device that triggers an effect, the electric shock itself; the distinction between the "brute energy" and the meaning of an artwork would become blurred. An artwork, in this sense, *has* a use; meaning and use, art and artifact are not opposed, like in Danto's or Layton's perspective, but they are the very same thing: the meaning of an artwork is its use.

All this said, Gell did not reject the notion of representation altogether, but he confined it to a very specific sense: for him, artworks are "representations" of someone or some agency, as far as they are indexes of this agency—as far as they point toward it. Just as ambassadors can act in the name of a country, so artworks could act in the name of the artist or any other agents who have manipulated it or imbued their intentions in the artwork. They are, as it were, part of these very

agents, tokens of a distributed agency that carry forward its intentions through time and space; an attack on an ambassador is the same thing as an attack on the country or government they represent (Gell 1998: 98). The country would be the "prototype" indexed by the ambassador. Likewise, a flag can be seen as part of the distributed agency of the country it represents or indexes: acts of flag desecration are illegal in many nations, as if they were an attack to the very country. The relationship of "representation," in these cases, would not be of the same kind that Layton is implying. For Gell the relation between the artwork and the agent is a causal or indexical relation: one comes from the other, the flag or the ambassador are an index of the country or the government, they "point to" the country or government as their causal source of agency, their prototype. The sign of danger that Layton is talking about is not a consequence of electricity, and it does not have the power of electricity; it is a text that explains the possibility of it happening—through a certain code that has to be understood by the viewer. The electric shock, on the other hand, would be an index of electricity, because it literally comes from electricity—you shouldn't have touched it with your fingers! (Figure 3).

This does not deny that there are signs in the wall, works of art that tell stories, narratives, representations, which respond to Layton's or Danto's notion of what art is—in fact art from the Renaissance until the nineteenth century responds perfectly to this narrative model. But artworks can also be seen from this other perspective that Gell was proposing: as machines or networks that do not represent in reference to a shared code, as much as invite to engagement.

Both are in fact kinds of signs, according to the semiotics of C. S. Peirce. One would be a "symbol," a conventional, abstract representation of the object, only understandable through a shared code (for example, language). The other one would be an "index," a sign directly related to its object. The typical example given by Peirce was not very different from electricity: fire. The word "fire" would be a symbol of the event of fire; it requires the knowledge of a particular code (language, and more specifically, the English language) to be understood as a sign. Smoke, on the other hand, would be an index of fire—since smoke comes from fire; it is a consequence of it. In terms of electricity, the electric shock would be an index of electricity, while a placard on the wall with a sign of danger would be a symbol of electricity.

Gell used Peirce's theory of signs only to an extent. He was very "anxious to avoid the slightest imputation that (visual) art is 'like language'" (Gell 1998: 14), or in other words, looking at artworks exclusively as symbolic. One could argue, with Layton, that by being exclusively focused on indexicality, his theory of art is very partial. On the other hand, it could be said that this was, probably, a necessary reaction after decades of symbolic analysis. In fact, several authors after Gell have formulated precisely the opposite criticism to Layton: that Gell should have gone

further in that direction. Gell's use of the very notion of the "index" was quite superficial (Arnaut 2001). He reduced the "index" to a natural sign: signs that are causally related to their object. But an index, in more general terms, is a sign in direct physical connection to its object—not through reference to a shared code, like a symbol (Peirce 1998: 460–1). In this sense, the index is clearly determined by time and space; it changes in relation to its context. This is particularly clear if we look at indexicality in language, which Gell clearly dismissed. For example, if I say "today" while I am writing this paragraph, the object of the sign "today" will be totally different for the readers—simply because it will be a different day for them. The relationship between saying the word "today" and today is indexical: the word is pointing to the temporal unit within which it is being said; and yet, as the context changes, the object of the word will change ... each day. Words like "here," "there," "I," "you" are indexical, since their meaning changes in relation to the context they are pointing to. In this sense, an index is a "shifter" (Silverstein 1976; Keane 2003) whose object changes in relation to its context.

Gell's model of the index is dual: it only accounts for object and agent; when in fact a Peircean model of any sign is always a trichotomy: object and agent only produce meaning through a third element, that in this case could be described as "context." But this does not mean simply that the meaning of the index changes after its context—that the index is an empty vessel whose meaning is simply subject to interpretation, depending on the point of view. The index is not determined by the context, but rather the opposite, the index *determines* the context: by saying "today," "you," "there," we are assigning roles in space and time, we are pointing to figures to come out of the background ("you, come here"); we are attributing points of view, we are asking agents, we are building the world around us. The index, as a shifter, is not just something that "changes" in relation to things, but something that makes things change.

This understanding of the index as a shifter, rather than simply a causal relation, gives more room to play for the very notion of "trap" that is central to Gell's initial formulation. The trap as an index is a device of generating relations, or in other words of generating agents, not just of tracing them back. If we don't reduce the index to a retroactive mechanism of causality, but address it as a recursive producer of agents, it becomes much more powerful and active than Gell seemed to realize. If the objective of an anthropology of art would be just to trace back the agencies entrapped in an artwork, down to its very origin, it wouldn't go much further than a traditional iconographic or symbolic search for sources or "origins." In fact Rofes (2006) noted that Gell reduces artworks to secondary, tertiary etc. ... derivate "agents"; ultimately one has to trace it back to a first agent or prototype, either an individual artist (in the case of modern art), or a cultural tradition (in the case of the

"rest"). If we see the artwork as a mediator, or shifter, rather than the endpoint of a chain of causality, we move from the agencies it contains to the agents it can possibly entangle; from "then" to "now," past to present. In this sense, the art "trap" is not just a document, trace, or extension of past agencies, but a machine of entrapping, and perhaps even making, new agents; just like the linguistic shifter "you!" makes agents emerge from the context, figures appear from the ground, so the art trap as a mediator, a dispositive, can make agents appear in a given context.

AGENCY AND EVENT

This understanding of the index as a shifter responds to a relational model, where relations take precedence over entities. As I mentioned in the introduction, Gell was explicitly influenced by Strathern and her formulation of relational entities in his theory of the "distributed person." But as Leach (2007) concluded, there are two sides to Gell's theory. On the one hand, Gell was interested in how objects, and in particular art objects, can operate as agents, "do" things; but on the other hand he clearly sees this agency as secondary to the "distributed mind" of a human subject. For Gell, "non-humans can only be agents by proxy. There are real subjects, namely we ourselves, and then there are those second-class citizens of subject-dom (i.e. objects and the like)" (Leach 2007: 208). The very notion of "agency" is, in itself, quite contentious. Gell himself acknowledged that there are two radically different approaches to agency: an "externalist" and an "internalist" one (1998: 126). He privileges an "internalist" position, which defends that "behavior is caused by the mental representations people have in their heads" (1998: 127): thoughts, wishes, intentions. All actions, and all agency, should be ultimately traceable to a human mind.

But he also recognizes that one can have an externalist theory of agency, a theory that is not concerned with what happens "inside," with mental representations, but just with actions: an agent would be simply one who acts. In this sense, we don't need to talk about "minds," and even less about "presupposed intentional psychology," to recognize some entities as agents. From a relational perspective, people and things are made through relations, not the other way around; this is a decidedly "externalist" perspective. In these terms, Strathern's "extended person" or Gell's "distributed person" would be formed through the exchange of gifts, as given situations in which entities emerge, rather than the other way around. From there, the notion of the "distributed person" would be radically different from notions of "agency" as essentially internal and mental. As Leach argued, there is a radical tension between these two strands of Gell's work, one based on an internalist

theory of the mind, and the other based on an externalist, relational theory of the distributed person.

In the next chapters we will come back to the gift and the distributed person. But for the time being, let's say that from a relational perspective, the question is not who "possesses" agency *a priori*, who comes first, objects or subjects, but how agents, as social persons, emerge in a given situation of exchange. Bruno Latour's work is also often cited among the host of theories which have claimed to "give back" agency to objects in the last few years, together with Gell. But his position is quite different from Gell's, taking a decidedly "externalist," non-representational, and relational perspective. First of all he questions the very division between people and things. The concept of "thing" itself, for Latour, is quite complex: following Heidegger (1971), a "thing" is not just an object without agency, external to human affairs and politics. The old Germanic term Thing designated a form of ancestral assembly or gathering, where matters of concern were discussed; the "thing" would be in this sense an "assembly" or gathering of beings (Latour 2005: 13). Material "things" may be discussed in similar terms. Heidegger gives the example of an empty jug. In terms of physics, an empty jug is not empty: it is full of air. A jug is only "empty" because it asks to be filled with water, or wine, to be offered—for example at a meeting. The empty pitcher entices the social relation that will be established through it—the gift of water or wine; some "thing" that happens, an event, out of which the positions of the different agents will be established—those who give water, those who are given water. In these terms, "agency" doesn't just come from people; in a given situation, different kinds of beings (human and non-human) can become actors in relation to each other.

Coming from the field of science studies, Latour describes scientific experiments as "events" (1999: 127) whose result is not reducible to the sum of entities that intervene in its production. For Latour, there is a before and an after of an experiment; through the event, these entities are modified, and more defined: some of them may emerge as actors. To describe the experiment as an event is not simply claiming that "objects" or "non-humans" have "agency" just like human subjects. The argument is a bit more complex: it comes to say that agents (regardless if we define them as humans or not) are a result of a given situation, or "event."

Latour's description of social action does not start from human agency or intentionality, then, but from events themselves. This approach, which we may describe as post-humanistic and relational, has many precedents both in art and anthropology; there is a long history of thinking about art practice and human action in general beyond theories of representation, agency, and intentionality. In the next section, I will address more specifically notions of device, apparatus, and assemblage, which in many ways extend on the discussion of artworks as "traps."

DEVICES AND ASSEMBLAGES

Art theorist Brian Holmes has discussed some forms of contemporary art as "artistic devices," "a mobile laboratory and experimental theatre for the investigation of social and cultural change" (Holmes 2006: 412). These are practices that "have complex referential content, but they also depend on a highly self-reflexive and deeply playful exercise of the basic human capacities: perception, affect, thought, expression and relation" (Holmes 2006: 411).

Notions of device, apparatus, and assemblage have been central to contemporary philosophy and social theory, from structuralist and post-structuralist philosophers like Althusser, Foucault, Deleuze, and Agamben, to contemporary Actor Network Theory (Beuscart and Peerbaye 2006; Law 2013). These concepts draw attention to mechanisms or situations of production of agents. For Lévi-Strauss, the unconscious itself was a device—a machine of producing meaning. Foucault's classical example of the "dispositif" or device is the Panopticon, the building designed to allow a watchman to see all the inmates of an institution, without being seen. Since the inmates could not see the watchman, they had to assume that he was there all along, as if they were being watched all the time and behaved accordingly, they became subject to the power of the institution without need of chains or bars or locks. For Foucault (1995), the model of the Panopticon was not only used in prisons, but also in other institutions like schools, hospitals, or factories, with the objective of creating disciplined subjects who felt under constant supervision. The success of the Panopticon is partially a result of the fact that the watchman doesn't really need to be there; the building (as a device) does the job for itself. It is indeed a very good example of what Gell called a "trap of agencies."

Althusser's argument on the "ideological state apparatus" (1971) was similar to Foucault's "dispositif." In the street, a policeman hails "Hey you there!"; somebody turns around, appearing as the subject of interpellation, separating himself from the crowd, appearing as a figure from the background. For Althusser, this is not just a form of recognition, but the interpellation produces the individual as a subject.

In both cases, we can see that Althusser and Foucault were talking about indexical relations: the Panopticon where the inmate is being watched (pointed at), the policeman's interpellation or hail. The "device" as an interpellation, or a look, appeared as an index, a mechanism of producing agents. Althusser's and Foucault's theories were explicitly post-humanist; they wouldn't take individual human agency as a given, but as a result of these very devices. As opposed to subjective consciousness, Althusser proposed that the very origin of the subject is this external event of interpellation, the "hey you there!" of the device (Althusser 1971).

Devices and apparatuses are scenarios, social theaters through which actors come into being. It is very clear to any reader of Althusser or Foucault that there is nothing specifically positive about the "device"; they are talking about mechanisms of production of subjects, but these are subjects of ideology, or discourse; the device is a form of entrapment into the "apparatus," the "regime," "power" etc. This understanding of the device as a trap is explicit also in Agamben's definition of apparatus:

> [...] literally anything that has in some way the capacity to capture, orient, determine, intercept, model, control, or secure the gestures, behaviors, opinions, or discourses of living beings. Not only, therefore, prisons, madhouses, the panopticon, schools, confession, factories, disciplines, judicial measures, and so forth (whose connection with power is in a certain sense evident), but also the pen, writing, literature, philosophy, agriculture, cigarettes, navigation, computers, cellular telephones and—why not—language itself, which is perhaps the most ancient of apparatuses—one in which thousands and thousands of years ago a primate inadvertently let himself be captured, probably without realizing the consequences that he was about to face. (Agamben 2009: 14)

Influenced by post-structuralist philosophy, the notion of "device" in art theory is often associated with regimes of power, and art is sometimes seen as a form of confronting and questioning these devices of control or "laying bare the device," in Rosalind Krauss's words (Blois 2011). Holmes, instead, understands that artworks can also be devices. But the artistic device is not just a mechanism of domination but also of empowerment, through Deleuze and Guattari's notions of desire and *agencement*, which involve not just the subjection but also the multiplication of agents. *Agencement* is normally translated to English as "assemblage"; and yet *"agencement"* has the same root as "agency" and agent (Callon 2006: 13). The *agencement* or "assemblage," for Deleuze and Guattari, was not simply a hybrid mixture or juxtaposition of different elements (a collage), but something more—the production of a sense that exceeds this mixture.

Holmes uses as an example of the "artistic device" the *Laboratorium* show (Olbrist 2001), whose ambition was to stage the relations between scientists, artists, dancers, and writers, including Bruno Latour himself. The idea was to open spaces of interpellation, not from a central institution that interpellates its subjects, but between the different collectives themselves. Thus the activities of each collective were opened for the others to see and ask questions: the artists were invited to the scientific labs, the scientists to the process of artistic production. The museum itself shifted its spaces, displacing the museum offices to the exhibition area for all the public to see. The show was in this way a multiple Panopticon, in which each

collective was, in turn, the watchman and the watched, the interpellator and the interpellated, hunter and prey.

A very different, but equally pertinent case could be the work of Catalan artist Pep Dardanyà. He conducted a long-standing fieldwork with the sub-Saharan community of immigrants in Barcelona, which has resulted in some interesting projects, some of which have been explicitly described as "devices" (Subiros 2002). One of these works, *Module of Personalized Attention* (Figure 5), reproduced the space of an immigration office inside a museum. But here, the immigrant was occupying the chair of the immigration officer. Dardanyà hired four illegal immigrants, whose job was to sit in the officer's chair and receive the public there. The public had to wait in line. By turns, they were summoned to the table, where the immigrant explained their trip from Africa to Europe. The device worked in very simple terms: the museum visitor was "entrapped" in the place of the illegal immigrant for a moment, confronting them directly in a way that very probably they had never done before, as an actual person with a particular story, not just a social fact. The "art" did not represent anything, it didn't have an explicit discourse or narrative about immigration, but it created a situation, a *détournement*, through which a particular relation was being established; the device shifted in regard to who was occupying each position. The "relation" here is not just taking candy or eating noodles like in the relational art of Gonzàlez-Torres and Tiravanija, but something more serious,

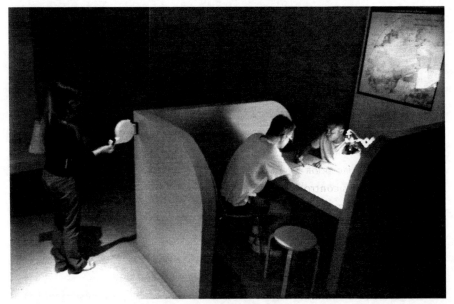

Figure 5 *Mòdul d'Atenció Personalitzada* (Pep Dardanyà 2005).

grave, and politically charged. One effect of this project was that the artist hired the illegal immigrants by means of a work contract, thereby legalizing their situation in the country, Spain. This was not announced to the museum visitors; the device appeared before their eyes just as "experimental theater," in which the public is not given answers, but asked to participate. Thus the immigrants became not only actual people to the museum visitors, but their legal status also changed from illegal to legal, and therefore their agency fundamentally changed: their "empowerment," in this case, was quite literal.

The objective of this device was not simply to represent, document, or denounce the reality of immigration. Neither was it an act of giving the immigrants their own "means of representation," because after all this is a setting designed by the artist. The device is proposing a situation of encounter, of unprecedented social exchange between different realities that don't normally meet. The objective is the truth produced by this unprecedented meeting. In and through the dispositive, actual people who may not have talked to each other can establish an actual conversation, through which they become concrete people, not just symbols or tokens of one or another identity. And furthermore, these devices can be used to produce a transformation of their social condition—for example, by giving them legal status.

The *Memetro* project, originally conceived by David Proto (Figure 6), is a radically different example. It started as a conceptual artwork in the form of a repro-ducible toolkit: a medicine box, containing a card that identifies its user as suffering a medical condition called "Memetro"; next to the card, an information sheet detailing the characteristics of this condition and the use of the card. "Memetro" would be a temporary memory disorder, which makes sufferers forget to pay to ride the metro. The card can be shown to ticket inspectors, to demonstrate that they are suffering from this condition and they belong to an association of Memetro sufferers.

But the *Memetro* project isn't just a conceptual prank. The project has also been developed as a community of "Memetro sufferers," with a website (www. memetro.net), a Facebook page, a Twitter account and lately (2014) an app. The community reports controls in the metro system through these social networks in real time, becoming a very effective device for controlling the controllers. In this sense *Memetro* is a clear example of subversion of institutional interpellation—in this case, of the public transport system; a way for the prey to escape from the trap. In the words of *Memetro* itself: a device against the devices of "panoptical control."[1]

The Memetro community, initially formed in Barcelona, has grown rapidly, and new communities have emerged in other cities: Madrid and Valencia. In fact the app

can be used on any transport network. In the context of the steep rise in metro ticket fares in recent years, *Memetro* has become an integral part of a citizens' movement of resistance to the rising cost of public transport. In these terms, one could say that *Memetro* has been a very successful device, not only in terms of producing an effect, but also of forming a community.

All these devices operate in relation to the apparatuses of institutional power; in a way they propose forms of *détournement* of these apparatuses. *Laboratorium* uses the spaces of work to question the very institutions that separate different forms of practice: science and art. Dardanyà's *Module* uses the implements of bureaucracy—tables, officers, paperwork, waiting lines—to propose an anti-bureaucratic situation. *Memetro* uses identity cards and virtual networks as devices to bypass ticket inspectors. In these terms, contemporary artistic devices bring together elements of the devices of hegemonic control (maps, offices, identity cards, virtual networks)

Figure 6 *Memetro*, David Proto (Roger Sansi 2013).

and play with them, to subvert the foundations of this very hegemonic control, and propose new relations.

Another interesting point about these devices is that they work both inside and outside of art spaces, questioning the division we have discussed in the previous chapter between art "inside" the gallery and "site-specific" practices. Dardanyà's work always implies a community that is outside the gallery space, but through the gallery space it offers them a service—a work contract to legalize their situation. *Memetro* started as an art project but quickly became a social network. Finally, *Laboratorium* plays with the interchangeability of site and museum by turning the museum upside down, exchanging spaces with scientific labs, offices, etc.

THE TURNS OF THE DEVICE

In a recent article, Law and Ruppert have proposed to define the concept of "device" around some core elements. In general terms, they say, devices are patterned teleological arrangements. The notion of teleology leads to purpose and functionality—devices do things, but sometimes they have effects that are not intended; the effects of the device are "not written in the package" (Law and Ruppert 2013: 230). Devices and their teleologies do not depend primarily on strategic subjects. The notion of a "patterned arrangement" doesn't imply that they are internally consistent and coherent, but on the contrary they are made of heterogeneous elements: things, wares, but also people and communities, are part of devices; they are better understood as rough and ready assemblages than as well-oiled systems or networks (Law and Ruppert 2013: 232). As such, their effects may be relatively unpredictable, and the device may turn out to be something radically different from what it was at its inception. This is a point that perhaps hasn't been made totally clear in the cases I discussed. In the cases of *Laboratorium* and *Module of Personalized Attention* it is less apparent what these effects may be beyond the very event of the exhibition. In the case of *Memetro*, on the other hand, the project has had several different incarnations—first as an art gallery product, then as a web page and Facebook page, a community, and an app; across these different platforms, the components of the assemblage have changed, and so has the very "nature" of the device—from an art object to a social movement. In this case the device seems to have followed a trajectory of growing empowerment. Some other cases may result in more complex situations. To introduce this complexity, in the following paragraphs I will discuss the project *We Can Xalant* as a case in point.

Developed at the art center I mentioned in the introduction, Can Xalant, by a collective of architects, the name *We Can Xalant* makes reference both to the art

center and the slogan of Barack Obama's then-recent political victory, "Yes We Can." The original idea of *We Can Xalant* was to build an autonomous, mobile extension of the art center that could be used outside the building itself. The collective came up with the idea of using abandoned caravans, which were recycled and refurbished for public use. The finished caravan was at the disposal of local neighborhood associations, and for artists to develop art projects outside the center. It was literally a mobile device.

But the project had a short life, as the credit crisis and local and regional political changes led to the closure of Can Xalant in 2012.

After the art center closed, the city council of Mataró, legal owner of Can Xalant and all its contents, took the caravan to its municipal depot. But that wasn't the end of the life of the caravan; in late 2013 it was displayed in an art show on the network of art production centers in Catalonia to which Can Xalant had belonged. It was shown in a very salient position—on the terrace of Centre d'Art Santa Monica, where the exhibit ion was taking place, right in front of the Rambla, one of the more central public spaces in Barcelona. The show was very polemical, since to the funding cuts the regional government had withdrawn most of its economic support from the network, forcing many art centers like Can Xalant to close. The use of the caravan in particular was the subject of a heated debate. It wasn't there representing the *We Can Xalant* project, or Can Xalant as an art center, but one of the art projects that used it. Thus the reference to the closed art center was quite indirect and difficult to deduce, if one wasn't familiar with the whole story. Some art critics argued that putting the caravan in such a preeminent place was a form of paying homage to that production center.[2] But one of the authors of the *We Can Xalant* project answered: "Does the hunter pay homage to the buck by hanging its horns in his house?" (Faus 2014).

The former director of Can Xalant, who lives nearby, saw the caravan by chance while it was being placed on the terrace with a hydraulic crane the day before the show opened. He had no idea that it was going to be used in that show. In his own words, "The caravan hanging on a crane in the middle of the Rambla seemed to me like a perfect metaphor of the decomposition and implicit perversity of showing the projects carried out by these centres": the exhibition was showing a selection of works, rather than addressing the critical situation of these centers where they were produced. For him, the "institutional network of production centres has become a trap that is closing like a fisher's net. Every man for himself!" (Dardanyà 2013). My translation may result in a loss of the play of words: he was comparing the network of production centers to a fishing net. In Catalan, network is "Xarxa" and a fishing net is "Xarxa de pesca," or also "Art de pesca," literally "fishing artifact." In this sense, he ironically argued that a "network" that should have enabled production has

actually become a fishing net that traps its very products like fish. "Art production" has been reduced to a "fishing artifact."

It is interesting to note the use of hunting or fishing metaphors, going back to Gell's metaphor of the trap: the horns of the buck, the network that becomes a fishing net ... In the case of *We Can Xalant*, we are in front of a very complex assemblage of institutions, agents, and things that seems to have turned into itself: the active network has become an enclosing, immobilizing trap; in the end the institutions that had to facilitate the production of the device (the city council of Mataró, the regional government) have turned it upside down, taking it away from Can Xalant to a warehouse. That does not preclude the caravan from still being used; it is still an active device. But its producers, the architects that refurbished it and the people of Can Xalant, have been totally excluded from the assemblage; instead of promoting social relations and building new agents, it seems that this device has ended up excluding them. The ambiguity of the network as trap, and the unpredictable turns of the artist device, are very evident in this case.

CONCLUSION: BEYOND REPRESENTATION?

In this chapter I have tried to explain why art cannot be addressed only as a text that represents reality, but also as a tool for action in the real world—shifting the focus from what art says to what art does. The emphasis on action is very clear in modern art since Dadaism, and has remained so in different forms of contemporary art. And yet, anthropology until very recently has been stuck in the analysis of artworks as forms of representation. This does not imply that artworks should not be addressed as representations, or that the "politics of representation" is not an important question, but there is something else, something more, both in art and anthropology. Gell's influential work at the end of the twentieth century was the first anthropological approach to art in terms of action. But as we have seen, his work still occupied a middle ground; describing artworks as surrogates of human agency and intentionality, as "secondary agents," we may be missing a part of the picture. A theory of agency does not help overcome the divide between persons and things, because things remain surrogate seconds to the primacy of the human "mind"—as primary origin of all social action, all social value, all agency. Is it enough to trace back the intentionalities that have produced an artwork? Maybe we should also be interested in the effects that the artwork produces. If we look at artworks as devices for action, we can take a different perspective; we are not just interested in the origin of the artwork, but also in its effects—in particular, how they constitute social relations and agents.

But what is the result of these events and devices? Many would raise their eyebrows at the pretension that they may have any consequence outside the art space; many would contend that these performances remain enclosed in the terrain of art, and that art turns politics into "aesthetics," pure theatre. At this point, the polemical notion of "aesthetics," and its relation with politics, deserves a longer discussion.

4 AESTHETICS AND POLITICS

Aesthetics has not been a very popular term in anthropology. Some years ago, four senior scholars gathered in Manchester for a yearly ritual performance, a "key debate" in anthropology. This time around, the subject of the debate was: "Is aesthetics a cross-cultural category?" The defendants of the motion, Howard Morphy and Jeremy Coote (Weiner 1994) argued that all cultures have aesthetic standards: standards of sensibility—essentially, of beauty—that we appreciate the world over and make art objects according to these standards. For the anthropologists who opposed this view, Joanna Overing and Peter Gow, aesthetics is not a cross-cultural category, but a "bourgeois and elitist concept in the most literal historical sense, hatched and nurtured in the rationalist Enlightenment" (Overing in Weiner 1994: 260). Western notions of art and aesthetics would be deeply, perhaps irredeemably, ideologically charged. Following Pierre Bourdieu's argument in *Distinction* (1984), Peter Gow affirmed that "our esthetic acts of comparing, contrasting, and judging are intrinsically discriminatory in class terms" (Gow in Weiner 1996: 271). The "standards" of beauty or aesthetic excellence in our society are a privilege of cultural elites. It is up to them to decide what is art and what is not, what is aesthetically valuable and what is not. Other societies may have elites of priests or wise men who have exclusive access to the principles of religion and the meaning of religious objects, and by exercising this prerogative, they reinforce their role as elites as opposed to the uncultivated masses. In our society, again following Bourdieu, the cultural elites have replaced these religious elites; aesthetics is the legitimate form of building social distinctions.

Bourdieu's criticism of "aesthetics" was also partially shared by Alfred Gell, who argued for a "methodological philistinism" (Gell 1999) in the anthropological study of art: just as the sociology of religion starts from a position of "methodological atheism," the anthropology of art should not participate in the "belief" in art; it should be subject to anthropological scrutiny under the assumption that this belief is not literally true. Aesthetics would be for art what theology is for religion: a "native ideology," a compilation of its articles of faith. For Gell, as for Bourdieu, art is a

modern form of religion and aesthetics its theology, just as museums are its temples and artists its priests. Anthropology, on the contrary, is explicitly "anti-art," or iconoclastic, because it starts from the "methodological" disbelief in this native religion.

A collective volume inspired by Gell's work was published under the telling title *Beyond Esthetics* (Pinney and Thomas 2001). In that volume, some authors extended this criticism of "aesthetics," not only on the grounds of being a Western ideology and a secular religion, but also because this religion is based on a particular form of asceticism, as it were, a withdrawal from the senses and bodily experience, that privileged detached contemplation. This asceticism is the very tool of the process of social distinction; the distancing and suspicion of the senses is also a process of taking distance from lower classes and primitive peoples and races, who would be guilty of excessive sensualism. The paradox of this asceticism is that "aesthetics" in origin, in Greek, means the domain of sensory experience; in Buck-Morss's terms, the Western ideology of aesthetics has turned the senses in the very opposite direction, an "anaesthetics" (Buck-Morss 1992), a disengagement from the senses, a "numbing of the human sensorium" (Pinney 2001: 160). In contraposition to this "anaesthetics," Pinney proposed a "corpothetics," focused on sensory immediacy and bodily praxis, rather than detached contemplation. For Pinney, the division between "anaesthetics" and "corpothetics" is not so much a Western/non-Western distinction, as the difference between an elite and a public aesthetic, one which identified detachment from the senses with social distinction, as opposed to a popular aesthetic that engaged with the senses fully (Pinney 2001).

So the anthropology of art at the turn of the twenty-first century took a very explicit "anti-art" position, questioning the very foundations of the Western "art cult" (Gell 2006), not just on the basis of its ethnocentrism, but also of its social elitism and ascetic detachment from the senses. However, the fact is that artists and art theorists themselves had been questioning the very principles of aesthetics, and of this "art" religion, for much longer than that, at least since the avant-garde, when the first anti-art movements like Dada emerged. These anti-art movements have been, perhaps paradoxically, at the basis of much of the art of the second half of the twentieth century, from situationism and conceptualism to social practice art. It could be said that the most common criticism of aesthetics in art practice is the opposite to the argument on corpothetics: art is not just a sensual experience, but a critical gesture—an act of communication, a social event. It could be said that the dominant theoretical framework in the art world in the last decades has been "institutional critique," the radical questioning of the very institutions of the "art cult": museums, galleries, artworks, artists themselves. In this sense, anthropology in the last few years has only been catching up with the central objective that modern

art has had at least since the beginning of the twentieth century: to go "beyond" aesthetics.

Jacques Rancière recently said that "the discontent with aesthetics is as old as aesthetics itself" (Rancière 2009a: 11); that is, it goes back to the eighteenth century. In fact, there is nothing particularly original in describing aesthetics as a dominant ideology or as a caricature of a "religion," if the "priests" of this religion of art—artists—have been the first to reject its "theology." What is the problem with aesthetics, after all? This chapter will propose to address this question from the perspective of anthropology. The final objective of this chapter is to understand which forms of social relation are proposed by aesthetics, and for that purpose, it will be necessary to build a particular genealogy of the term, going back to its roots in the eighteenth century. Rancière has proposed a strong reinterpretation of this genealogy, which I will partially follow. His work has shown how many of these ideas are still very contemporary, not just as remnants of a tradition of domination, but also as the foundations of a promise of liberation, the "aesthetic revolution." My objective is not so much to reclaim the concept, and even less the "belief," but to unfold its complexity and implications for anthropology, beyond its dismissal as the bourgeois dogma of art. In the final part of the chapter, however, I will depart from Rancière on one important point: the anthropocentrism of his definition of politics.

THE PROBLEM WITH AESTHETICS

The term Aesthetics was invented by Alexander Baumgarten in the mid-eighteenth century (Baumgarten 1954 [1735]). Following the Greek distinction between "Noeta" and "Aistheta," objects of thought and objects of sense, he proposed that if objects of thought are studied by Logic, objects of sense should be studied by the discipline he called Aesthetics. For Baumgarten, our senses and imagination are analogous to reason, but second to it—a lower faculty of cognition, confused and indistinct, as opposed to the clarity of reason. Baumgarten was directly following Leibniz, for whom sensory perception is confused knowledge. Leibniz explained this confusion by making reference to art criticism: when judging an artwork, often we cannot say why we like some and not others, except by saying that the artwork has "something, I know not what" (*je ne sais quoi*) (Leibniz 1969: 291); we are not able to explain our view by giving a logical reason.

Baumgarten's aesthetics was not just a theory of art, but a theory of the senses and imagination, in general. It starts from perception, not the production of art. This is a radical departure from classical philosophies of art and poetics in the seventeenth century, such as that of Boileau, who in *The Art of Poetry* (2008 [1674]) defined

beauty in objective terms: as a quality of things themselves. Beauty for Boileau would be truth; as such, beauty is to be found first of all in Nature, and Art would only find truth if it imitated Nature faithfully. The strict laws of art for classicism would be, themselves, an imitation of the laws of nature, guided by truth and reason.

Baumgarten's shift from poetics to aesthetics, from production and objectivity to perception and subjectivity, is in fact part of a more general cultural change in the eighteenth century, from a naturalistic to an anthropological understanding of art, from imitation to imagination, from rules to taste, from logic to sense. Our understanding of art and aesthetics today is partially still based on the *"je ne sais quoi*/I know not what," a sense of irreducibility of the aesthetic experience to objectified knowledge, of sentiment to reason. In these terms, eighteenth-century theories of taste and aesthetics could be read as purely subjectivist and sensualist, as opposed to the poetics of classical thought in the seventeenth century, which were objectivist and rationalistic. Kant's contribution to aesthetics in the *Critique of Judgment* aims to complicate things a bit further, by rejecting ready-made contrapositions between the objective and the subjective, reason and the senses, and proposing that perhaps aesthetics is a third way between these irredeemable dualisms.

Kant is one of these authors (together with Descartes) that many anthropologists have written against. This is partially understandable, since "Kant" stands for the whole tradition of modern Western thought, something that anthropologists are supposed to question. Specifically in the case of aesthetics, Kant's writings have been foundational; they have been incorporated not just by other authors, but also by the institutions and practices of modern art and education—they have become *our culture,* the way we are thought to relate with art. But precisely because of this influence, it is indeed very difficult to read Kant directly, without having some previous notion of what he said. So in the next few paragraphs I will try to explain some of Kant's arguments at a very general level, as if it were for the first time, to avoid taking his arguments for granted.

Kant's philosophy is an anthropology—a philosophy of how humans think and relate with the world. Humans can discover truth through reason, by analyzing our experience and discovering the natural laws that organize the world. Take for example an apple. If you were Isaac Newton, using your pure reason, seeing the apple fall from the tree, you may have discovered the law of gravity. Now, let's imagine that our Newton is hungry after doing so much thinking. He wants to eat the apple. But can he? Is he in his own garden? Maybe not? Is he allowed to eat the apple? For that he needs a different kind of thinking—not his reason, but his moral understanding. Morals for Kant have different ends than pure reason: they are after "the good," not "the true"; and things are not good or bad in themselves, only in relation to us humans. Kant's world, in the Enlightenment, is divided in two.

On the one hand, we have the objective world of nature, a world of *truth* guided by natural laws, which works independently of the interests and desires of human subjects. On the other hand, we have a subjective or social world ruled by morality, that has no objective reality behind subjects. Nature and society are separated by an incommensurable gap.

But there is a third form of relation of subjects and objects, behind objective reason and moral understanding. This is our aesthetic judgment, or judgment of taste. When we exercise our judgment, we are making a statement about the qualities of objects independently of their relation to us—for example, when we consider something beautiful. Let's go back to the apple example. Imagine that Newton, before seeing the apple fall from the tree, was not hungry or thinking about natural laws; he was just looking around, distracted, and at one point he looked up at the tree. He sees this apple, perfectly mature, shining in the sun. Before it fell down, he may have thought: "What a beautiful apple!" When he was thinking that the apple was beautiful he was not thinking of it either in relation to natural laws (following pure reason) or to human morality, but as an object *in itself*.

In the *Critique of Judgment* Kant defines aesthetic judgment as free of need and finality: object and subject are independent and the subject has no interest in the object, but the subject sees the object as such, in its own objecthood, as it were; you can see it as *beautiful in itself*, independently of you.

Saying that the subject has no interest in the object does not mean that he or she is indifferent towards the object; it does not imply a renouncing of the world. This has been a common accusation against Kant's aesthetics, described as too intellectual, detached from the senses, ascetic and elitist. Heidegger, a philosopher who is much more popular than Kant in contemporary anthropology, pointed very explicitly to Schopenhauer's reading of Kant as the cause of this. For Schopenhauer read Kant's aesthetic experience as a form of withdrawal from the world, the will, the senses, desires, and pain, to take refuge in representation and contemplation, in a kind of ascetic indifference.

But for Heidegger, what Kant meant by "devoid of all interest" was the very opposite of a withdrawal from the world. To have an "interest" in something means to relate with this object because of its importance to me, to the subject. "To take an interest in something suggests wanting to have it for oneself as a possession, to have disposition and control over it [...] Whatever we take an interest in is always already taken, i.e., represented, with a view to something else" (Heidegger 1979: 105). On the contrary, to relate with an object without interest implies that "we must let what encounters us, purely as it is in itself, come before us in its own stature and worth"; it comes forth as a "pure object" (Heidegger 1979: 106), not as a representation of something else.

After Schopenhauer, many have questioned Kant, to reclaim life, desire, the body, and the senses against the contemplative and ascetic approach of "aesthetics," including Nietzsche and Bourdieu. For Heidegger, what Kant meant by "devoid of all interest" is that one does not see the object in relation to one's own interests and needs; one has no particular interest in possessing or owning the object. But this does not mean that the judgment one makes is indifferent or detached from the senses. On the contrary, it can be very sensual, because it is focused on the object itself, not in what it *represents*: a property of something or someone, or the satisfaction of a need. To go back to our example: we can enjoy the sensuous qualities of the apple more fully if we are not concerned with the price of the apple or the hunger we feel. But still, the aesthetic judgment can be very passionate, because for Kant, we aspire to share our judgment. Judgments of taste are universalizing: we want everyone to understand and share our judgment; we see the beauty of the apple as an objective quality that everybody else *should* see. But paradoxically, we recognize it as a subjective "taste," our own take, and we know other people may have different tastes. This is the paradox of the *sensus communis*—a "shared sense" by which we put ourselves in the position of others. Kant defines this *sensus communis* in the following terms:

> [...] we must [here] take *sensus communis* to mean the idea of a sense shared [by us all], i.e., a power to judge that in reflecting takes account (a priori), in our thought, of everyone else's way of presenting [something], in order as it were to compare our own judgement with human reason in general [...] Now we do this as follows: we compare our judgement not so much with the actual as rather with the merely possible judgements of others, and [thus] put ourselves in the position of everyone else. (Kant 1987: 160)

The aesthetic judgment results in a "free play" of our reason and our moral understanding, an exercise of these faculties without any explicit goal or obligation. Kant described beauty as a symbol of freedom, because aesthetic judgment is essentially free of any constraints—a symbol of an autonomous subject exercising his judgment in view of others like him (the *sensus communis*). In fact, as Whitney Davies says, aesthetics in the Kantian tradition is essentially "a social process of winning others' agreements to one's judgments of taste," something that would not be so different to Gell's "distributed person," even if Gell plainly rejected Kant (Davies 2007: 202).

In the *Letters on the Aesthetic Education of Man*, Schiller (who, according to Heidegger, "alone grasped some essentials in relation to Kant" [1979: 104]) brought these ideas further. Beauty is not just the symbol of freedom, but "it is through beauty that we arrive at freedom" (Schiller 1910: 4); only through the aesthetic

judgment can we learn to relate to objects in the world free of need and interest. And not only does it make us free in relation to objects, but also in relation to other subjects in society: "The aesthetic communication alone unites society, because it applies to what is common to all its members" (Schiller 1910: 62). Kant's *sensus communis*, by which we put ourselves in the position of others, is the foundation of an education into the "common," as a transcendent goal that is not limited to individual objectives, will, passion, prejudice, or need.

For Schiller, the aesthetic judgment can teach people to be free, not by teaching them *what* is beautiful, but by teaching them to judge for themselves, freely and at the same time being tolerant and recognizing other people's views. The exercise of aesthetic judgment can lead to the formation of citizenship as a consciousness of public responsibilities independent from both private interests and from the strict adherence to general principles or prejudices. Schiller was writing this at the dusk of the French Revolution (1794). He was once an enthusiastic partisan of the revolution, but became horrified by the triumph of the regime of terror, which was imposing the revolutionary principles through violence, forcing citizens to be "free." Schiller understood that to develop a revolutionary citizenship, it was necessary for citizens to think beyond their private interests, but he was also against the violent imposition of revolutionary rules from the top down. It was necessary to cultivate the seeds of freedom in individuals, allow them to become responsible and free citizens by themselves. Aesthetics may be the way to achieve this, since it makes people cultivate their "play drive." By talking about "play," Schiller was not being ironic or irresponsible; he took "play" very seriously: "man only plays when in the full meaning of the word he is a man, and he is only completely a man when he plays" (Schiller 1910: 30). Schiller followed Kant's idea that through aesthetic judgment we put our faculties—our reason and our moral understanding—into play, and at the same time we can take a distance from them, precisely because we are free of their imperatives. This play makes the subject aware of the object as such—as a "pure object," as Heidegger would say—and at the same time of the other subjects as part of a community of sense, a *sensus communis*.

AESTHETICS, THE PUBLIC SPHERE AND THE CULTURAL FIELD

The free play of our faculties in aesthetics makes us aware of our commonality with other subjects, and at the same time of our difference from objects. This, for Schiller, is fundamental if we want to educate good citizens—people who are able to discern and discuss public issues independently of their private ends. Schiller's

aesthetic utopia aims at the formation of a public consciousness, a revolution in education that has to precede any political revolution, because only free people can lead a free society. The exercise of this public consciousness is constitutive of what Habermas called the "public sphere." In Habermas's own words, "Schiller stresses the communicative, community building and solidarity-giving force to art, which is to say, its public character" (Habermas 1992: 46). According to Mitchell, the "public sphere provides the space in which disinterested citizens may contemplate a transparent emblem of their own inclusiveness and solidarity, and deliberate on the general good, free of coercion, violence, or private interests" (Mitchell 1990: 35). This is the reason why it is considered that art should be public, because it is considered to be fundamental to education, not only for its content but also because of its form; not only to cultivate good taste, but to educate judgment, and stimulate *sensus communis*—what is common to all.

The educational role of the arts and culture in the formation of the citizenship is at the basis of the creation of an autonomous cultural or artistic field, as has been theorized in classical sociology, for example by Pierre Bourdieu—a field that has been granted an autonomy allowing for the construction of a cultural system of value, independent from other forms of social value or interest (e.g. religious or economic). These "fields" would have different systems of value and forms of relation of objects and subjects. We could describe these differences through the institutional settings they prefigure: the market for the economic field, the temple for the religious field, the museum for the cultural or artistic field. In the market people relate to objects as commodities. They buy and sell them according to their needs, desires, and strategies. The commodity is a means to achieve these objectives. And in these objectives subjects may be in competition with one another, since according to one basic law of economics, means are scarce. Thus the differences between subjects are mediated by the access to resources that one or the other has. Social differences depend on what they have. In the temple, the objects of adoration mediate the relation between people and the sacred—the sacred being the primary subject to which people are no more than objects, in fact. In this case there are no questions to be asked; the only thing that one is expected to do is pay homage and adore the sacred. The relations between subjects in this sphere are not mediated by competition but by hierarchy—their proximity to the sacred. What counts is what they are, not what they have.

Some would say that the museum is like a market, some like a temple. But could it be something else? If Kant and Schiller were right, it should be something else. First, a place where people are not obliged to adore or pay homage to anything, or need anything; where persons are recognized in principle as equals, since judgment is subjective and doesn't depend on what you have or what you are; and where their

only aspiration is to reach an agreement, but free of coercions, needs, and hidden agendas.

This sounds very enlightened indeed—or romantic, if you wish. Is the museum in reality so different from, say, the temple? Some anthropologists and sociologists, for example Bourdieu, would say no. For him, museums in reality are like temples. They enforce social distinctions because they reproduce the superiority of the ruling classes who have access to "taste." This appears to be a paradox, since "taste" is said to be "natural" and independent of class position. But for Bourdieu, in reality it isn't; it is socially constructed. Thus, aesthetics and art are other means of reproducing social power. But they are a means very particular to our modern society. In *Distinction* (1984), Bourdieu characterized the aesthetics of disinterestedness as an aesthetics of the bourgeoisie, as opposed to a working-class subaltern aesthetics of the "practical," the "useful."

At another level, for Bourdieu both the museum and the temple had to be understood as part of a larger institution: the market. The "priests" of different temples, of different religions, compete with each other for followers, in an "economy of the goods of salvation" (Bourdieu 1991: 23). That is also the case for art institutions and schools competing for the public in a wider market of artistic fame.

For Bourdieu, every social field had its form of value defined in opposition to other forms of social value. Thus, for example, religious values would be defined in their opposition to economic values. But the structures of each field are analogous; they all work in the same way. They are all fields of forces—fields where value is disputed by social actors. The value of each field is accumulated by actors in a specific form of "capital." Thus some actors may have little economic capital, but they could have, for example, a lot of religious or cultural capital.

The model for the structure of all fields, then, is the economic model, which doesn't mean that all fields are subordinated to the economic field, just that they function according to its model, that of capital, by building autonomous values. But this model, for Bourdieu, is often misrecognized—or not acknowledged—because of the structural opposition to the economic field. The cultural or artistic field is paradigmatic for this model. The values of the cultural field are in radical opposition to the economy and its values. Artistic ideology is based on the suspicion of commercial success as a mark of losing edge, of selling out, of becoming mainstream. Artworks are the opposite of commodities. Taste is something that cannot be bought or sold, because it is seen, in a way, as something innate, personal, natural, and the judgment of taste is disinterested. This opposition to the economy, for Bourdieu, is precisely what constitutes cultural capital. In his words, "the literary and artistic world is so ordered that those who enter have an interest in disinterestedness" (1984: 40) The cultural field should be an egalitarian field of practice; each man has his own

taste and that is irreducible to what he has or has not. But this is not exactly true, reveals the sociologist; some have better taste than others. And that distinction is *naturalized*; it is not recognized that some have better taste because they have more access to cultural capital.

But if the cultural field is built as a religion, how to explain the constant attempts to destroy its foundations by its own practitioners—and its own priests? How can the sociologist explain a field that is constantly destroying itself? For Bourdieu, the "anti-art" movements within art were nothing but "ritual acts of sacrilege" (1994: 80) that have become a necessary part of the liturgy; contemporary artists have to follow the example of Duchamp, and mock and vandalize the "sacred" art of the past.

So sacrilege and iconoclasm become consecration and creativity in the religion of contemporary art. The rules of art are the subversion of old standards of taste, the rejection of the Academy. Then, the rules of the game dictate that those who were once rebels will become the new masters, and so another generation will rise against them and replace them in their own turn. And yet, Bourdieu had to acknowledge that there are forms of transgression that cannot be accepted by the field: those who question the logic of its functioning and the functions it performs, those who refuse to "play the game" but question the rules of the game itself and the belief which supports it (Bourdieu 1994: 81).

But from Schiller's aesthetic utopia, through Dadaism, surrealism, situationism, to social practice art, many art movements questioned these rules. Were all of these outside of Bourdieu's artistic "field"? If art practices are constantly overflowing the field of art, how useful is this concept after all? To put them together under the rules of a single "game" is to reduce very different historical situations to one rather simplistic narrative. Perhaps one needs a more encompassing and less reductive understanding of these concepts, and it may be a good idea to start with the idea of "play," as Jacques Rancière did.

THE DISTRIBUTION OF THE SENSIBLE

A first critique one could make of Bourdieu would go along the lines of Heidegger's reassessment of Kant. Bourdieu wrote *Distinction* in direct contraposition to Kant's aesthetics; he described the "disinterestedness" of the aesthetic experience as an essential part of the *habitus* or culture of the higher cultured classes, as opposed to the functional aesthetics of the working classes (Bourdieu 1984: 42–3). The cultured classes would have an "interest in disinterestedness," as a tool of social domination, through their superior taste. But in this point, Bourdieu explicitly followed the

Schopenhauerian reading of Kant (Bourdieu 1984: 487); he described aesthetics as a form of asceticism of the higher classes, the asceticism of good taste, distinction, and cultural capital.

This account misses the classical, Kantian–Schillerian account of aesthetics on two grounds. The first, as Heidegger explained, is the confusion of the non-interested character of the aesthetic relation with an ascetic rejection of the senses, when in fact it is the opposite: the aesthetic judgment does not relate to the object through external interests and needs, but it offers an engagement with the object in its own terms—letting what encounters us come before us in its own stature and worth, as Heidegger said. The object is not a "representation" of something else, but a thing in itself. In this sense, it does not imply a detachment from the senses, but on the contrary, a free, unconditioned engagement with them.

Bourdieu also missed the point that the judgment of taste for Kant and Schiller was not "natural" or "given" at all, but the result of a *sensus communis*. This is one of the main issues that Jacques Rancière has raised in recent years, proposing a reassessment of the problem of aesthetics beyond theories of the public sphere and the artistic field. He starts with a reassessment of the work of Schiller. According to Rancière, the *Letters on the Aesthetic Education of Man* not only offers a model for the construction of a bourgeois public sphere or a cultural field, but is proposing a fully fledged revolution, "a revolution of sensible existence."

This revolution would be based on the politics of aesthetics. For Rancière, politics is the definition of a particular sphere of experience, of objects posited as common and as pertaining to a common decision, of subjects recognized as capable of designating these objects and putting forward arguments about them (2009a: 24)—the formation of a *sensus communis*, in Kant's and Schiller's terms. In fact art, for Rancière, is always intrinsically political—not because it "represents" political issues or makes reference to the current state of affairs, or because it "represents" particular groups or social collectives, but because of "the type of space and time that it institutes, and the manner in which it frames this time and peoples this space" (Rancière 2009a: 23).

This particular time and space is not the "cultural field" of Bourdieu; it is built precisely against the constitution of any specialized fields of practice and knowledge within a given social structure, proposing instead the construction of a community of sense against this very social structure. The apparent "separation" from other fields of practice is in reality a form of questioning them, of questioning the very social division of labor into "fields" in modern society, the reduction of practice to labor. Aesthetics, after Schiller, does not simply constitute a separate field of practice based on the "autonomy" of art. It is not art that is "autonomous," but the mode of experience that aesthetics is proposing (Rancière 2002: 133), a mode of experience

based on play. This is precisely what is central about the notion of "play"; for Schiller, "[p]lay's freedom is contrasted to the servitudes of work" (Rancière 2009a: 31). Work is what we do for a living, out of necessity, but it is not necessarily what we want to do, something we identify with; play, as opposed to work, would be a free activity where people can afford to be themselves. Schiller's proposal to put play at the center of existence is not just a proposal to educate good, responsible citizens, but also the utopian promise of a different form of life, in which what we do and who we are, work and life, are not separated: "a collective life that does not rend itself into separate spheres of activities, a community where art and life, art and politics, life and politics are not severed one from another" (Rancière 2002: 136). This reading of Schiller is clearly in line with a long Marxist tradition of critique of alienation of work, represented by philosophers like Lefebvre (1953), whom I introduced before in relation to his influence upon situationism. It is also deeply indebted to the questioning of the academy and the professional role of the artist since Dadaism; the very notion of starting from scratch, as a "primitive," is central to Rancière's work well before he engaged directly with aesthetics. In his seminal book, *The Ignorant Schoolmaster* (1991), he proposed a radical conception of pedagogy. As opposed to the given fact of the inequality between master and student, by which the master has knowledge and the student is ignorant, Rancière proposes to start from another perspective: what if both master and student were ignorant? In that case, the role of the master would be not to explain his knowledge to students, but to make them learn by themselves, as his equals. From this shared ignorance, a new knowledge can emerge. A shared ignorance would be thus at the foundations of the assumption of equality. In this sense, Rancière makes a radical departure from the sociological critique of the school system, for example in Bourdieu's work, which explains how the given inequality between master and student inevitably ends up reproducing social inequalities, not only in terms of knowledge, but also of social class. Rancière's argument is not to deny the sociological fact that Bourdieu is denouncing, but from the perspective of a political philosopher rather than a sociologist, he is proposing other possible ways of understanding equality and education. Rancière's work is not about what education (or art) actually is, sociologically speaking, but about what it could be, if we sidestep given inequalities, hierarchies, separations, and "fields," if we start from the radical presupposition of equality, and our common ignorance.

In this sense, the politics of aesthetics after Schiller and in Rancière are a utopian politics of the community that is to be, a community that is free insofar as it no longer experiences the separation of work and life, master and student, but starts from the radical assumption of equality, from a shared ignorance. For Rancière, from Schiller to relational aesthetics, art reaffirms this essential idea: "that art

consists in constructing spaces and relations to reconfigure materially and symbolically the territory of the common" (2009a: 22).

Yet Rancière goes further than Schiller; he transforms the notion of *sensus communis* into a "distribution of the sensible," aiming to stress precisely the plurality of senses, the possibility of formation of multiple communities of sense, based on disagreement, rather than consensus. Politics for Rancière is not the exercise of power or the acceptance of the established order; that for Rancière is "the police," by which he means not the actual police but policy, the administration of power. Politics is what interrupts policy—an event of disagreement with the order of power, which proposes a new distribution of the common world. He describes political subjectivation as "the process through which those who don't have a name, attribute themselves a collective name, which they use to re-name and re-qualify a given situation [...] a collective of enunciation" (Rancière 2004: 83) that expresses its dissent. Or in other words, those who don't have knowledge, or a position in the hierarchy of knowledge, assert themselves as subjects of a new form of knowledge. Through particular distributions of the sensible, political subjects are constituted in relation to their objects of disagreement; they appear as subjects redefining the coordinates of the sensible, the space of political play.

This space of political play is not separate from, but integral to aesthetics and art as a form of aesthetic practice. For Rancière, the relation between art and politics in not limited to political art; art is not political just because it represents political issues. On the other hand, art is not political just because it "reaches out" of the museum, because it tries to bring art to people who normally don't go to the museum. Rancière questions the very topography that separates the "inside" from the "outside" of the museum, and the assumption that this separation is a problem to solve, that the museum has to "reach out." This "reaching out" is a result of the notion that the museum as a public institution has to create "consensus." There, Rancière radically disagrees; for him the political function of art is to "discover new forms of dissent, ways of fighting against the consensual distribution of authorities, spaces and functions" (Rancière 2004: 76). Art has to create dissent, as opposed to consensus. Consensus produces a clear separation of responsibilities and authorities; art questions these separations. In fact, for Rancière art is *always* politics. This argument questions the distinctions that we have seen in previous chapters: between art projects "inside" and "outside" the museum, gallery projects versus site-specific projects, as if one kind was "aesthetic" and the other "political" or "ethical."

Aesthetics is a historical event, a particular form of the "distribution of the sensible," a "regime" which was born precisely with the work of Kant and Schiller. This new "aesthetic regime" emerged out of disagreement with the previous regime of art—what Rancière calls the "representational regime." The latter would

roughly be mapped on post-Renaissance art, "classical" or "academic" art from the fifteenth to eighteenth centuries, the former to modern and contemporary art after Romanticism from the late eighteenth century until today. But to reduce these regimes to particular historical frames is a bit misleading, since several features of the "representational regime" survive in the contemporary art world, as we will see.

The "representational regime," established in the Renaissance, defined the autonomy of the Fine Arts from other manual crafts. Before the Renaissance, the artist was a manual technician, a worker; the classical artist after the Renaissance was no longer an artisan, but an intellectual and humanist, who applied his erudite knowledge to his work. In the representational regime, beauty is an objective quality of nature, and artists must learn to represent it correctly. For that purpose they would be trained in academies, where they would not only be taught the skills of painting, sculpture, architecture, music, but also geometry, physics, and the humanities: the "arts," in plural. These arts would be based on a set of clear rules, through which artists would learn to imitate nature in the correct form. The first rule is precisely the rule of representation—the splitting of the world in two: a nature to be represented, and an "art" that will imitate it—and this would be done through precise techniques, imposing form upon inert matter (Rancière 2004: 39). Matter has to be dominated, fetched, to achieve correct mimesis, and this implies a disciplined process of learning the rules and techniques of art. Technical mastery—the correct mimesis of nature—would be identified with superior quality and beauty. Academic knowledge is a clearly hierarchical, regimented knowledge, built on distinction; only those who have knowledge of the processes of representation can be the arbiters of beauty.

The aesthetic regime would break with this hierarchical access to beauty. The aesthetic judgment of taste would not be the privilege of a few academicians, but the constitutive quality of a community of sense. The "representational" regime of art was based on poetics, making art according to an academic rule, but the aesthetic regime art is based on politics. Art is no longer concerned with making "beautiful" objects that imitate nature, but on the judgment of the community of sense. In this context, the Academy, its teachings, rules, techniques, hierarchies, and forms of knowledge no longer make sense. Modern and contemporary art is "anti-art" because it goes against the principles of the "art cult" that was constituted precisely in the representational regime: the sacralization of the artist as genius with "creativity," the museum as a temple of culture, and so on. The hierarchy of the academy is replaced by the egalitarianism of the distribution of the sensible.

The aesthetic regime brings art to its extreme form, to become its very opposite: heteronomy, the dissolution of art into everyday life. "Art" in the singular, as a form of life, replaces "the arts" as a profession. The mission of art in the aesthetic regime

is to show us the way of liberation from labor, and on the way, disappear as such. Artists in the aesthetic regime would aim to reintegrate art and life, labor and play.

The founding paradox of the aesthetic regime is that art is art insofar as it is also something other: as far as it brings a promise of emancipation, the elimination of art as a separate reality, and its transformation into a form of life (Rancière 2009: 36). Since Schiller, through the avant-garde to contemporary social practice, many forms of art have aimed to be something more and something else than "art," but just life.

On the other hand, this movement towards the total dissolution of art into everyday life in the last two centuries, has often been counteracted by the opposite movement, of protecting and reinforcing the "autonomy" of art, of resisting its dissolution into everyday life. This is what Rancière calls the "politics of the resistant form," which "encloses the political promise of aesthetic experience in art's very separation, in the resistance of its form to every transformation into a form of life" (Rancière 2009: 44).

At this point Rancière's argument becomes a bit paradoxical. For him, the persistent tension of the "politics of becoming-life in art" and the "politics of the resistant form," or heteronomy and autonomy, is constitutive of the politics of aesthetics, or what he calls the aesthetic regime. In many ways, however, what he calls the "politics of the resistant form" can be read simply as the resistance of the regime of representation, with its institutions and values, from the critic to the artist as genius (a notion that we can trace back to the Renaissance), and the belief in the transcendent value of the work of art, that reaffirms the separation of "art" from other forms of social practice—in other words, the autonomous "field of art," with its rules, as it was described by Bourdieu. In this sense, one could question to what extent we have to understand "the regime of representation" and "the aesthetic regime" as two historically consecutive and mutually exclusive regimes of art, or simply as two extreme models of artistic practice: "art for art's sake" (autonomy) versus the dissolution of art in everyday life (heteronomy). In any case, besides assessing the historical or sociological exactness of Rancière's theories, what is important is that he does not reduce artistic practice to the autonomous "field of art," like the sociology of Bourdieu, but he puts the emphasis on the tension between autonomy and heteronomy, the constant give and take between art for art's sake and art as everyday life, institution and utopia. And this distinction is not simply limited to a contraposition between aesthetic art "inside" the museum and political art "outside," in the field; this give and take is much more complex and ambiguous.

COMMUNITIES, PEOPLE, THINGS

Rancière's intervention in the debate on aesthetics can help us address a number of issues that are central in this book: the relation between art and representation, art and work, and aesthetics and politics. And yet the close fidelity of Rancière to a Kantian–Schillerian philosophy of aesthetics also imposes a limit on how far he can go. His notion of a "distribution of the sensible" brings the notion of *sensus communis* much further than Kant, by insisting on how subjects and communities are built upon dissent, not just consensus. And yet there is also a limit to this distribution; the communities defined by Rancière are communities of sense—subjects that emerge as being capable of designating objects. This notion of an emergent community of subjects, coming out of a disruptive act of "distribution of the sensible," has many points in common with some concepts we discussed in the previous chapter: the device, assemblage, or trap, as scenarios or events of production of agents. But there is a fundamental difference; for Rancière, it is taken for granted that subjects are people and objects are things. Both positions are not reversible or exchangeable. In this sense, Rancière remains very closely attached to the Enlightenment and its anthropocentrism (Bennett 2005). Is it actually possible to think of an aesthetics, and a politics, beyond this strict division between subjects and objects?

The Kantian definition of beauty as a symbol of freedom is based on the idea that in the aesthetic judgment, we recognize the object as such, in its own sensible qualities, and this judgment is totally independent from our interests; the distance between object and subject is constituted through the aesthetic judgment. But there may be aesthetic events where this balance between object and subject is broken; events in which the magnitude of the object overcomes the subject, by seeing things so grand that we fear that our understanding cannot encompass them—for example, the first time we see the sea, or when we are at the top of a high mountain. For Kant, an aesthetic experience that overwhelms is the sublime.

Besides the sublime, there may be other forms of aesthetic experience that question the balance between object and subject. One among them is essential to understand surrealism: the uncanny. The uncanny would be the opposite of the sublime: something terrible behind our understanding. Sigmund Freud (2003 [1919]) wrote a short piece on the uncanny, where he gave a perfect example. Once while on a train, he got up, and as he was about to open the door of his compartment he saw a mature man confronting him with an angry expression. Then he realized that it was his own image in a mirror. This sudden awareness produced in him the sensation of the uncanny: the realization that his image was strange and menacing to himself, that he, in a way, had become another to himself.

The uncanny is not only a result of a misunderstanding. On the contrary, for Freud, these moments are revelatory of something fundamental to the self, that may be beyond our immediate understanding, our consciousness, but still has a meaning somewhere else, somewhere deeper: in our unconscious. And this meaning, although troubling, may be fundamental to understand the self. In a way, to understand the self one has to see oneself first as an other—as an object. Freud plays with the German word for uncanny: *Unheimlich*. *Unheimlich* is the contrary of *Heimlich*, homely, familiar. The uncanny for him would be the familiar revealed in its double: the repressed, unconscious, disturbing things that we don't recognize in our conscious familiar life.

These ideas are essential to understand surrealism. When Breton said that beauty has to be convulsive, he meant that beauty has to shake the self; it has to engage the object and the subject in a convulsive shock, a sort of mutual encompassment—something, of course, never imagined by Kant. The surrealists showed how aesthetics can be built on the mutual encompassment and interpenetration of people and things, the shock of the inversion of positions of objects and subjects, rather than in their clear separation. The criticism of the "asceticism" of Kantian aesthetics could be redefined in these terms; the question is not so much the denial of the senses, but the possibility of an exchange of positions between people and things, which Kant with all certainty did not contemplate. In fact, for Kant such a play would be the opposite of judgment: fetishism.

Is it possible to imagine a politics grounded on such interpenetration of people and things, on "fetishism"? The renewed interest in "things" in anthropology and philosophy indicates that this may be the case. The rise of "things" in recent social theory has been read as an extension of an earlier generation's claim to give agency back to the "subaltern" (Holbraad 2011). Back in the eighties, anthropologists started to defend the agency of the oppressed, the colonized, the dispossessed, ethnic and sexual minorities, before the structures of domination (Ortner 1984). Their claim was that the dominated also had political agency over their own lives; they were not just victims of the social system. Rancière's "distribution of the sensible" can be read along these lines, as a theory of the emergence of new agents, "those who don't have a name," as political actors, new communities of sense.

For Rancière, however, these communities are always made of human actors. The new interest in "things" in anthropology and philosophy has proposed, on the other hand, that beyond humans, there are many other kinds of entities that participate in political processes. In Gell's terms, things may have "agency" (1998). The philosopher Isabelle Stengers has introduced the idea of a "cosmopolitics" (Stengers 2010, 2011), proposing to overcome the divide between the social and the natural, science

and politics, to acknowledge the relevance of non-human agencies to describe the political.

The idea of including things into politics is not just a paradoxical intellectual game. As we have seen in the last chapter, notions like event, device, or assemblage draw attention to the fact that agents emerge in complex situations, scenarios that include the participation of radically different entities, human and non-human. In fact the argument of some of the authors of this "thing" literature, such as Stengers and Latour, may not—or not quite—just be to give agency back to things, but something a bit more complex. Latour, for example, is fairly ambivalent about these very notions, as we have seen in the previous chapter. First of all he questions the very division between people and things; it is not just the case that people "distribute" their agency, as Gell argued, that somehow humans recognize intentions in things: for Latour, different kinds of beings (human and non-human) can become "actants," acting beings, in a given situation. An actant is defined by its capacity to have transformative effects upon other beings in that given situation (Latour 2005: 71). The concept of "thing" itself, after Heidegger, has a particular meaning, as we have seen before: not just an object of judgment, but "some thing" that happens, an event where social relations emerge.

"Agency" in this sense is more an outcome than a premise of the event. It is a quality that one reads upon actants once they have already acted, rather than something we presuppose before action. For Latour, the emergent aspect of action is central to define an actant. Actants are not defined by their intentions, but by their actions. The distinction between natural event and human action, in this sense, becomes irrelevant. In Latour's own words, "an actor that makes no difference is not an actor at all. An actor, if words have any meaning, is exactly what is not substitutable. It's a unique event, totally irreducible to any other" (Latour 2005: 153).

Many of these notions are already present in Dadaist and surrealist notions of chance, situationist practices of psychogeography, and contemporary artistic devices; all of them consist in an active engagement with the event of encounter for the production of agents, bringing together all the elements at play, people and things. In fact, these practices bring to its ultimate consequences the very notion of "play": a form of relation of people and things not based on need, interest, or domination; a device of liberation of both people and things, instead of a system of production in which subjects control objects. In fact, if we take the notion that beauty is a symbol of freedom to its ultimate consequences, we should acknowledge that it is not just a symbol of the freedom of people, but also of things. After all, as Heidegger said, aesthetics proposes to engage with the object in its own terms. This may take aesthetics well beyond what Kant and Schiller, even Rancière, had envisioned, but in the direction that contemporary art and contemporary anthropology seem to be going.

CONCLUSION

In this chapter I have approached the problem of aesthetics, an extremely contentious issue for generations of anthropologists and art theorists alike. Bourdieu and Gell identified "aesthetics" as a form of naturalizing distinction and justifying domination through the argument of a "natural," superior, good taste. This "disinterested" good taste would take the form of an ascetic detachment from the senses and the useful, as opposed to the sensualist, utilitarian, "lower" aesthetics of people with bad taste. I argued that this criticism ignores the Kantian–Schillerian account of aesthetics, which does not propose a "detachment" from the senses, but, on the contrary, offers an engagement with the object in its own terms—letting what encounters us come before us in its own stature and worth, as Heidegger said. The object is not a "representation" of something else, but a thing in itself.

Bourdieu and Gell also missed the point that the judgment of taste for Kant and Schiller was not "natural" or "given" at all, but the result of a *sensus communis*, a social process that takes a lot of conscious work, the construction of an imagined community of sense—what Rancière calls a "distribution of the sensible." This "distribution of the sensible," for Rancière, is at the basis of any politics, if we define politics as the constitution of a common. Aesthetics, in these terms, is not the opposite of politics, but it lies at its very foundations.

Rancière has discussed aesthetics as a particular form of the distribution of the sensible, a "regime" in which the mission of art, through play, is to show the way of liberation from labor, reintegrating art and life, and disappearing as such in the process. The founding paradox of the aesthetic regime is that art is art insofar as it is also something other than art: as far as it brings a promise of emancipation, the elimination of art as a separate reality, and its transformation into a form of life (Rancière 2009a: 36). While this promise is achieved, art practice is in a constant give-and-take between autonomy and heteronomy, between reaffirming its separation from society, as an avant-garde of the society to come, and disappearing into the everyday as non-art. As we will see in the next chapter, this persistent tension between autonomy and heteronomy, representation and aesthetics, is constantly present in contemporary art.

In spite of having made a brilliant reassessment of the question of aesthetics, there are limits to Rancière's theory of the distribution of the sensible. While his understanding of politics as emergent action is quite in line with the discussion we had in the previous chapter on notions like event, device, and assemblage, there is one fundamental point where Rancière departs from these ideas: the distribution of the sensible involves subjects designating objects, or in other words, humans determining the value of things. The agents that emerge from the distribution of the

sensible are only human. The presupposition of equality that is at the foundations of this emergent community of sense is based on a shared ignorance, but a shared ignorance among human subjects. But as we have seen in previous chapters, the politics of art involves a more complex entanglement of people and things, in which things can also become political agents. From the avant-garde, in particular from Dadaism and surrealism, art events show the reversibility of people and things, in what I have defined as a process of unveiling commodity fetishism. Their interest in chance, in starting from scratch, in being "primitive," in withdrawing their agency, was based not only on the presupposition of equality between artists and their public, but on the presupposition of equality between people and things, seeing the artistic process as the result of a collaboration between different entities partially driven by chance. In fact the radical criticism of the division of labor, art and life, work and play, that in Rancière's terms is at the foundation of the aesthetic regime, is also a criticism of the division between people and things: workers and objects of work, consumers and objects of consumption, artists and works of art. The encounters, situations, and devices of contemporary art present forms of subverting the relations of production upon which these very divisions have been built, through practices of *détournement*, turning commodities into gifts, for example. This is a point that Rancière does not engage with, and that we need to address in more depth, with the tools that anthropological theories of exchange and the notion of the person provide. This is precisely what we will do in the next chapter, which will focus on the very notion of "the gift."

5 PARTICIPATION AND THE GIFT

As we have seen in the previous chapters, the theme of the gift appears often at the center of artistic practice. It has become even more important in the last decades, with the exponential growth in relational and participative artistic practices. The situations and relations that these art forms generate inevitably go back to the gift and the general forms of the social: how do we relate to each other, how do we relate with things, how are communities built, how do we work in common … In many of these practices, there is a direct or indirect criticism of the commodity form, and the market, as the hegemonic framework that articulates social relations. Many propose to generate alternatives to the market form, and this leads to the gift as an alternative paradigm. But does this reading of the gift or "gift economies" as alternatives to commodification or "the market" address the complexity and ambiguity of the concept in anthropology?

At this point, perhaps we need a deeper discussion on the gift as social and artistic practice. It is impossible to make reference to all that has been written about the concept of "the gift" both in art and anthropology, but it would be useful to consider in general terms how this notion has been used in both fields, since, in many ways, this is the key through which they are inextricably related. In this chapter, I will address this question first by discussing contemporary art practices of gift exchange and participation. These practices, and the critical discourses articulated around them, like relational aesthetics or collaborative art, have been very controversial in the last few years. After that, I will place these controversies within the more general framework of the ideology of the gift and participation in modern aesthetics—what Rancière has called the "aesthetic regime" of art. I will show how modern aesthetics describes the gift as a fundamentally voluntary, free exchange between peers, an exchange that results in an egalitarian community.

In contrast with aesthetics, anthropology has often described gift exchanges not as being voluntary and egalitarian, but obligatory and hierarchical. From that contrast, the anthropological theory of the gift can offer a counterpoint to the field of art, showing how apparently opposing discourses in the field of art are in fact sharing a

common ground, starting with the presupposition of equality between subjects in gift exchange and participative practices—a presupposition that the anthropology of the gift may not share at all. On the contrary, anthropological theories of the gift can show how gift exchanges and participative practices in art result in the very opposite of equality and freedom: the expansion of distributed persons and the formation of hierarchies.

But it would be unfair and precipitate to conclude on that note, simply showing what can anthropology teach art about its own participative practices. There are more things to say about the gift. Georges Bataille and the situationists after him were interested in anthropological theories of the gift in relation to their own visions of expenditure and excess: beyond the traditional anthropological understanding of the gift as a form of reciprocity and reproduction of communities, these authors were interested in gifts as forms of excessive expense, events of transgression that questioned the reproduction of the existing social order. In the conclusion, we will try to make sense of the relation between these three visions of the gift—as a voluntary, free exchange between equals, as the reproduction of social hierarchy, and as an event of transgression—and how they are reflected in contemporary artistic practice.

PARTICIPATION AND GIFT IN CONTEMPORARY ART

In the late nineties, the themes of the gift and participation became a central object of discussion in contemporary art practice and theory, especially through Bourriaud's relational aesthetics, as we have seen in the previous chapters.[1] Many have questioned relational aesthetics (Kester 2011; Alliez 2010; Rancière 2009b), but perhaps the fiercest criticism comes from Bishop (2004, 2012), who is not against participative art—on the contrary, but challenges the reading that Bourriaud makes of these practices, and the examples he chooses to illustrate them. Bishop argues that the end of art is not to generate a "friendship culture," but to question, antagonize, and promote dissent. Bishop's argument is partially based on Rancière's theories of a distribution of the sensible: she champions works with a critical or "antagonistic" approach, appealing for "more bold, affective troubling forms of participatory art" that create "artificial hells" (Bishop 2012: 6–7) rather than Bourriaud's "everyday micro-utopias."

We could find some examples of this "antagonistic" approach in the work of Santiago Sierra. In one of his best-known works, *250 cm line tattooed on 6 paid people* (Figure 7), Sierra tattooed a line on the backs of six young unemployed Cuban men, who were paid $30 in exchange for being tattooed. The resulting artwork is

a photograph in which the six men are shown in a row, making a continuous line of 250 centimeters. In *21 Anthropometric Modules made from Human Faeces by the People of Sulabh International, India* (2007), Sierra showed 21 monoliths made of human excrement, which had been collected by a charity in India, Sulabh, employing lower-caste Dalits whose task is cleaning the streets and public toilets of bodily waste. The faeces were dried and chemically processed to become odorless, and were shown at a London gallery as human-size monoliths, just coming out of the crates in which they were shipped to London. When asked about "exploitation" by a *Time Out* journalist, Sierra replied: "Exploitation is everywhere, especially in a city built on imperial foundations like London. It's in the water and the coffee we drink" (Ward 2007).

Sierra doesn't shy away from it: he has clearly made economic exploitation the central theme of his work. He doesn't pretend to express generosity, to create communities, or to renounce authorship on behalf of the public, but on the contrary, his work makes manifest the mechanisms of artistic authorship in participatory art

Figure 7 *250cm line tattooed on six paid people*, Santiago Sierra 1999 (Roger Sansi 2013).

as a form of exploitation. But precisely because of that, Sierra's work is also made of social relations, if radically opposed to "gifts": after all, commodity exchanges are also a form of "social relation." Furthermore, Sierra's work is clearly recognizable as art: it doesn't try to disappear in everyday life; his works are still "sculptures," in the sense of authored exhibits presented in art galleries. In fact he explicitly claims to be a minimalist with a guilt complex (Sierra 2004: 33): instead of drawing lines or making monoliths with materials, he makes them with people. And the results are objectual works and photographs sold in international art galleries.

Another example used by Bishop is Tania Bruguera's *Tatlin's Whisper 5* (2008). Bruguera hired mounted policemen to demonstrate crowd-control techniques inside Tate Modern, where the police cornered some members of the public, who were not told this was a performance. Are these "Artificial Hells" so radically different from Bourriaud's "micro-utopias"? Both "hells" and "utopias" construct situations that produce certain effects, devices. These devices can certainly be ambiguous "traps," like Bruguera's *Tatlin's Whisper 5*, in which the museum-goer feels temporarily threatened by a mounted policeman, while probably asking themselves if it is a "real" police performance or not ... The police, after all, are the very model of Althusser's "interpellation." Instead of the "antagonistic" shock of being cornered by the mounted police, "relational" devices may involve an act of gift-giving, or activate a social relation, like giving candy to strangers; it may be nice instead of violent, but it is still a device whose aim is to constitute social relations, activate agents. And yet the question could be, which agents? In both sides, from González-Torres and Tiravanija to Sierra and Bruguera, it seems that the one and only agent that emerges from the device are artists themselves; they are both traps, where the ultimate hunter seems to be the artist. These projects are, deep down, about the fame, the reputation of the artist.

In the end, as Grant Kester has argued (2011), Bishop's and Bourriaud's positions are not so far away. They are presenting artists within the strict limits of the art world. In this context, either in the form of willing participation or wage labor, the agency of the "audience" is reduced to the form of a living sculpture, subject to the agency of the artist. Both the public of the museum getting candy from Felix Gonzalez-Torres or the young men being tattooed by Sierra are working for the artist. In both cases it could be said that these "works of art" enact social relations, but are these actual social relations, or just representations of a relation? Do they have an actual effect over the social world or do they only affect it through what they are representing? For Bishop, that is precisely what art is, "not only a social activity but also a symbolic one, both embedded in the world *and at one* (sic) removed from it" (Bishop 2012: 7). In this, sense Bishop clearly takes the side of the autonomy of art from social life, the "politics of the resistant form," as

Rancière would say, and she dismisses the "positivistic social sciences" as ultimately less useful to understanding art than political philosophy (by which she means Rancière). In particular she defends "reinforc[ing] the need to keep alive the constitutively undefinitive reflections on quality that characterize the humanities" (ibid.) But in the end Bishop's argument is a bit contradictory to her purported allegiance to Rancière's "political philosophy." For Rancière, the distribution of the sensible is not just an affirmation that good, "aesthetic" artworks are antagonistic as opposed to collaborative. For Rancière, the distribution of the sensible does produce political communities, even if these communities may unite not just out of "friendship," but also in dissent of "the police" (the established order): that would be a more accurate criticism of Bourriaud from Rancière's point of view (2009b). Rancière's "aesthetic regime" is not yet another theory of the autonomy of art, but of the tension between autonomy and heteronomy, art disappearing in everyday life and the politics of the resistant form; art's autonomy is always in question. Championing the art historian's authority to make "judgements of quality," Bishop puts herself back in the representational regime, which Rancière situates before aesthetics, when experts and scholars had the authority of dictating the correct poetics. Perhaps that is only another example of how this "regime of representation" that Rancière places in the past is still here with us; it has been perpetuated through the "autonomy of art."

Outside the strict borders of the major art venues and their "autonomy," there are many other kinds of projects that engage in social relations, exchanges, and gifts in much wider and more politically challenging ways. Purves (2004), in an extensive survey of "gift" art, proposed a classification in four kinds of practices: the first, "gift sculpture," gallery-based exhibits that consist in giving away or dispersing the "work" (candy, posters, food …). "Gift sculpture" would be quite formalistic, respecting the boundaries of the art institution. This classification fits quite well with González-Torres or Tiravanija. A second kind of project would involve a much more confrontational approach, described by Purves as situationist *détournement*: these would be projects using alternative exchange systems as a forum for social dissent, to denounce the limits of commodity fetishism. One example would be Wang Jin's *Ice. Central Plain* (1996), a public art project built across a newly opened shopping mall in Zhengzhou, China. The project consisted of a 30-meter-long wall of 600 ice blocks, containing desirable consumer goods. People in Zhengzhou threw themselves at the wall to break the ice and take the goods, in a sort of potlatch of consumerism that almost became a riot. Jin's project was clearly proposing a "twitch" on the new consumer culture on the rise in China, subverting the commodity form that was being imposed through the opening of shopping malls. A project like this clearly exceeds the relational framework of Bourriaud, not just because of its use of public

space outside the gallery, but also for its much more ambiguous and uncontrollable outcomes, even if the background—questioning mass consumption—seems to be the same.

The third kind of practice would be "democracy projects," in which artists would renounce their authority over the work in favor of giving the means of production to the community they work with. One example would be *Nunavut* (1995), a project that took the form of a TV series of an Inuit community. The production team, Isuma Productions asked the Inuit to design, write, and participate in the filming. In democracy projects then, the gift does not consist of stuff or food given by the artist to the audience, but artists give their place to the audience.

The fourth and last kind of project described by Purves is what he called "social aesthetics," which in many ways takes the "democracy project" to its ultimate consequence: artists would not only release their authorship to the community, but would actually not expect the community to produce any "art." On the contrary, they would only use the institutional framework of art, its resources and funding to allow the community to make its own projects, even if these don't have "art" as an end result. One example that Purves gives is WochenKlausur's work, which ranges from designing classrooms with school students in Vienna (1996) to the organization of a community center in Efford, near Plymouth, UK (2011).[2]

These last examples of "social aesthetics" go all the way down to the dissolution of art into social practice, being at the core of what authors like Kester call collaborative art (2011). We have discussed one of his examples in a previous chapter, the Dialogue collective working with Advasi communities in India. For Kester, what is interesting about these projects, more than their outcomes, are the work processes they enact:

> The exchanges initiated in their projects constitute a form of labor that is distinct from the "work" of possessive individualism. Their goal is not the violent extraction of value or the suppression of difference, but a co-production (literally, a "co-labor") of identity at the interstices of existing cultural traditions, political forces, and individual subjectivities. (Kester 2011: 112)

One could argue that there is a clear difference between the projects of Dialogue with the Advasi and Sierra's work with the Dalits, for example. The first presents itself as a collaborative project that helps ameliorate the life of the villagers, while the second quite shamelessly defines itself in terms of exploitation. But a closer look at these projects would show a more complex picture. It is difficult to assess from the descriptions, but we could ask to what extent the interventions of the Dialogue collective in the villages have been consensual or have generated resistance. On the

other hand, in spite of Sierra's cultivation of a bad boy image, his project with the Dalits was actually sponsored by the charity that employs them, Sulabh, which didn't accept any payment because they understood that this work was actually good publicity for them (they kept one of the pieces).[3] In this sense Sierra's project was collaborative. Maybe we can't take for granted that just because a collective is well-intentioned, serious, does research, and spends a lot of time on the field, their work will be more democratic and co-operative with the community than an international star whose ultimate goal is to make a shocking piece for the international art market. In both cases, the issues at stake are the actual power relations, the play between the actors that are established on the ground, rather than their intentions.

Collaborative and social practice art can end up entailing the same contradictions as relational aesthetics, in terms of establishing unequal power relations between "collaborators." In fact, Bishop's ultimate criticism, more than of "relational art," is directed to the other forms of "generous art" described by Purves: democracy projects and social aesthetics, works where artistic authorship, and the very identity of the practice as art, is diluted. But rather than the identification of these practices as "art" or not, what is being questioned is the actual political and social context, and the outcomes of this kind of work. Is the construction of ephemeral communities, atmospheres of democracy, and everyday utopias through gift-giving really a subversive act against the hegemony of the market? Or is it just a useful, sweet icing on the cake, a "smoothing over of the gaps of capitalism," as Fowle and Bang Larsen would say (2004: 23), a temporary relapse that actually allows for its reproduction? Are artists actually helping the system they want to question by providing for social services at low cost, "the other side of the capitalist coin" (Martin 2007: 379)? Which kinds of agents emerge through the devices articulated through "democracy" projects and "social aesthetics"? Fully autonomous agents or subjects of the state funding these projects? Users of social and cultural services? Are not these artistic devices, after all, very similar to the old "ideological apparatuses of the state" they apparently question?

During the New Labour governments in the UK, as Bishop has mentioned, community art was embraced as a sort of "soft social engineering" (Bishop 2012: 5), promoting "participation" in the arts as a form of preventing social exclusion. For Bishop, social "inclusion" for New Labour was deeply rooted in a neoliberal agenda, seeking to "enable all members of society to be self-administering, fully functioning consumers who do not rely on the welfare state and who can cope with a deregulated, privatised world" (Bishop 2012: 12). Notions of "creativity" as innate talent of the socially excluded, an energy that could be transformed from a destructive to a constructive impulse, are also quite common in these cultural policies. Participatory and community art could become, in this context, devices of

neoliberal governmentality (Miessen 2011). Any project of "participation," like the gift, contains the seeds of its opposite: market competition and exclusion.

As we have seen in Chapter 2, a decade before Bishop, Miwon Kwon's discussion of " site-specificity" already underscored the contradictions of turning art into "social service" (2002). In response to this argument, the defendants of collaborative art can say that this risk does not invalidate these practices in themselves. Many of these projects may manage to be "ethical," and give an actual return to the community they work with. Some may even manage to bypass the risk of becoming agents of neoliberal governmentality. But these are only justifications, not arguments on why we should think these practices are interesting. Perhaps from the perspective of anthropology, more than if they are morally unquestionable or politically effective, what is remarkable is their very process, even if it's a failure. The experimental character, the drive to bring together different kinds of agents into a common project, may say something important about the collectives, agents and forms of relations they are playing with. Why did the Indian charity accept Sierra's proposal and refuse payment? What did the mounted police who participated in Bruguera's piece at Tate think they were doing? What did the Advasi think of Dialogue's interventions, once Dialogue is gone? All these are fieldwork questions that may give relevant information about something more than art itself—also about the social relations it helped to build. In this sense, the "gift" in art as a method, more than in relation to its effective results, may be interesting because it opens up a field of possibilities.

I will come back to this point in the conclusion. But for the time being, we should stop to consider how do we arrive at this contradiction. How is it possible that practices of gift exchange end up enabling the reproduction of market society? How do apparently contradictory concepts, such as participation and individualism, end up meeting? At this point we need a deeper consideration of what participation and gift mean in art theory and aesthetics.

ART AS GIFT

A good place to start is Lewis Hyde's classic essay on *The Gift* (1979), which has become standard reading in the field of the arts in recent decades.[4] For Hyde, artworks are "gifts" at different levels. At the level of the production, one can talk of gift at least in two ways. First, making art may be a "gift" as in something that is already there in the artist, "given," natural, which is not "made" by any training. This could be understood as the notion of the raw genius. This definition is complemented by a second sense, in which art is also a gift, when the object gives itself:

As the artist works, some portion of his creation is bestowed upon him. An idea pops into his head, a tune begins to play, a phrase comes to mind, a color falls in place on the canvas. Usually, in fact, the artist does not end himself engaged or exhilarated by the work, nor does it seem authentic, until this gratuitous element has appeared, so that along with any true creation comes the uncanny sense that "I," the artist, did not make the work. "Not I, not I, but the wind that blows through me," says D. H. Lawrence. Not all artists emphasize the "gift" phase of their creations to the degree that Lawrence does, but all artists feel it. (Hyde 1979: 19)

In this second sense, the gift is an event, something that comes as given, rather than simply a product of the artist's agency: "through me," through the artist, but not out of him. Instead of describing the process of production of art in terms of technical control of the specialist over the material, Hyde describes it as an encounter, where people and things are reciprocally constituted: people may not be necessarily masters that can domesticate matter; on the contrary, matter can "express" its will through people, who are "inspired" by the things they encounter. This understanding of the gift as an event is connected with the notions of the gift in Heidegger we have introduced before, as an event in which the thing gives itself, and we will come back again to it later in this chapter.

There is still a third sense in which art is a gift: when we experience art, when an artwork is important to us, we receive it as a gift (Hyde 1979: 19). Regardless of the price of the artwork, the fact that it is ours or not, we receive the experience of art for free. We don't need to buy an artwork to like it.

Hyde's reading of art as a gift in this third sense is deeply anchored in what Rancière has called the "aesthetic regime" of modernity: the notion of the aesthetics experience as free of interest and finality in Kant and Schiller. This reading of the gift as free, spontaneous and disinterested appears in the eighteenth century in radical opposition to commodities, as bound to interest. Interestingly enough, James Carrier, in his historical account of discourses about the gift in the modern West, points to the emergence of the notion of a "true" gift in the eighteenth century. The perfect present should be given freely, as an expression of individuality, or—perhaps better—personality:

The good present is the spontaneous, unfettered expression of the real inner self and inner feeling. In this way the notion of the "good present" has two meanings. The good present is one that reflects or expresses the giver, and if it is good in that sense the present is also morally good. Conversely, the present that is constrained and interested is repulsive, because constraint and interest conflict with the source of goodness, which is spontaneous expression. (Carrier 1995: 162)

The "spontaneous" gift would then be the absolute opposite of interest, and therefore, of the world of commodities. Carrier documents historically the withdrawal of the "gift" to the realm of personal relations and disinterest and its separation from the "commodity" and the realm of private interest. Paradoxically, it is the very emergence of an impersonal market that allows for a notion of the "personal" and "free" gift to emerge in opposition to it (Carrier 1995: 163).

The emergence of the notion of the personal and free gift in the eighteenth century is not just contemporaneous with modern aesthetics, but it is intimately connected to it: both express the possibility of thinking a domain of practice, a form of relation of people and things "free of need and finality," as Kant would say; a form of relation in radical opposition to the emerging, dominant regime of modernity: the impersonal market. In the end, aesthetics is also based on subjectivity, like economics, but the subject of aesthetics, as we have seen while discussing Schiller's work, is constituted precisely in opposition to economics: instead of the calculating, maximizing individual who thinks in terms of need and utility, Schiller described aesthetics as the promise of a society where free citizens would think beyond their immediate interests, but for the common good. In these terms, the gift emerges as the natural embodiment of aesthetics as a form of relation based on freedom and play, as opposed to the commodity based on need and utility.

In spite of this frontal opposition, aesthetics and economics, as forms of relating objects and subjects, are both essentially based on freedom, as far as they defend the autonomy of the subject in regard to the imposition of the state and tradition. In the same way that economic liberalism defends the idea that the value of commodities must be the result of a spontaneous (natural) relation among individuals, the "market," through the so-called law of supply and demand, and not an artificial value imposed by an absolutist state that fixes prices, the autonomy of taste defines a direct relation of subjects through objects, in which aesthetic value emerges spontaneously and freely, not institutionally and hierarchically, as a poetics imposed by an academy, as it used to be previously, in what Rancière has called "the regime of representation." The presupposition of equality and freedom are in fact at the center of Rancière's "aesthetic regime," which is still today the dominant regime of art. One could say that the paradox of this utopia is that, from its outset, aesthetics has been built in direct opposition to the economic model of bourgeois utilitarianism; and precisely because of that, it has many things in common with it: they share an ideology based on equality, freedom and individuality, which are the keys of bourgeois modernity.

MAUSS AND THE GIFT IN THE ANTHROPOLOGICAL TRADITION

The anthropological literature seems to give a diametrically opposite reading of the gift, as any reader of Mauss will be aware of. The influence of Marcel Mauss's essay on *The Gift* (1990 [1925]) on anthropology has been enormous[5] and also extremely controversial. This is partially because of the text itself, short but full of ideas, brilliant and multiple, open to many readings. Still, many anthropologists would agree in saying that the main object of the book is to question the notion of a "natural" economy, based on the market and commodity exchange between individuals, guided by the principle of utility. Against utilitarianism, which is a very modern, Western ideology, Mauss displays a panoply of ethnographic, historical, and philological sources showing that not all forms of exchange in world history are market exchange: in many societies, the first and foremost form of exchange is the gift. And yet, this does not mean that he describes these societies as egalitarian and free, utopias where everyone gives and takes freely, following their own desires. On the contrary, the gift and the social relations it entails are often described by Mauss as hierarchical and bound to strict social obligations. He said it explicitly at the beginning of the essay:

> [I]n a good number of [Civilizations] exchanges and contracts take place in the form of presents; in theory these are voluntary, in reality they are given and reciprocated obligatorily. (Mauss 1990: 3)

The gift results in what he called a system of total services, implying a triple obligation: the obligation to give, to receive, and to return (Mauss 1990: 7). In the movement from one obligation to the other, social hierarchies are produced, between those who give, those who receive, and those who return. The two classic ethnographic examples used by Mauss were the Melanesian Kula and the Potlatch of the northwest coast of North America. Potlatch, according to Mauss, means to "feed" or "consume" (Mauss 1990: 7). Potlatch festivals were absurdly abundant; the hosts would liberally distribute gifts among their guests in great quantities, even to the point of destroying wealth in oil, blankets, houses, and breaking precious coppers, to show detachment from material possessions (Mauss 1990: 49). This extreme, even aggressive munificence was not simply savage economic irrationality, but a ritually organized form of gaining rank and honor. By giving away in great quantity, to the point of destruction, the gift-givers were trying to gain a name, reputation, rank, a "face." A poor and failed potlatch would mean for the gift-giver a shame, to "lose the face." This is what Mauss calls a system of "total services of an agonistic kind" (Mauss 1990: 8).

The second ethnographic example that Mauss used was Malinowski's classical study of the Kula in Melanesia in *Argonauts of the Western Pacific* (Malinowski 1922), which Mauss described as a "grand potlatch" (1990: 27). The Kula is a ring of exchanges between different archipelagos in Melanesia, in which "signs of wealth" (Mauss 1990: 30), bracelets and necklaces of a certain kind were offered as presents. These gifts were not to be kept, but to be given again to other partners in the Kula ring. The objects exchanged in Kula, as opposed to trade goods, have a name, a story, a personality. Like in the Potlatch, the Kula ring is based on the circulation of fame. In Nancy Munn's extraordinary reappraisal of the Kula ring, *The Fame of Gawa* (1986), she presents the transmission of Kula valuables as an expansion of the person in space and time, an expansion of her name, her fame. Kula valuables have the names of famous travelers inscribed in their legends, as much as the more famous travelers are those who exchange the objects of bigger prestige. In this sense, "shells and men are reciprocally agents of each other's value definition" (Munn 1983: 283; quoted in Strathern 1988: 174). People and things constitute each other's fame and hierarchical rank. Things, like people, have a spirit, as Mauss would say.

The adventures of the *Argonauts of the Western Pacific,* their search for fame, should not necessarily be understood as a form of individualist search for the accumulation of "symbolic capital," in Bourdieu's terms. The theory of symbolic capital, or capital in general, presupposes a subject that objectifies the world, accounting and accumulating it (as capital). The fame of Kula does not imply a movement of accumulation of objects, or control over other people, but an expansion of the person. Fame means that your name, your stories, your things, travel far in space and time, they become known. The person travels with them, since, through these histories, things take with them a part of the person. The accumulation of symbolic capital is a movement of objectification and introspection, in which the strategist seizes the time of others. Fame, on the other hand, is an expansive movement, in which the traveler creates relations and becomes a part of the life of others—he is appropriated by them. In fact, the movement of accumulation of capital would be, in the Kula world, the opposite of fame: it would be witchcraft (Munn 1988: 227).

In his essay on "The notion of the person," Mauss (1985 [1938]) questioned the presumed universality of the notion of the individual, the "unitary self," as a single mind-body entity. Mauss insisted on distinguishing the individual from the social person, one that responds as a social actor. In other words, what one is socially does not depend so much on the externalization of internal individual desires as on the social relations one is involved in. These relations would not be limited to identifying the "unitary self," the "natural," pre-social mind-body unity, as an actor, but the "person," that is not only constituted by a single mind-body. The social person, as a social actor, may be composed of corporate groups of people, like families,

and other elements like names, titles, dresses, objects that put in relationship this identity with others. These assemblages of elements and people are not only *instruments* of social exchange, or a "working force," through which the "individual" relates with "society"; they are not *properties* of the person, "objects" in the sense of a "capital" that people can "invest in" for increasing their social power. These ensembles are constitutive of the social person, and they remain as such even when they are physically detached from the rest of the constitutive elements of the person in space and time. In other words, "things" may be persons, or parts of persons, not just objects of accumulation.

This notion of the person is extremely important to the discourse on "The Gift": one of the more important points in this text is that through gifts, people give themselves to other people (Mauss, 1990: 59). This would be impossible if we identify the self with the notion of the individual, as an indivisible unity of body and spirit, totally different from objects, as instruments. If we think, with Mauss, that social persons may be constituted by an assemblage of elements, including bodies, things, names, that may be physically detached from one another while remaining the *same*, maybe we can understand how one can give one's self, one's person, while giving something. These Maussian discussions of "person" and "gift" have been reassumed and extraordinarily developed by authors like Marilyn Strathern, in *The Gender of the Gift* (1988). As I pointed out previously, Strathern's notion of "partible person" and Gell's "distributed person" draw heavily on Mauss, but Strathern's relational approach takes it in a particular direction. First, she stresses the continuity of people and things, as entities involved in the relation—without presupposing any hierarchy between them: they are just entities. Secondly, she points out that it is in fact through the relation that the identity of these entities is established. She is stressing, therefore, that through these relations, these entities *become* persons and things. These relations do not simply renew existing social bonds but they create the very identity of the partners in exchange.

At this point, shall we say that there are radically different economies, one based on the gift, one on commodity exchange? According to Gregory, "commodity exchange establishes a relationship between the objects exchanged, whereas gift exchange establishes a relationship between the exchanging subjects" (Gregory 1982: 41). The end of a gift economy would be enlarging, producing, and reproducing social relations, not incrementing material capital. In gift economies, exchange takes the form of a "personification" of objects, while in commodity economies people, as working force, become "objectified." The value of gifts is qualitative, not reducible to a measure of equivalence, as opposed to the quantitative value of commodities. A point that Gregory emphasizes is that the "gift" is a form of creating social relations, by creating alliances. Thus, for example, in a marriage exchange, giving away a

daughter as a "gift" does not imply that one "sells" her, that one "alienates" her from the family, but on the contrary, one establishes an alliance with the family she is given to in marriage, by creating a larger unit and guaranteeing reproduction. Thus the new wife is still the daughter of her family of origin; her value as a daughter is inalienable.

The notion of inalienablilty, as opposed to the alienability of commodities, is important and controversial. In *Inalienable Possessions* (1992), Weiner stressed that in addition to gifts, there are objects that are kept away from exchange as long as possible, precisely because they constitute the essential value of a group, lineage, or person. These inalienable possessions are not objectified as property, instruments, or capital, but are personified, in Strathern's terms. They participate in a "gift" economy, not a "commodity economy," but they are not easily given away, precisely because of the risk of alienation. This is what Weiner defined as the paradox of keeping-while-giving: social actors, persons, families, lineages need to exchange part of themselves to reproduce themselves—things must be exchanged so that everything remains the same. The problem with inalienability, as Strathern points out (1988), is that it implies the possibility of alienation; the possibility of commodification. In a "gift" economy this would not be an option; which means that, in fact, the very notion of a "gift," as opposed to a commodity, may be unthinkable in a "gift" economy.

ART, DISTRIBUTED PERSON AND PARTICIPATION

In these terms, are "gift" and "commodity" exchange totally independent and irreconcilable forms of valuing objects and persons? Would some societies, like Melanesia, be based on gift exchange, and "we" Westerners on "commodity" exchange? If "the West" is based on a market economy, does that mean that gift exchange is not relevant? Many authors (Caillé and Godbout 2000; Graeber 2013), including Mauss himself, have said the opposite: the gift is central to our society, more than the ideology of market economics would like it to be. It has also been argued that one sphere in which this is particularly clear is art and cultural production (Myers 2001; Sansi 2007). Art as cultural heritage is a perfect example of what Annette Weiner (1992) called "inalienable possessions": things that embody the very essence of a family, a community, a nation—"Gifts to the Nation," as the British Museums and Galleries Act of 1992 defines them—and whose loss or destruction would challenge the reproduction of this very nation.

The gift, as we have seen, is central to art theory, but in radically different ways to what anthropology has said. Lewis Hyde himself recognizes this fact. Hyde made explicit and wide use of Mauss's *The Gift*, which he acknowledged as the only major

study on that concept. And yet he also recognized that his use was partial. He explicitly said that:

> I am not concerned with gifts given in spite or fear, nor those gifts we accept out of servility or obligation; my concern is the gift we long for, the gift that, when it comes, speaks commandingly to the soul and irresistibly moves us. (Hyde 2009: 24)

Of course this is precisely the opposite of what many anthropologists and sociologists have discussed after Mauss: obligation, power, and hierarchy—gifts that, as Strathern has insisted, "convey no special connotations of intimacy. Nor of altruism as a source of benign feeling" (Strathern 1991: 295). The aesthetic regime, as we have described it, has addressed the gift as a symbol of freedom, rather than obligation—a mechanism of building communities of free individuals through the "free play" of aesthetics, bringing to fruition the aesthetic utopia.

But on the other hand, many art practices and objects can be interpreted from the perspective of an anthropological theory of the gift. Gifts in art do not just respond to a "friendship culture," they are not just spontaneous and free exchange between equals, but they can generate unequal and hierarchical relations: they can result in the production of famous artists, through their "distributed person," and invaluable artworks, "inalienable possessions." In similar ways to the agonistic gifts of the Potlatch and the Kula, artists as givers distribute their person and produce objects of inalienable value. The relational aesthetics of González-Torres is a quite clear example of that. His work takes the form of a gift—such as in the piles of candy that are constantly being shared with the public. But these gifts don't end in the event of the giving: the piles of candy are constantly being re-filled by the personnel of the museums where they are shown. They are artworks that belong to the museum, "inalienable possessions," that reproduce the fame of the artist, his "distributed person." In similar terms, as I mentioned in the introduction, Rirkrit Tiravanija's workshop *Disruption* can be described as an event in which the artist shared his life, distributed his personhood with a group of young artists. In exchange, these young artists acquired the reputation of having collaborated with him.

In exchange of their distributed personhood, relational artists may obtain fame and recognition in the art world—a hierarchical value that, nonetheless, they will not share with the participants in their relational actions. And yet, this recognition is not reducible to a theory of symbolic capital. Participative artists don't expect a return or counter-gift from the participants; they don't count their gifts as debts. I am not talking in moral terms, but I am simply describing the process of exchange

they follow: it is not so important that the participants feel indebted to the artist as much as that the art event has a wider repercussion: that it gives the artist recognition, and fame, in the art world; that the artist's name is in the minds and words of other people, like the Kula travelers. In this sense, beyond being critical of these artistic events, perhaps it would be more interesting to consider a bit more carefully what we mean by participation.

When we talk about "participation" inside or outside of art, we often depart from an egalitarian ideology, where participation is understood as a voluntary practice by which autonomous subjects work in common: they agree to develop an activity where the objects of production are clearly separated from the subjects. But the separation between object of production and producing subject, and within producing subjects themselves, is not often questioned … neither is the fact that these practices can create unequal, hierarchical relations, in radical opposition to the autonomy and freedom they presuppose.

Maybe participation is not just a form of bringing people together and collaborating in a common project, but it can go further; it can be a dispositive of building and sharing persons, and hierarchies between persons, not just egalitarian communities between separate individuals. In this sense, perhaps the "relationality" in art is not so different from the relational anthropology of Marilyn Strathern, as I mentioned in the introduction.

And after all, perhaps, this is not so contradictory with contemporary art. If, as I mentioned previously, the history of art since Dadaism can be seen as enacting a "relentless disavowal of agency" (Kester 2011: 4), a withdrawal from artistic expression in favor of chance, perhaps the recent upsurge of participation in art is only taking this disavowal to its ultimate consequences by proposing to work not just with random objects and events but with uncontrollable social assemblages. Proposing to control and direct this "participation," to make it egalitarian and fair to all its participants, to make it result in a common good that they all can autonomously enjoy, may amputate the element of chance that is central to the very process. In fact it is precisely this close relation between gift, participation, and chance, its unpredictable, unforeseeable, and perhaps transgressive elements, that may be more interesting to consider in the relationship between art and gift.

THE IMPOSSIBLE GIFT

I have shown how the construction of a discourse on the gift in Western society, in the domain of the arts as in others, is inevitably built against the background of its contraposition to commodity exchange and the market. Strathern's point still stands;

to think about inalienability, we inevitably have to put it in opposition to its other: alienability and commodification.

The philosopher Jacques Derrida made a similar point about the concept of "gift." Derrida took the concept of the gift to its logical conclusion, which inevitably contradicts Mauss's formulations on the gift as a social institution based on reciprocity. For Derrida, a pure "gift" cannot be reciprocated, because if a return is expected, the gift always implies its opposite: interest, benefit, utility, accountancy, commodification. The time elapsed between gift and counter-gift is a time that counts, transforming gift into debt, giver and receiver into subjects of an objectified exchange, and the gift into an object of exchange. The pure gift must be given without expectation to be returned, without intentionality; in fact it must be forgotten in the very event of giving, because any memory or trace of the gift would turn it into a debt. Derrida was not saying that pure gifts don't happen, but when they happen to be forgotten as gifts. That is the aporia or impasse of the gift. The gift is not the thing given, but the event of giving; an event that gives itself, and that has to be forgotten as such. "The gift, like the event, as event, must remain unforeseeable [...] It must let itself be structured by the aleatory; it must appear chancy or in any case lived as such" (Derrida 1992: 122).

Derrida's understanding of event and gift are explicitly indebted to Heidegger's discussion of "the thing" as a gift (1971), as the establishment of a relation, giving itself as an event. The gift, in these terms, happens as an event *before* there is a division between subject and object, before there is being as substance (Derrida 1992: 24). To put it in Strathern's terms, the gift as a relation takes precedence over the entities it constitutes; but paradoxically, it has to disappear as such in order not to become its opposite: debt.

However, in the same way that the "pure" gift is impossible as such, one could say that the pure commodity is also impossible. Is there such a thing as a totally impersonal, objectified commodity exchange without social relations, contextual values, personal issues, hierarchies, corruption, love, third parties, "unaccountable" factors? Do things have the same price for everyone? Is there such as a thing as pure exchange value? Isn't there always gift (or theft!) attached to market exchange? It would be difficult to argue for the existence of a "pure" commodity and a "pure" market, besides the ideal models of microeconomics. Just as the "pure" gift is a utopia (the aesthetic utopia), so the pure commodity only exists in the utopia of a market society that, so far, has never existed in a pure form. After all, that is precisely the central point that Mauss was making: the examples he was using are not "pure" gifts, but they are social practices and institutions between these two ideal models, gift and commodity; the objective was to show how the commodity and the market were not the natural and only forms of social exchange but just one ideal form in a much more complex social and historical landscape.

But on the other hand, what Derrida's discussion of the gift introduces is precisely that in that notion, there is always an element of unpredictability, of chance, or alternatively, one could say, of disruption and possibility—a utopian projection. This reading of the gift, in fact, does not originate in Derrida, but much before him it was also central to other authors and movements, like Bataille and the situationists. In the next section I will introduce in more detail their reading of the gift as transgression.

THE POTLATCH IN BATAILLE AND THE SITUATIONISTS

As I mentioned in previous chapters, Mauss was a direct influence on artists and intellectuals in France during the thirties. It was through Bataille that Mauss's ideas on the gift would still be influential to the new generations after the Second World War. In *The Accursed Share* (1993 [1949]), Bataille proposed nothing less than a political economy based on abundance and expenditure rather than scarcity and utility. Mauss's description of the "potlatch," as a manifestation of absolute excess and prodigality, was central to Bataille's argument. Bataille was fascinated by what Mauss calls "*le plaisir de la dépense artistique généreuse*" (Mauss 2003 [1925]: 93), "the delight in generous artistic expenditure." Mauss was his main inspiration, but there is no question that Bataille went much further in his search for the creative potential of "the pleasure of expense" (Marcel 1999). Bataille was not so interested in the circular theory of the gift as social obligation as in the very act of giving as expense without return. The potlatch is central to his argument precisely because it turns expense into a public spectacle. The ultimate outcomes of this spectacle in terms of hierarchy, ranking or fame, what it is made *for*, are less important than the very act of expenditure; expenditure in itself is useless. In these terms, Bataille does not intend to rationalize the gift, making it "reasonable" from a bourgeois perspective; on the contrary, he is interested in transgression and the most extreme, destructive forms of gift-giving; the ultimate form of the gift would be sacrifice, or the gift of life. It has been pointed out (Risaliti 2002) that Bataille combined Mauss's ideas with traditional Western aesthetics, such as Schiller's ideas on play and the freedom of the imagination. Bataille envisioned a human condition that was not determined by need and utility, but empowered by pleasure and play. But still Bataille's notions of free play don't have much to do with the democratic utopias that Schiller or even Lewis Hyde envisioned; on the contrary, his image of the gift as expense is transgressive and destructive. Bataille's gift is not just "free of need and utility," like the aesthetic utopia, but it is the outcome of the desire to consume

excess: the principle of expenditure. Expenditure is not just free of utility, but the very opposite of utility. Expending luxuriously in the arts, sacrifice, and war would be different incarnations of this same principle, and hierarchies, ranks, fame, and inequality are built in the process.

After Bataille, the potlatch was also at the very heart of the situationist project, not just as the title of their journal (Bertolino 2002). For the situationists, the "potlatch" had a great revolutionary potential, as a supreme form of "*détournement*" that could subvert the foundations of capitalism, its "constant, icy, utilitarian calculation" (Mauss 1990 [1924]: 98), by putting the gift at the center of social relations of the market economy. In *The Revolution of Everyday Life* (2009 [1967]), Raoul Vaneigem made a sharp distinction between two different kinds of gift: one that would imply hierarchy, another that would be the gateway to the revolution. The first is the feudal gift—the gift of what Mauss would call "archaic societies," before capitalism. For Vaneigem, the feudal mind seemed to conceive the gift as a sort of haughty refusal to exchange, a will to deny exchangeability; hence its competitive, agonistic character, where one has to be the last to give, to keep their reputation (Vaneigem [1967]: 57). Vaneigem's vision was not to return to the feudal gift, but the opposite: to move forward to the "pure gift":

> The insufficiency of the feudal gift means that new human relationships must be built on the principle of pure giving. We must rediscover the pleasure of giving: giving because you have so much. What beautiful and priceless potlatches the affluent society will see—whether it likes it or not!—when the exuberance of the younger generation discovers the pure gift. The growing passion for stealing books, clothes, food, weapons or jewelry simply for the pleasure of giving them away gives us a glimpse of what the will to live has in store for consumer society. (Vaneigem 2009 [1967]: 59)

What the "pure gift" means here is the "*don sans contrepartie*," the gift without return, that according to Vaneigem would characterize the future society, in opposition both to bourgeois society based on the market, and the previous aristocratic society based on the agonistic gift, which didn't play for benefit, but for fame and rank. In this sense, the situationists dismissed the agonistic and hierarchical aspects of the potlatch that were central to Mauss's and Bataille's argument. In the "pure gift," instead, the "young generations" would play for the pleasure of playing itself. "The gift" for the situationist has the subversive potential of questioning commodification and property relations in themselves. Following Bataille, the transgressive, excessive character of the gift is put forward, very far away from the measured, liberal humanism of modern aesthetics. On the other hand, this transgression for

the situationists doesn't have the aristocratic tone of cosmic tragedy of Bataille's sacrifice, but on the contrary, it is a utopian hope.

It is interesting to note how Vaneigem had a very clear understanding of the "problem" or the impasse of the gift: the impossibility of thinking the "pure gift" if not in opposition to the commodity. In these very terms, situationism projects this "pure gift" as a revolutionary, utopian horizon of subversion of the existing social relations, which comes *after* commodity exchange. It is also interesting to note that the main example of Vaneigem's pure gift is nothing but ... theft: "The growing passion for stealing books, clothes, food, weapons or jewelry simply for the pleasure of giving them away" ... Can theft be a gift? It seems very far away from it, but at the same time, it is opposed to commodity exchange in parallel, if inverted, terms: in theft, there is no equivalent value between the thief and the owner of the stolen goods—the stolen thing is taken without payment, like a gift is given without payment. In this way, gift and theft may meet in their basic transgression of the laws of private property. Vaneigem clearly elaborates on the connection between the two notions, by emphasizing the idea that the "young generations" steal objects of desire to give them away, not to hoard them.

Perhaps this connection is a bit far-fetched, but still, any anthropologist can recognize that giving is always the counterpart of taking; often the anthropological literature has made reference to the aggressive soliciting of gifts by people who feel entitled to have them, or even the simple act of taking the gifts without permission, if they are not given. This aggressive soliciting may take place in confrontation to commodity exchange, for example in colonial situations or during fieldwork, when the colonists or the anthropologist are asked to share what they define as their "private property" (i.e. Sahlins 1993). In this sense, Vaneigem's understanding of the "pure" gift as theft emerges clearly as an aggressive form of questioning the market, *after* commodity exchange, in response to it, as a revolutionary act.

FREE DIGITAL CULTURES AND GIFT ECONOMIES

The revolution of the information technologies in recent decades has generated a renewal of debates on intellectual property, cultural production, and the gift. Bourriaud himself complemented his writings on relational art with a book on the subject, *Postproduction* (2005). If *Relational Esthetics* was discussing practices that involve interpersonal relations, as opposed to the impersonal relations of consumption produced by mass culture, *Postproduction* introduces artistic practices that involve processes of reappropriation of this mass culture, or better, the means of production of the culture industries, to produce relational art forms—or simply,

social relations. Sampling and the internet have made available a wide range of cultural products that can be reproduced, reappropriated, transformed, and redistributed, autonomously from the formal market of intellectual property and copyright laws—or better, in direct contraposition to it, through peer-to-peer communities. The culture industries paradoxically provide the spaces through which artistic practices can contradict property laws.

These ideas were already circulating in different spaces for decades in networks such as Creative Commons, Copyleft, or the Free Software movement. In this context, Mauss and the notion of the gift becomes, once again, a core reference (see Barbrook 1999; Bergquist and Ljungberg 2001; Zeitlyn 2003; Corsín and Lafuente 2010). For Barbrook (1999), the internet and new forms of technology may enable the constitution of a "gift-economy" from within capitalism itself. Drawing on situationist ideas, Barbrook defined the internet as an already existing anarcho-communism.

And yet not everyone in that field has the same reading of what a "gift economy" implies, or even if it's an appropriate term to describe exchange practices in this domain (Kelty 2008). Creative Commons, for example, is not necessarily against authors' rights, as much as it is against the corporate monopoly of cultural production … Mauss himself, in *The Gift*, agreed with the institution of authors' rights, understanding that it is fair that artists should receive compensation for their contribution to the public domain (Mauss 1990 [1925]: 85–6). In these terms, Mauss's take on intellectual or cultural production in terms of gift-giving didn't have much to do with anarcho-communism, but with notions of fame, recognition, the expansion of the distributed person through cultural production as a gift—which is exactly one of the main points that Mauss makes in relation to the potlatch and the Kula, and Gell after him. According to Cox (2010), Mauss's view is not that far from Lawrence Lessig's (2004), one of the main instigators of Creative Commons, for whom the existing legal framework should provide enough room to protect both the public domain and authors' rights. "The question remains of how to organize a society in which producers-exchangers give, receive and repay to the satisfaction of mutual interests (without the use of arms)" (Cox 2010: 132). This is more a liberal argument, of defense of freedom and personal autonomy, than an anarcho-communist fully fledged attack on property. Again, as in Hyde's work, the gift emerges in terms of personal freedom and equality, rather than social obligation and hierarchy.

The "gift economy" of the internet has come under increasing scrutiny in recent years by a literature many internet users contribute, consciously or not, to the rising revenue of internet companies. The emergence of the figure of the "prosumer" who helps improve the products he then consumes without being paid, questions

the "voluntary" and "participatory" aspects of the internet as a form of false consciousness that in fact camouflages free, unpaid labor under the ideology of "free access" and the production of community (Terranova 2000). Just like in the participatory arts, participation in the internet can be seen as a mechanism of neoliberal governmentality that, under the illusion of creativity, participation, and freedom, hides a new form of production of people and commodities.

At the other extreme, some authors have even dared to say that the digital utopia hides the fact that many users of peer-to-peer networks are not and do not feel part of any "common," but operate as free-riders giving nothing in return for what they are taking. For Whelan (2009), the "gift economy" vision does not go far enough; it misconstrues peer-to-peer as utopian, progressive, reciprocal, and communal, when in fact peer-to-peer "poaching" should be better described following Bataille's reading of the potlatch as a transgressive, anti-economic practice (Whelan 2009), a form of creative destruction posing a real risk to the industry and intellectual property, which is struggling to find the ways to reappropriate and monetize it. In this sense, these practices bring us back to the radical re-reading of the gift as theft by the situationists, "the growing passion for stealing," that may lead the market and consumerism to collapse. Of course, as in the "younger generation" that Vaneigem praised, these poaching practices may not be consciously revolutionary; on the contrary, they may just follow "acephalous" (Whelan 2009) passions and desires. But their transgressive potential is still difficult to contain.

CONCLUSION: FREE GIFTS?

Any understanding of the gift seems to result in multiple ambiguities and contradictions. On the one hand we have the Maussian tradition of an anthropology of the gift as a social institution based on obligation and reciprocity, a circle of exchange that may produce and reproduce social hierarchies; on the other hand, the Derridean definition of the gift as an unmotivated, unintentional event open to chance, that has to be forgotten as such. Mauss was not looking for pure gifts but for actual, historical institutions of social exchange, like the potlatch and the Kula, which he could put in contraposition with the "market" as an ideal type. None of these institutions could respond to the ideal type of the pure gift either, but were rather in between gift and commodity. Derrida, on the other hand, was interested in the gift as a philosophical question, in the very concept of "gift." That interest took him to the foundations of what constituted a free, pure gift and its aporia or impasse: the gift disappears at the very moment it is acknowledged as such, since any account, any recognition, any hint of the necessity to return a gift, turns it into a debt.

Derrida's aporia of the "free" gift is based on a very modern interpretation of the gift in its radical opposition to the "interested" commodity, which we have traced back to the eighteenth century, in close connection with the birth of aesthetics. As a form of relation based on freedom and play, the gift naturally embodies the aesthetic utopia, as opposed to economics and the commodity, which are based on the opposite: need and interest. In the ongoing tradition of what Rancière has called "the aesthetic regime," two hundred years later, writers and thinkers like Lewis Hyde described the gift at the heart of artistic practice, as a form of creating egalitarian communities based on freedom and play.

The many contradictions in the use of the gift and participation in contemporary art practice can be traced back to Derrida's impasse or aporia of the "free gift": at its very outset, any "free" gift that is recognized as such, any practice of "free" and "egalitarian" participation that claims to be so, contains the seeds of its opposite: creating bonds and hierarchies, instead of freedom and equality. In the case of relational aesthetics, for example, we have seen how these practices are organized around gift exchanges, which are supposed to form "friendship cultures" and "everyday micro-utopias." But on the other hand they can also be described in less egalitarian and spontaneous terms, as "potlatches" as it were, that build on the fame, hierarchy, and "distributed person" of the artist, and end up producing separate objects as "inalienable possessions." Thus, Maussian and anthropological discussions of the competitive and agonistic gift, as a producer of hierarchy and fame, could be much more appropriate to address these practices than the discourse of the "free" and egalitarian gift of writers like Hyde.

The same could also be applied to participatory art practices at large, beyond "relational aesthetics." In their attempt to build communities, many of these projects run the risk of reproducing the inequalities they were fighting against, or building new ones. The situation is even more complex when we move from artistic practice to a much more general sphere of cultural exchange, like the internet, where the forms through which persons are distributed, give and take cultural objects for "free," despite claims to the contrary, do not easily respond to the "gift economy" ideal, but result in multiple, and sometimes contradictory, practices and ideologies of exchange: from liberal, well-meaning attempts to build "commons" that try to work with the existing structures of property law, to anarcho-communist arguments that question the structure of intellectual property altogether, to free-riding poachers who take and don't give anything in return.

From there, we have taken a wider look at the problem of "participation." To start with, the "participants" in art events are not necessarily separate and equal subjects, who freely decide to "collaborate" in a common project, but they can also be seen as parts of a totality constituted by the very act of exchange. This totality could be

egalitarian or hierarchical: participation can create relations of dependency and/or re-cognition, unequal relations in which the distributed persons of participants are expanded and superposed upon each other.

If the "participants" are not necessarily equal and separate subjects, but part of the process, so are objects. One of the fundamental points of the anthropology of gifts is precisely a questioning of the distinction between the two. In these terms, things are not just objects of property, resources, or goods, but co-participants. Gift exchanges can be more than a mechanism of building communities, but also a form of transgression and attack on the system of property, on which commodity exchange stands. In its more radical reading, the gift does not only lead to a criticism of private property in favor of common property, but far beyond, to question the very principle of property, based on the ontological distinction of objects and subjects.

This radical reading of the gift was basic to the situationists. Following Bataille, the situationists were interested in the potlatch and the gift in general as events of transgression, not just as friendly exchanges between equals. But the situationists' gift was not a return to the feudal gift either, the gift of fame and hierarchy, the agonistic ritual that Mauss described. For situationists like Vaneigem, the feudal gift was a thing of the past, while the new society of abundance of the proletarian youth would be based on the pure gift. This pure gift would not simply take the form of a friendly exchange, but a transgressive attack on private property: quite literally, theft. The situationist revolution was not just an aesthetic utopia, based on freedom of need and interest, but a direct attack on the principles of property. The gift does not appear in these terms simply as an alternative to the commodity, but in antagonism with the market economy and private property. The "pure" gift is not an impossibility and an aporia, but a radical gesture of subversion.

After the situationists, the reading of the gift in art as a radical gesture of transgression seems to have been replaced by more conventional, liberal understandings of the "free" gift as a mechanism of producing and re-producing communities in participatory artistic practices. But this shouldn't necessarily imply an absolute dismissal of these practices. It still may be interesting to analyze the very processes they engage with, even if their outcomes aren't clear. These processes propose particular experiments with the very thread of the social. They actually do bring forth some of the situationist understanding of the gift as a performative gesture: an event that will almost inevitably result in contradictions, but that is still worth proposing, as a method, to open a field of possibilities. To cite Derrida again, the gift is an event open to chance. That unpredictability is precisely what puts it at the center of modern and contemporary artistic practice, in its "relentless disavowal of agency."

In the next chapters, we will continue this discussion on the gift as process and method by focussing more specifically in notions of work, from two perspectives: first artistic work—what does production, project, process, and work actually mean in contemporary artistic practice? After that, we will discuss how these very notions of artistic practice can help anthropologists understand their actual work, as in fieldwork.

6 WORK AND LIFE

In 2008 I attended a workshop at Can Xalant, the art production center I mentioned in previous chapters. This center was in an old farmhouse on the outskirts of Mataró, a town in the periphery of Barcelona; it wasn't exactly around the corner. But the place was packed when I arrived. The name of the workshop was "The Transparent Factory," and its aim was to discuss the meanings of "production" in contemporary art. Most of the speakers, artists, critics, curators, between their late twenties and late forties, were relatively fluent in contemporary critical theory, and shared some common view of the contemporary artistic condition. This implied, basically, a frontal rejection of the romantic myth of the artist as genius, and creator; the artist, from their perspective, is a producer among others, a worker. This production is not individual, but collective; many of them in fact belonged to different art collectives. Furthermore, this production should not be commercial, addressed to an exclusive and elitist market, but public. For most of them, art was not a self-justified activity, "art for art's sake," but a means to an end—this end being, in most cases, social and political.

Towards the end of the day, after several very dense and thoughtful presentations, one of the members of the audience, with a foreign accent, dared to formulate a question. "You have spent the whole day talking about artistic production," she said, "and I have been told that this is a center of artistic production … But I can't see any artworks around. Where are the artworks? Where is the production?"

It was clear that this person did not belong to the contemporary art world of Barcelona, and that this was her first time in that place and at such an event; in fact she explicitly said that in her country art production centers are full of paintings and sculptures, which was obviously not the case in Can Xalant.

At this point the director of the center made an intervention, saying something that most of the speakers up to then had taken for granted. Art today, he said, does not necessarily focus so much on the production of objects like paintings or sculptures, but in experimentation with processes and methodologies; the final result may be rather immaterial, it may be more a process of learning and knowledge

than of material production. In fact the name of the art center was "Can Xalant. Center for Creation and Contemporary Thought" (Centre de Creació i Pensament Contemporani).

What would be this "contemporary thought"? To answer this question, I will make reference to yet another conference, a much more high-flying one, earlier that year, in January 2008, at Tate Britain in London, under the title "Art and Immaterial Labour."

ART AND IMMATERIAL LABOR

The speakers at this conference included some of the central figures in contemporary critical thought, such as Toni Negri. Some years before, these names wouldn't necessarily have been associated with contemporary art; Negri is a well-known Marxist thinker coming from the autonomist movement of the 1970s in Italy, and has written extensively on capitalism and labor. But there he was, at the Tate, the *sancta sanctorum* of art at the beginning of the twenty-first century. Radical thinkers like Negri have become influential in art because of the relevance of their ideas about "immaterial labor" for contemporary artistic practice. For Lazzarato (2006) and Negri (2000, 2011) capitalism has moved from a Fordist model of production of material commodities to a post-Fordist model of "immaterial" labor, the production of immaterial services, ideas, and affects: advertising, web designing, teaching, caring—forms of labor that don't result in the production of material commodities. The contemporary artist could be seen as a good example of the post-Fordist, "immaterial" worker; after all, contemporary conceptual art explicitly departed from the production of objects to work on "ideas" or "concepts."

Lazzarato (2006) would also argue that not only the object of production—the commodity—has been dematerialized, but the spaces of production themselves today are without walls, as it were; labor is not determined by the physical space of the factory, the disciplinary regime of the chain of production constrained inside its walls, but it has extended beyond the workspace proper. Post-Fordist, immaterial work extends beyond the space and time of the workplace, not only through electronic means (through laptops, smartphones and tablets), but also in the minds of workers, who keep thinking about work projects in their spare time. At the same time that work has become immaterial, it has also become more personal. Post-Fordist workers are made responsible for their work; they are not just alienated hands in a chain of production, but they contribute with their ideas to the production process. This production process is not organized only around the physical, material production of outputs for the market—cars, sausages, or what

have you—but through participation in the design of projects, whose responsibility and authorship is shared by the work team: a web page, a community service, a syllabus, a corporate brand, an art event. The traditional critique of alienation seems to be superseded. To put it in very simple terms, the basic Marxist critique of alienation pointed to the fact that factory workers sold their manpower in exchange for wages, but their work was totally separated from their life, what they did outside the factory; they did not identify with the products of their labor, their work was alienated. This situation would be radically different for the post-Fordist worker, who on the contrary would identify with his work, becoming increasingly unable to separate work and life, what he is from what he does for a living.

Communism intends to overcome the separation of work and life, but not quite in these terms. In the post-Fordist model, even if the forms of work are collaborative and workers are called to participate and feel responsible for their company in a "communitarian" scenario, the fact is that at the end of the day, they work for the company, and the company benefits from them. The company is still a capitalist enterprise. So alienation hasn't been cancelled, but on the contrary, extended to the whole domain of life. Workers still feel their work as their own, even if ultimately it does not really belong to them; in fact, this identification with work is often used precisely to justify exploitation: the notion that workers have to "take responsibility for the company" justifies that wages have to be "contained"; the idea that the worker is doing what s/he wants to do, and that s/he is investing in her/himself, justifies precarious work conditions. Life and work are not separated, but not so much to liberate work as to alienate life. The "communist" scenario of post-Fordist production, in which everyone shares responsibility and collaborates in a collective project, would be a spectacle, the spectacle of the "transparent factory" without walls, which hides the same old truth of capitalist exploitation. To understand this extension of the alienation of labor to the whole domain of life, theorists like Negri or Lazzarato have used the Foucauldian notion of biopolitics. Beyond the discipline of the factory, post-Fordism (or neoliberalism) becomes a biopolitics of life as a whole.

It could be said that "artists" and "art" are good examples of post-Fordist work practice; not only visual artists, of course, but any form of practice that can lay claim to being defined as art, or "cultural production," from the fine arts to cuisine or web design. But in fact, "art" is more than an example. For sociologists Luc Boltanski and Eve Chiapello (2005), art and the aesthetic utopia are key to understanding the "new spirit of capitalism." The modern aesthetic utopia emerged as a critique of capitalism, precisely because it proposed an alternative form of life, which would overcome the division of work and life. This aesthetic utopia has been a recurrent theme in recent art theory, as we have seen. In Bourriaud's terms, "modern art rejects

the separation of the finished product from existence. Praxis equals poiesis. The act of creation is to create oneself."[1] Situationism was the ultimate incarnation of this rejection, and it became a major influence in the events of May 1968. Boltanski and Chiapello's argument starts precisely at that point. Since the sixties, the "new spirit of capitalism" has incorporated the aesthetic utopia into the new managerial discourse, in order to build a new identity for the worker—from alienated factory wage laborer to "creative" professional. In this context, not only have situationist practices been re-appropriated by advertising and the society of the spectacle, but in more general terms, the artistic critique of capitalism has been incorporated in a hegemonic discourse in which workers are invited to identify with their jobs, participate, be "motivated" and "creative," and work in their free time. Therefore, it is not only the case that modern capitalism is based on "immaterial labor" and "cultural production," but discourses about work, beyond what is being produced, are articulated upon the principles of identification of work and life and autonomy that were supposed to question capitalist alienation in the first place. The revolutionary life politics of the situationists seems to have been reduced to an ordinary bourgeois biopolitics.

THE LIMITS OF "IMMATERIAL LABOR"

What implications does this approach to post-Fordism, immaterial labor, and the new spirit of capitalism have for art practice itself? First of all, it seems that in the incorporation of the artistic critique to capitalist production, the artistic exception is cancelled. The identity of artists, constituted precisely in opposition to the Fordist model, is diluted in this new model; if everyone is an artist, if art is the general form of work, the specificity of art as practice disappears. We live in a world where many people are asked to be "creative" (Ross 2009; Raunig 2011) in their jobs—whatever "creativity" means—and share this artistic ethos in some way. This is not to say that before this "new spirit of capitalism" only art was a "creative" endeavor—on the contrary: modern art had explicitly rejected notions of innate "creativity" and the artistic genius. But in its re-appropriation of the artistic critique, managerial discourse has resuscitated "creativity" to dilute it in a much more general and indeterminate sense of being relatively autonomous and resourceful; to "create" oneself. But then, where is the specificity, the singularity of art as a form of practice in the age of immaterial work? Does that mean that "art," as an institution, has disappeared as an autonomous form of practice?

Well, not really. "Art" hasn't fallen off its pedestal—quite the opposite. Contemporary art has never been more valued as a commodity than it is today.

Even if the forms it takes can be surprising and bizarre (works of video art can be sold in the form of a limited edition CD), the art market is alive and well. So is the romantic figure of the artist genius that inevitably accompanies it, and which hasn't substantially changed since the nineteenth century. The elite of contemporary art, that which constitutes contemporary art proper, is probably wider and more global than some decades ago, but it is still an elite. After all, the "regime of representation," art as an autonomous, hierarchical institution, still survives, in spite of the aesthetic utopia. However, it is true that this wider contemporary elite is surrounded by a much bigger "multitude" of art students, local art centers and networks that have multiplied exponentially around the world (Gielen 2010), on which it partially feeds but which also stands in relative contradiction to this elite; this artistic "multitude" seems to be pushing further for a more radical program of engagement with the everyday.

This apparent contradiction is just one of the problems that the model of the post-Fordist world seems to pose. The notion of "immaterial labor" could be questioned on several grounds. David Graeber, who came along with me to the "Art and Immaterial Labor" conference, has already raised some of them (Graeber 2011). The first is that the very notion of a post-Fordist age of "immaterial labor" as opposed to Fordist "material" labour is misleading; it seems to operate on a rather coarse materialism, which does not acknowledge that what constitutes work in the first place is social action and process, and not its more or less material end results. It is precisely this reduction of action to object that constitutes the basis of commodity fetishism for Marx. Work has always been immaterial and material at the same time. Moreover, the distinction between "productive" (industrial) and "non-productive" labor has always been ideologically charged, not just in post-Fordist times, either to deny forms of affective work (like housework) as such, or to justify the superiority of "intellectual work" over manual work. For an anthropologist like Graeber, it is evident that all these forms of work (manual, affective, cultural, etc.) have always existed together, and they can't be so easily disentangled. He also questions the specificity of the biopolitical regime we live in, as if the regulation of life was peculiar to our contemporary world. Finally, Graeber also makes the point I have made before about art, that there is indeed an art industry, or an art world, *the* art world, which is not subsumed in the multitude of "creative labor," but which, on the contrary, lives in close connection to financial capital.

Some years after that conference, one could add that the very concept of a post-Fordist capitalism based on immaterial labor before 2008 rested on shaky ground. In many ways, this was the radical, revolutionary version of the liberal discourses on the rise of the "creative" or "cultural" economy (i.e. Florida 2004) that was to be the future of post-industrial countries. The credit crunch of recent years has shown that

"culture" was only a small portion of our economies, which were based on financialization rather than on cultural production. The countries that recovered quicker were those based on a solid, "material" ground of industrial production. In a way, one could certainly say that financialization is a good example of post-Fordism; the financial sector is based on the production of immaterial products (financial products) and it has indeed been very "creative" in the last 20 years—even if "creative accountancy" is probably not the first example of creative economy that manuals would use.

Having said all this, these ideas about "immaterial labor" have been influential upon the "artistic multitude" that attended the conferences I mentioned at the beginning of this chapter. Regardless of the historical period, Fordism and post-Fordism, the correct diagnosis of the nature of capitalism today, or the nature of work itself, any criticism of theories of art and immaterial labor cannot deny that the forms of work in art have changed and multiplied substantially in the last century, and this has resulted in a substantial change in how work and life are related in art practice. In the remainder of this chapter, I will address this relationship from two perspectives: first, the definition of work as "project," and second, the question of skill.

THE BIOPOLITICS OF THE PROJECT

Many works of art today cannot be readily identified as objects or finished products; as opposed to the "objecthood" of painting and sculpture, they are assemblages and devices with a precarious and short-lived materiality in the majority of cases, not to mention ephemeral performances, events, and situations which only leave material traces through documentation (Buskirk 2003). These are not "objects" in the same way that artworks used to be. The activities that artistic work entails may have also widened substantially; many art practices today involve not just relations of production with objects, but social relations with people, places, communities; they are participatory, relational, etc. These artistic practices are often described as "projects" more than finished works (Gratton and Sheringham 2005; Bishop 2012). The "project" is also central to the "new spirit of capitalism." Workers have become "flexible," "mobile," "adaptable," participating simultaneously in several different "projects" rather than keeping a lifelong job with the same ongoing tasks and responsibilities. Instead of being built on a single long-term trajectory, the project results in a totally different temporality, composed of multiple lines and with many openings and closures. All these characteristics may also be applied to art as "project"; in fact Boltanski and Chiapello explicitly use artists, as well as scholars, as an example of this (Boltanski and Chiapello 2005: 312).

None of the critiques of theories of immaterial labor would deny that this entails a particular kind of "bio-politics," as art theorist Boris Groys would say—a particular form of "organizing life as an event, as pure activity that occurs in time" (Groys 2002: 6). In wider, more anthropological terms, we could ask if art as "project" results in particular forms of relating persons, things, and time.

In the classical model of artists as producers of distinct works (paintings, etc.), the collection of works would constitute his or her *oeuvre*—the "body" of his/her work, as opposed to the body of the artist him/herself. The *oeuvre* implies a certain form of temporality, and a certain process of construction of the person, built on the accumulation of an external "body of work" separated from the artist. On the other hand, many artists today may not only, or preferentially, make finished products, but they have "projects" and produce events, performances, or situations that are only temporal manifestations of these projects. The effects of these events and performances, the results of these projects, may not end up being fully objectified as unified "work," but just an assemblage of documents, a scattered archive. They may not even become an autonomous product. The temporality of this process, and the relation of object and subject, is totally reversed from the model of the *oeuvre*; what constitutes the focal point around which the activity of the artist unfolds is the origin of the "project," and not its outcome, the "artwork." The life of the artist him/herself turns around these projects. As an artist friend told me once, "projects are never finished, they are only closed." Many projects often remain open, without a clear end, and then, completed or not, they become material for future projects. This activity, instead of being cumulative—building upon the past, the construction of an *oeuvre*—is projective; it builds towards the future. In this particular form of what we may call "biopolitics," the distinction between the artist and his/her work is much more diluted and ambiguous than in the "objectual" model of the past; art, work, and life become very difficult to disentangle in the person of the artist.

BIOPOLITICS AND THE DISTRIBUTED PERSON

In Groys's terms, "art is now becoming bio-political because it has begun to produce and document life itself as pure activity" (Groys 2008: 54). Groys's approach to biopolitics is quite critical: he asks to what extent art documentation can actually represent life itself? My concern here is less with how successful these practices are as art, or even less if documentation is "successful" in "representing" life. I am more interested in the particular modes of relation of persons, things, and time articulated through these art practices. I want to move beyond a restrictive understanding of "biopolitics" as a form of control through which, for example, artists would

become disciplined in a "projective" time that would transform them into subjects of this "new spirit of capitalism." I don't question that this is often the case, but maybe we can understand this concept in wider terms. For Lazzarato, for example, "biopolitics" is not exclusively a mechanism of domination, but the very condition of production of new forms of life (Lazzarato 2002). Perhaps we could articulate this productive notion of biopolitics with anthropological arguments about the relationship between people, things, and time.

For that purpose, it is inevitable to make reference yet again to Alfred Gell. The concluding chapter of *Art and Agency* (1998) is precisely dedicated to the question of the relationship between the artist, his work, and time. Gell addressed the very notion of the artist's *oeuvre,* his body of work, as a "distributed object":

> We can imagine the artist's oeuvre, at the macro-scale, as one indivisible work, consisting of many physical indexes (works) but amounting to a single entity, like a persistent thunderstorm which is made up of many, momentaneous, flashes of lightning. The artist's oeuvre is an object which, so to speak, is made out of time, not the tenuous dimensional time of physics, but the kind of substantialized time which Bergson named durée. (Gell 1998: 235–6)

The main example that Gell used is Marcel Duchamp:

> Almost all of Duchamp's work, from 1913, is part of a single, coherent project [...] Duchamp's oeuvre consists of a single distributed object [...] This was intentional and explicit, since Duchamp's basic objective was to create a fourth-dimensional entity. (Gell 1998: 245)

But Duchamp can be read very differently. Gell thought that the fourth dimension is the key to his *oeuvre,* and *The Large Glass* would be the final realization of this (see also Dell 2013). But there are other ways of approaching Duchamp's life and work, which are much closer to what we have described here in terms of "project" than *oeuvre.* Moreover, Duchamp's case can also be useful to bring the question of the "project" a bit further from the critique of biopolitics that Groys and other authors are proposing.

Here I am using the example of Duchamp after Gell, and one could question to what extent this is a valid example, if we are talking about contemporary artistic practice. But with Bourriaud (2002), I would contend that Duchamp's model not just of art, but of life, is still very influential in contemporary art. That is not to say that it is enough to discuss "saint" Duchamp to understand contemporary artistic life and work, but it is certainly a place to start.

According to Henri-Pierre Roché, Duchamp's lifelong friend and eventual art dealer, Duchamp's most beautiful work was his "*emploi du temps,*" his use of time—in

other words, how he lived. Time was indeed very important for Duchamp, but in a slightly different way than Gell implies. The research on the fourth dimension may indeed have been very important when Duchamp started projecting *The Large Glass*, still under the influence of cubist debates on this notion. But it took a long, long time to "produce" *The Large Glass*, and by the time it was finished, Duchamp was very, very far away from cubism or any other form of representational art. It is worth going through the whole process of "production" of *The Large Glass* to understand this point.

The project more or less started in 1913, according to the notes and studies that Duchamp later published as *The Green Box*. When he moved to New York after the beginning of the war, the Arensbergs, collectors of his work, gave Duchamp a periodic assignment to keep "working" on *The Large Glass*, and they kept the "work in progress" in their New York flat. Indeed, the work was in progress for many years. After a long absence from New York, in 1920 Duchamp returned to find that the Arensbergs were moving to California, and he had to take the "project" of *The Large Glass* to his own flat in order to finally finish it. But for a long time it was left in a corner, gathering a lot of dust—so much so that Duchamp and his friend Man Ray decided to take a picture of the dusty surface, which then became the artwork titled *Dust Breeding*. After that, Duchamp cleaned and polished his work. But by 1923, he was so bored with *The Large Glass* that he declared it officially "unfinished." In 1926, while being transported, the glass broke in the shipping crate. Duchamp repaired it partially, but left the cracks in the glass intact, accepting what had just happened as a part of the piece.

In the thirties Duchamp made several small-scale reproductions of *The Large Glass* as part of his *boîtes*, or boxes—small-scale reproductions of his full *oeuvre*. In the sixties, he authorized three 1:1 replicas of *The Large Glass*, all of them with a broken glass. After making *The Large Glass*, Duchamp said that he had run out of ideas, and that he had no longer any desire to be a practicing artist. He was in his late thirties. In fact, Duchamp's *oeuvre* almost ends there; he made things that sooner or later were considered art and sold and shown as such, but that was not his first intention in most cases. His main objective, according to people who knew him well, was just to live, without the need of having a full-time job and producing new "work." He spent most of the rest of his life playing chess. To make ends meet, he accepted occasional invitations to curate exhibits, advised collectors, bought and sold art, and made the *boîtes*.

If an artist's *oeuvre* is a distributed object, made of stoppages or events, Duchamp's *oeuvre* stopped relatively early in his life. From then on, his job was to administer his own legacy—that is, himself; to live off his reputation, his name, his fame. In this case, the distinction between artist and *oeuvre*, person and object is very difficult to

make. That is not, deep down, in contradiction with Gell's notion of the distributed person. It just adds to the fact that persons can be distributed in different ways, and Duchamp's most radical contribution is precisely being the model of a new kind of artist "person," different from the classical artist and his *oeuvre*—an anti-artist, if we like, whose main work of art is his own life, the use of his own time; the artist and his work, distributed object and distributed person, are the same thing.

At this point I would like to come back to the question of "discipline" in the biopolitics of the "project." If one thing seems to be clear in Duchamp's story, it is precisely the total lack of discipline, and the ambivalent, to say at least, attachment to any particular project. For example, the anecdotes punctuating the "biography" of *The Large Glass*—Man Ray's photograph of the dust, the accidental cracks on the glass that then become part of the artwork—are not just meaningless events. For Duchamp, events were the very essence of his work; they were never irrelevant. While *The Large Glass* was "made" from 1915 to 1923, Duchamp had come up with the idea that made his fame, much more than *The Large Glass itself*: the ready-made. It was precisely through the ready-made that Duchamp came to see the work of art as an event of encounter. And an event of encounter is nothing else but an event in life. His artwork was himself, his life: his use of time. Particular works are events more than objects, points in time, in the ongoing process of production of Duchamp. In Bourriaud's words, the act of creation is to create oneself; and work is life, a form of life.

In fact, one could say that the very terminology of the "project" does not fully explain these forms of life, for the discourse of the project may presuppose a clearly outlined line of action, an intention, a timeline, a method, a design that these ways of making don't seem to have. In fact, on the contrary, they seem to react against them. What defines the modes of relation of persons, things, and time in these forms of life is less the "project," as opposed to the object of classical art, than the process itself. "Process" defines yet another form of relating with time; unlike projective time, it is not oriented towards an outlined future, as a promise that has to be fulfilled, but it is constantly altered by events that reshape the social relations they entail. These processes are often a form of "research," in its wider sense—a search for these transformative events.

Notions of process and event also introduce a radically different component to Gell's notion of the distributed person. For Gell, distributed mind and distributed person were almost equivalent; the distributed person transfers agency to the object of its design, so that movement, and time, always start from the action of the subject upon the object. The model of the event, as we saw in previous chapters, is radically different precisely because it doesn't have a "first agent"; it doesn't define action as determined by intention or mind, but by "objective chance." Replacing "agency" by

"objective chance" as its driving force, the "network of stoppages" proposed by Gell as a model takes a different shape; the "artist," as it were, would not necessarily be the initial point from which the network would spread, but a point of intersection between lines of action.

One could say, then, that the artistic research processes do not necessarily conform to the temporality of the project. And yet it seems inevitable that the term "project" is commonly used in art practice, even to describe processes that don't really conform to it. Most artists, even if faithfully following Duchamp's model of living art as a form of life, can't afford to live without working! And there, the discourse of the "project" inevitably emerges as a mechanism to find resources; to apply for funding, one needs to write a proposal with a strong rationale, convincing outcomes, and a defined timeline—in other words, a clear project, where artists have to sell ... themselves. But still the project is never totally closed and impermeable to the indeterminacy of the research process. In many cases, the outcomes of the project are not really adjusted to the proposal; often they are difficult to assess, and again, the project itself can be used as a platform or resource to move on to the next project. The relative openness of the project, in particular in regard to its outcomes, gives some room for the actual research processes to take place. In these terms, the biopolitics of the project don't have to be seen simply as a disciplinary cage that transforms the producer in his own product, in the neoliberal trap of the new spirit of capitalism. Still, artistic production is often built upon this ongoing tension between the external form as a project that has to be "sold" and its internal dynamics as an open research process.

SKILL AND DESKILLING

There is another very important issue in relation to the forms of practice in art, besides the "project": the question of skill. One of the central points of the shift from the academic art to the avant-garde is the deskilling of the artist. Academically trained artists have a very specialized and sophisticated set of skills, founded upon a humanistic culture that provided for the themes represented in their work, and the techniques to represent them. By contrast, the different forms of anti-art that have emerged since the early twentieth century have been built precisely on systematic deskilling, *un*-learning the craft of the artist. Again, Duchamp exemplifies this radical move when he decided to "forget the hand" of the academic artist, to replace it with mechanical drawing. In his quest for moving beyond representational art, Duchamp found a chocolate grinder. He decided to make a drawing of it, but this drawing would not be based on the academic skill of the "hand":

> The problem was how to draw and yet to avoid the old-fashioned form of drawing [...] Mechanical drawing was the saving clause. A straight line done with the ruler, not with the hand. Forgetting the hand completely, that's the idea [...] I unlearnt to draw [...] I actually had to forget my hand. (Duchamp cited in Tomkins 1997: 126–7)

After Duchamp, the avant-garde was not necessarily about proposing new artistic techniques or skills *per se* (new media, as we would say today), but about shifting the role of the artist from skilled producer with a particular technique to unskilled "amateur" who finds objects, images, techniques, and people. In this sense we can say that many contemporary artists "work with" film, video, sound, or digital media, without necessarily being professional filmmakers or media professionals—which is to say, without claiming to be in control of the media they are using. In the same way, artists work with people in participatory and site-specific projects, without claiming to have the specific skills either as social scientists, or social workers, but just working from their own experience as social beings.

Duchamp was not only reacting against academic art and the threat of a new academicism (i.e. the cubists) but he was also, perhaps unwittingly, proposing art as a counterpoint to industrial production. This counterpoint was not a romantic return to artistic "skill" and "craft" but on the contrary, it was an embrace of deskilling and mechanization. The ready-made was an absolute inversion of the alienation of industrial production: the industrial worker made reproducible objects that they did not recognize as theirs and which, by default, made them part of a chain of production. Duchamp encountered reproducible objects that he did not make, which then became his unique and non-reproducible work by the simple act of finding them and designating them as "art." This "rendezvous" that Duchamp called art was a radical questioning of the very mechanism of capitalist production.

John Roberts has argued (2007, 2010) that this radical deskilling of the artist could also be seen as a *re*-skilling, in terms of "immaterial" skills of conceptualization. The conceptual artist is no longer an artisan working with different materials through his manual skill, but he acquires an "executive" role, in which he directs and organizes materials produced by others (Roberts 2010: 84). An example of this point, besides Duchamp, would be László Moholy-Nagy's *Telephone pictures* (1923). He delegated the production of these pictures to a sign factory in Berlin, by giving them instructions over the phone. Minimalist and conceptual artists, many decades later, also delegated their work to fabrication workshops. Nowadays, the production of many artworks could not be conceived—or in fact realized—without highly specialized fabrication workshops that in some cases (like MDM in London) have become industrial in size (see Crear 2012).

Conceptual artists often rely on delegation, surrogates, prosthetics, while they focus on the "conceptualization" of work. Does that mean then that they have acquired a "managerial" role? One could say that classical artists also worked in workshops, but there is a radical difference: these workshops were theirs. The artists were the masters of the workshop, with specialized technical skills, and they supervised their assistants. On the other hand, conceptual artists may not even pretend to have the skills to produce their works, they only transmit their "concept" or "project" to an external workshop where professional "fabricators" work. But to delegate work is not exactly the same thing as to "manage" or coordinate a workshop; the effective control that the "conceptual" artist has over the production process is quite relative: there is a high degree of openness and unpredictability in the production process. This has resulted in no few problems and complications in many conceptual art projects in the last few decades (Buskirk 2003). But perhaps these problems and complications are part of the process in many cases; the very act of "delegation" by phone call, first enacted by Moholy-Nagy and then repeated countless times by many artists (Crear 2012), may be a purposeful strategy to distance concept from fabrication, precisely to leave the room open for this unpredictability. I am not saying this is always the case, but "delegation" always implies a degree of leaving the door open for external factors that the artist cannot control.

In these terms, has the post-Duchampian conceptual artist been re-skilled, with "immaterial" skills of "conceptualization," as a manager of people rather than possessing manual skills? It is difficult to say if these art practices are really "skills." First because the process of "conceptualization" in art does not seem to follow any particular, clear method and cannot be tested against any particular standards of quality. There are technical ways of assessing if a painter or a sculptor is skilled in their job, but are there any technical means of assessing the conceptual skills of an artist? In fact many conceptual artists don't seem to be particularly concerned with the "skill" with which their ideas have been formulated or transmitted, but on the contrary, they purposefully seek openness and inconclusiveness. Second, to delegate the production of a work to a workshop is not really the same thing as to manage this workshop; it is first of all a "disavowal of agency," leaving the work open to the intervention of other hands, and that does not require specific "managerial" skills.

We can extend these considerations a bit further, to "participatory methods" in art. If it is difficult to say that "conceptualization" is a particular skill of the conceptual artist, do artists working with participation have "participatory skills"? That is to say, are they trained in specific professional techniques to work with communities, or in specific sites either as social scientists or as social workers? The answer in many cases would be negative, unless we consider what we call, generically, "social skills." But that is precisely the point: the tools that artists have when

they want to deal with people are just the generic "tools" they possess to deal with everyday life as social beings; they are not the result of any particular training. In fact they are not "tools" in their "possession": so-called social skills are part of who we are, not things we have. In these terms, they are professionally "deskilled" and open to chance in their relationship with communities, just as Dadaists and surrealists were deskilled in their relationship with the objects they encountered. In the very same terms, describing the artist as a skilled "immaterial" social worker who manages people would not only be limiting, but also misleading, precisely because often participative artistic projects depart from the opposite position: from rejecting the distinction between artist and public, specialized knowledge and everyday ways of making, work and life.

At this point, it would be important to address what anthropology has to say about skill, and the division of work and life. In his discussion of skills and creativity, Ingold (2007, 2011a) has proposed to pay attention to the differences between the model of the practitioner and the student or analyst, in which the latter's work would be based on applying a model or a preconceived plan, while the practitioner is more focused on the process than the outcome, and borrows, appropriates from his surroundings, improvises, in a lifelong process of embodied work with the materials (Ingold 2011a: 6). In a way, we could say that Ingold's distinction corresponds to the difference between project and process.

Ingold would describe the creativity of the practitioner in terms of "concrescence," not in opposition but as a continuation of the world and its materials: that very moment of becoming by which the world, as it unfolds, continually surpasses itself (Ingold 2007: 47). The skill of the practitioner would be this embodied understanding of the materials of the world and his or her attunement to them. In this sense, for Ingold, the process of production, or work, is not at all opposed to life, but part of it (Ingold 2011a: 6).

This vision of the practitioner-in-the-world is very clearly opposed to the modern model of production, in which culture and nature, object and subject are alienated from each other, and in which technology is designed to control the world not as a living environment but as a resource to be utilized. Avant-garde art emerges as a critique of this model of production, and as an attempt to foreclose the division between work and life.

But still, we can guess that most modern and contemporary art after the avant-garde does not exactly correspond to Ingold's vision of "creativity." Avant-garde artists were trained academicians who explicitly rejected academic knowledge, not to return to the pre-industrial model of the craftsman, but to embrace ignorance and chance, which is not exactly the same thing. The post-Duchampian artist explicitly rejects skill, "forgets the hand," and starts from scratch. Duchamp's devout follower,

John Cage made an explicit point of rejecting improvisation, since it inevitably led, even unconsciously, to already-known forms and personal choices. Chance, not improvisation, was Cage's "method" (Kauffman, Cage and Alfred 1966) to make totally impersonal music and withdraw his own agency.

In this sense, the mode of "creativity" of most post-Duchampian art is closer to Lévi-Strauss's bricolage than to Ingold's notion of "concrescence." "Bricolage," as Ingold himself explains, appears as a rearrangement of preexisting forms, through a punctual event of encounter—a "revelation," as it were. As opposed to this, Ingold's notion of "concrescence" insists on the continuous process of unfolding of "life," of forms, rather than punctual events (Ingold 2007: 47–9).

There is another point that may need some consideration. Ingold's practitioner doesn't distinguish between work and life, subject and object. But this is not exactly the case in a lot of modern and contemporary art. As we have seen, many authors, from Duchamp to the situationists, questioned these separations, not from a position of actually ignoring them, but on the contrary, by actively trying to overcome them through an active engagement with chance. Just as in the previous chapter we have seen that the modern artistic engagement with the gift is born out of the attempt to question commodification, deskilling implies an active rejection of skilled labor, as separate from everyday life. But just like the antinomy of the gift, the attempt to overcome this separation may end up producing the opposite effect: by documenting chance, and the event of encounter, they may end up transforming everyday life into just another "form" to be produced, turning it into an art object.

CAN XALANT: PROJECTS AND OBJECTS

To clarify some of these points, I will introduce some projects that have taken place and residents who have worked at the art production center with which I started this chapter, Can Xalant.

Can Xalant itself, as a "project," opened in 2005. At that time the town of Mataró was experiencing a real estate boom, and the city council decided to preserve the historic farm building in its periphery called Can Xalant and use it for cultural purposes. The city council launched a call for "projects" to manage the center under contract. The bid was won by a collective of contemporary artists from Mataró, in conjunction with a cultural management firm, Transit. They proposed to use the building as an art production center, a "factory of creation."

The Can Xalant project had four main working programs: residency, lab, curatorship, and diffusion. First, in terms of residency, it offered working spaces for

artists, providing all the material they required for their work within the budget of the art center. These residencies were for both local and international artists. They didn't just consist of workspaces, but the residents could actually live there: the center included an apartment with different rooms.

As a "lab," the center offered media and digital resources for the production of photography or film, a room that could be used for film sets, as well as the assistance of a media technician. But the "lab" wasn't only the media lab; more generally, courses and workshops were also defined as part of the laboratory. These workshops were not only technical, but they also involved theoretical and political subjects, and they were participative (open to the public)—think, for example, of the workshop I mentioned before, or the "Disruption" workshop with Tiravanija that I referred to in the introduction. This expanded definition of the "lab" comes from the notion that artistic experimentation also includes all these practices of knowledge production. Experimentation and research in art is both a practical and intellectual endeavor; in fact it is difficult to distinguish the two. These lab activities had a training component, but they were also a form of collaborative production and a social event. In fact, according to one of the directors of the art center, in Can Xalant "everything was lab."

The two other work programs, diffusion and curatorship, were complementary to the centrality of the "lab" to Can Xalant's program. The diffusion program involved the art shows with works produced at Can Xalant, and the Open Doors, or Open Studios day at the end of the summer. The "curatorship" program, on the other hand, is more difficult to define, according to the directors of Can Xalant. In fact, the very notion of "curation"—or display of works of art— seems quite alien to the whole project, which was more focused on the other end of the spectrum: production. This is one clear example of how the "project" doesn't always adjust to the process: in Can Xalant, the first two working programs, residency and lab, were much more central than diffusion and curatorship.

To explain more thoroughly what was being produced at Can Xalant, I will give some examples of artists who had a residency there, and then I will focus on one of its more important projects, *We Can Xalant*, which I already introduced in previous chapters.

I will start with two of the residents: Cristina Ibáñez and Carolina Bonfim. Cristina Ibáñez was a resident in Can Xalant for a couple of years following completion of her studies in Fine Arts. She applied for a workspace in Can Xalant partially, as she herself recognized, because having a workspace forced her to be disciplined to work. But she didn't use the workspace to think about future projects: "in the workshop I only produce, I don't think."[2] The ideas for her work come from everyday life, from the street. The first project she showed me is called *The Train*

Route (Figure 8), and consists essentially of a roll of paper that she took on her train ride to Barcelona, in the commute she made every day from home to university. This was an outcome of boredom: in her own words, "Many times I do things because I get bored or to spend time …"[3] With a pencil in her hand, she would register the bumps of the train, like a Geiger earthquake counter. This was, or could be considered to be, an action, but she says she is more interested in the register (the paper) than the action itself.

Common threads in Cristina's work are monotony, chance, and the use of time. In another time-based project, Cristina transcribed the broadcast of a football match. Again, this action was a result of boredom; she doesn't like football, but watching matches on TV is an almost compulsory social event with her friends. She decided to register this action as a video in which one can hear, but not see, the broadcast. Instead of the match images, the video shows the words of the transcription appearing simultaneously with the audio on the screen. In a similar way to the previous project, Cristina is interested in the "bumps" along the way—this time through the mismatch between the spoken word and her transcription; not being a professional transcriber, she often made mistakes, forgot or misspelled words.

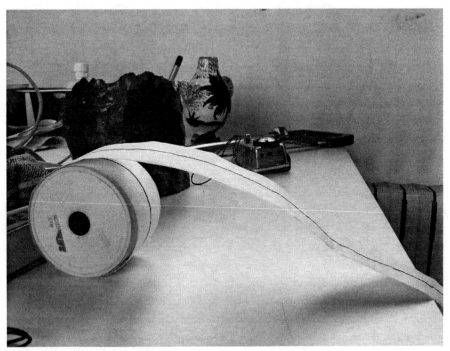

Figure 8 Roll of paper from the train route of Cristina Ibañez-Tarter, made in 2007 (Roger Sansi 2012).

In her everyday trajectories Cristina finds ideas, sentences, or images that she captures with her cell phone. In fact there are many thoughts, images, or ideas that come to her but which are not her art work (in her own terms, in Catalan "*no son obra*") because she hasn't thought about, or doesn't know, how to present them as "art"—how to produce them, as it were. For example, she spends a lot of time driving, and once she saw a driver's license plate with the number 0000. She found that funny, and took a picture. After that, she started a "collection" of license plates with numbers under 100. But she stopped doing it because on one occasion she almost had an accident. She doesn't think she can turn this into work ("*no es obra*") or that anyone but her is interested. Likewise, while we visit her workspace, she shows me a group of boxes she has made; with a nervous laugh, she says this is not actually her work: "I just made it, but it's not work, it's not production."[4] In fact she remembers that one of her teachers in art school told her once, "you are not very productive."

What is the difference between "work" ("*obra*," or "*Oeuvre*" in French) and life? Not easy to answer. Artists may try to make a distinction, but in fact it is not always clear if these non-work activities will eventually become "work," a "project," "art."

Carolina Bonfim is also a good example of these fluctuating limits of art and the everyday, project and chance. Carolina is a Brazilian artist from São Paulo who discovered Can Xalant on her first visit to Barcelona. When she came back to Barcelona for good, she decided to spend some weeks in residence at Can Xalant, actually living there, to focus on the project she was undertaking: she was writing a report about the relationship between performance and site-specific arts for the Brazilian Arts Foundation. She needed time and space to separate herself; in her own terms, "residencies oblige to do something."[5] After that she became a stable resident with a workshop.

Carolina comes from the field of performance. She arrived in Barcelona as a member of an art collective, Corrosivo. She has been in several art residencies before, in Brazil, Argentina, and France. But she liked Can Xalant in particular, she says, because she found it very laid-back. At the time I talked to her, she had been working on a "project" which had not started as such, called *Moog*. One night, shortly after coming to Barcelona, she decided to go out on her own, and she ended up going to a club. Once inside the club, she was quite surprised by the way people danced, which was quite different from clubs in Brazil. She was fascinated with the different use of the body, and started to go to that club (called Moog) often. She spent the time looking at the dancers and memorizing their movements. Back at home she would rehearse the movements from memory. Initially, she says, this was not a "project," just something she did for fun. But then she was invited to present a performance, and she decided to perform what

she had learnt at the club: her embodiment of these movements. And she called this piece *Moog*.

As we can see, the projects that Carolina develops also have a component of chance, of encounter with everyday life. Her work is not exactly "site-specific," but many times her projects don't start intentionally, they just reveal themselves as such at the end of the process. Like in Cristina's case (or for that matter Duchamp), what is "work" and what is not eventually only reveals itself in the process of making it.

In the medium term, however, there is one important difference between Cristina and Carolina. The first has almost abandoned her career as an artist, becoming an educator. On the other hand, Carolina is pursuing her career as an artist, applying for grants and residencies, participating in shows, working on further projects. Building a trajectory, she has to demonstrate a purpose and coherence to provide a clear narrative, which can give her work an identity among others. As a result she has to keep producing outputs of her work, in the form of performances, photography, or video of her actions, reports for projects, etc.

In comparison to these personal trajectories, the temporalities and forms of objectification of participative projects may take a very different shape. If we go back to the *We Can Xalant* project we can see this point in more detail. The story of this project is actually longer and more complex than what I presented previously and is in many ways central to the very essence of the art center itself, as a "project."

One of the first works made at Can Xalant in 2005 was a stilt house, the "Xiringuito," made of recycled materials on the center's patio, under the coordination of the Japanese artist Tadashi Kawamata. This was a collaborative event that embodied the spirit of the place: the objective was participation, more than the building itself. But in July 2008, the Xiringuito burnt down; some "pyromaniacs" came to burn the shack with gas. It was not clear who they were; the center is close to an area full of nightclubs, so maybe the pyre made the night for some revelers. In any case the team at Can Xalant didn't seem to be too concerned, they took it as fair play. Their provisional conclusion was that "ephemeral art can't last."

But as time passed, the Can Xalant team thought of building something new on the patio to replace the Xiringuito. This new project was also a response to their concerns in terms of the "diffusion" of the center outside its doors. Up to then, the activity of Can Xalant had focused mainly in the laboratory, which was open to everyone, but the burning of the stilt house perhaps was pointing to the fact that Can Xalant had to work in closer connection with its immediate surroundings; it had to work outside its premises. The project *We Can Xalant* emerged precisely as a response to this concern, with the idea of building a "nomadic prosthesis" of the center.

We Can Xalant was the outcome of a fairly complex network of agents, as is quite common in these cases. Initially, it received funding from Disonancias, a platform "for driving open and collaborative innovation between artists and companies." The original idea was to offer placements for artists in companies which did not necessarily have a relationship with contemporary art, to develop research projects that "enable creative social environments," looking at "creation as a factor of innovation."[6] Disonancias was bringing the discourse of the "artistic model" of work full circle: putting artists to work in an actual context of "innovation." In this case the artists were a77, a collective of architects from Argentina, with Pau Faus, a local architect, and the company was Transit Projectes, which was in charge of the administration of Can Xalant.

Initially, a77 and Pau Faus didn't know exactly what they were going to do. The first few months were spent resolving how to transform the remains of Kawamata's stilt house into a "nomadic prosthesis" and still respect the idea of working exclusively with recycled materials. Then they came up with the idea of putting two abandoned caravans inside the remaining structure, one of which could be still used on the road, while the other would be used as an external room of the center. Caravans don't need to have a license plate or car insurance, and any car can take

Figure 9 *We Can Xalant*, Pau Faus (Pau Faus 2009).

them, so they would be easy to use as a "mobile device." Nevertheless, it took a long time to find two abandoned caravans, restore them and, worst of all, go through the long bureaucratic process of getting the MOT certificate for the caravan that was still in use. Once they had all the permits, they could finally put the caravans into the structure, in a collective process of building similar to Kawamata's original project (Figure 9).

We Can Xalant was, in part, a form of architecture, but of course it also involved many forms of work that didn't have much to do with what an architect learns at school: from restoring caravans, to finding permits, to working in collaboration with a bunch of people to put a caravan on top of an already existing structure. The whole process was collaborative and "transdisciplinary"; it relied less on a clearly outlined project and the professional skill of the artists/architects than on the collective process of learning by working with different materials, places, and situations, in "bricolage" with people and things. It was a research process rather than a project. This "bricolage" was not just a form of "DIY" ("do it yourself") but also of DIWO ("do it with others").

Eventually the caravan became the mobile unity of Can Xalant. It was at the disposal both of the resident artists and of the neighbors' association of the area, for them to use as they wished: for educational purposes, to show films, etc. In 2011, the mobile caravan was also used for a research project, *Camping, Caravaning, Arquitecturing* [sic], a psychogeographic "drift" (in the caravan) through the camping sites of the Mediterranean coast of Spain, to describe their architecture, use of the territory, and the "forms of nomadic life" of these sites.[7]

We Can Xalant was participative in two senses: first the building of the caravan/shack was a collective endeavor; it wasn't made just for the space and the people inside the art center, but was also available to the people outside it, the surrounding neighborhood. It was a gift to all of them, a kind of reverse Trojan horse, from the inside to the outside. The name "*We Can Xalant*" made reference to "Yes We Can" in English, and its politics were also quite clear: creating communities through collaborative processes of construction.

But beyond the project *We Can Xalant*, the use of this "gift," as objectified in the caravan, has taken an unexpected turn. The city council of Mataró decided not to renew the contract of Can Xalant in 2012; that was the end of the "project." The justification was the budgetary cuts of the regional government, but this was clearly also a political decision; the party that came to power in Mataró in the previous year had promised the closure of the center if they won the elections, attending to the protests of some of their conservative voters, who thought that the center produced "nonsense," whereas an art center should be showing painting and sculpture.[8] In spite of the opposition of the local neighborhood association and all the other

political parties in the local council, the new local government closed the center in 2013.

As a result, all the "production" of Can Xalant has become the property of the city council, including the *We Can Xalant* project. The structure on the patio was thrown away, but the caravan was preserved, and has recently been used as an artwork at an exhibition in the center of Barcelona. As I mentioned, the caravan in the show wasn't making direct reference to Can Xalant, or to the *We Can Xalant* project, but to one of the art projects that used it: *Camping, Caravaning, Arquitecturing*. This upset some of the people who were involved in its production, not simply because it made no particular reference to their work or authorship but because it didn't explain what happened with Can Xalant. In other words, the "authors" recognized that this was not simply their "artwork," which as a gift and a device had acquired its own life besides their ideas, but they also lamented that it had ended up being something very different to what they had expected: just a piece of "equipment," furniture for the city council of Mataró, to be kept in its depot.

The caravan of Can Xalant can give us a glimpse of the contradictions that can emerge out of collaborative art projects, in terms of their objectification. The caravan in itself is not simply an object, an artwork with an author or authors, and even less a commodity to be sold in an art market, but a constitutive component of several different assemblages and processes, at different levels: from Can Xalant as an art production center, to specific art projects that use it as a device, like *Camping, Caravaning* … It is also the outcome of a collaborative process of work, a gift to a community or several interrelated communities (from the local community to the artistic community). But as these assemblages and processes implode, as these "projects" are closed, if not finished, the process/device/gift of the caravan is reduced to something else, perhaps much more simple: a piece of public equipment.

CONCLUSION: WORK AND LIFE

In this chapter I have set out to look at what anthropology can say about a very old, but central question in art—what is the relationship between art as a form of work, and life? I started by considering the substantial change in the forms of work in art in the last century, from the production of objects to the "biopolitics of the project," following authors like Groys. I proposed to qualify this transformation by situating it in relation to anthropological discussions of people, things, and time in art, in particular through the work of Gell and Ingold. I emphasized the importance that chance, process, deskilling, and bricolage have in the forms of art practice that emerged in the twentieth century, from the ready-made to participative art,

going back to one of the central questions that I have been discussing all along: the disavowal of agency in art practice, and the search for a reunion of art and life—or in other words, the definition of art as a form of life. I concluded by pointing out how the aim to cancel the separation between work and life may end up being contradicted by the fact that most artistic processes end up being objectified in some form, becoming separated from the flow of the everyday.

These are important points for the next chapter. Artistic forms of work are becoming increasingly influential for anthropologists to understand their own work. The next chapter is dedicated to discussing this influence, and one of the key points is to rethink the relationship between the research process (fieldwork) and its outcomes (ethnography).

7 FIELDS AND LABS

Artists using ethnography as a method are often questioned for their lack of "professionalism." How long did they stay there? Which methodologies did they use? Did they take into account the ethical implications of their work? The artist would be an amateur ethnographer, as opposed to the anthropologist, professionally trained in ethnographic methods.

But frankly, can anthropologists argue for their professionalism without a certain embarrassment? Aren't these the same accusations anthropologists have always directed against themselves, in particular in the last thirty years? Is there such a thing as spending enough time in a place to know it well? What verifiable methodologies, in positivist terms, do anthropologists actually use? And what are their "ethics"? In the end, border hunting often appears as the nervous reaction of those not quite sure of the grounds of their territory.

Wouldn't it be more interesting to turn these accusations upside down, and try to see the apparent handicaps and weak points of ethnography as their strengths? Perhaps there is something anthropologists can learn about anthropology precisely from the way that artists have appropriated it. This chapter starts to close this book by turning the argument towards anthropology itself, looking at how art can inform anthropology, not just as a methodological tool, but in more general terms, in rethinking what constitutes its very work process: how does it proceed, what does it achieve, which are its outcomes. As in the second chapter, I propose to consider this relationship in the long term. Before discussing the changes and innovations in recent ethnography, and how conceptual and participative art practices are being incorporated in anthropology today, we should consider how, all along, since its origins in the early twentieth century, the practice of modern anthropology started from a radical shift in its forms of work, analogous to avant-garde art.

THE PRIMITIVE ETHNOGRAPHER

Ethnography is not only used by anthropologists and artists, but it has also become a very popular "method" among many different forms of social research. It is often presented under the general rubric of Qualitative Methods, as opposed to actual, Quantitative Methods. Of course, the problem of the "qualitative" is precisely that it is based on aesthetics, rather than accountancy: qualities are not accountable, and more importantly, they are not exactly reproducible, since they are immediate experiences. Reproducibility used to be one of the *sine qua non* conditions of scientific method: an experiment made by one scientist should be reproducible by another scientist, to test its results. An ethnography, on the other hand, is not reproducible; there are never two ethnographies produced in exactly the same conditions. To put it in simple terms: one cannot repeat exactly the same social event that happened a year ago in the same way as a scientist in a lab can repeat the same experiment a number of times. This is because the experimental field where anthropologists work is not a controlled site, isolated from the outside, like scientific labs used to be; but it is this very outside, the world of everyday life. The experimental field of ethnography is the field of everyday experience. And this site is totally out of the control of the ethnographer.

Ethnography, or to be more specific, fieldwork, is not just a method—or perhaps we should say, it is something more and something less than a method. Fieldwork, as anthropologists have done it for decades, was not quite a method as scientists understood it in the first place, because its object of research—the field—was totally out of control for the researcher. On the other hand, it was also something more than a method, precisely because its object was not stable; this indeterminacy, serendipity, and improvisation was what was supposed to bring about the "magic" of the ethnographer. As Stocking said, although Malinowski, the mythical father of modern anthropology, tried to formulate the ethnographic method as the "application of a number of rules of common sense and well-known scientific principles" (Malinowski 1978: 6; Stocking 1993: 53) the fact was that

> [...] the fieldwork style he validated was less a matter of concrete prescription or method, than of placing oneself in a situation where one might have a certain type of experience. Like the situations that elicited Trobriand magic, it was one that was initially threatening and could be dangerous, and in which "the elements of chance and accident" often determined success or failure. (Stocking 1993: 58–9)

The magic of the ethnographer consisted precisely in putting these bits and pieces of experience together into a coherent narrative: the ethnography proper, the written

monograph. That is the model upon which generations of anthropologists have been trained. For decades, students of anthropology have been told to take as long as they could in the field. For most of the time, nothing, apparently, would happen, and they would be bored like Malinowski once had been. But then, little by little, the threads of participant observation, which is nothing but everyday life, would come together; the fieldworker would get to know the natives and their language, and by "chance" and "accident" (as a profane revelation, a gift) things would happen—things that the ethnographer would recognize as meaningful events in the life of the field. Of course, chance and accident only appear when they want to, and when one is able to actually recognize the subtle transformations of a given life world in real time—hence the need for patience and time. Contingency (Battaglia 1999) and serendipity (Rivoal and Salazar 2013), making room for the unpredictable, is central to fieldwork; in fact it can be considered one of its main achievements (Strathern 2000: 287). Fieldwork is a "self-driven, multi-stranded and open-ended mode of free enquiry" (Strathern 2000: 284). The result, as many founding fathers and mothers have said, is that the ethnographer doesn't fully know what he will end up discussing; he may come to the field with one project and leave with something different, but more interesting. Malinowski or Evans-Pritchard recognized that they studied the *kula* or Nuer cattle partially *because* that was the main concern of the people they encountered while doing fieldwork. In this sense, students in anthropology have to accept that the field has its own agency, which will ultimately impose itself upon the project of the student, and they have to let go. This is reminiscent of Heidegger's words on the aesthetic experience: we must let what encounters us, purely as it is in itself, come before us in its own stature and worth (Heidegger 1979: 106), as a gift. In these terms, it is very difficult to contain fieldwork within a discourse on the orthodox "project," with clear methods, timelines and objectives; it should be seen rather as an open research process.

In recent decades anthropologists have been questioning the power relations that fieldwork entailed, in which the ethnographer appeared as the agent of colonialism. But this relation of power was always very particular: while they are agents of a superior, external power, and may have very specific forms of knowledge, ethnographers are also peculiar people who put themselves in awkward situations, by trying to speak the local language and ask private or obvious things. The fresh ethnographer is a strangely vulnerable character (McClancy 2005), a kind of "holy fool."

Anthropology professors often humorously said to future ethnographers that fieldwork had more to do with "initiation" than with training. And actually that was quite literally the case, since often the ethnographer-to-be was hardly trained, in any particular sense, to deal with the radical life change that the field may involve. The student was literally "thrown" into the field, with some words of common sense,

told to find the way by himself, to be patient but perseverant, wait for chance and accident, let himself be taken by the field.

The field appears as a trap into which the student voluntarily falls. This may be the path of the hermit, or the saint, more than a technically detailed plan of work whereby the technician is in control of his instruments and resources. As in any initiation, the ethnographer inevitably went through a liminal period, at the end of which he or she was "born again." This process has been described in terms of empathy, mimesis, even "self-othering" (Berliner 2013)—processes of de-identification more akin to theater or spirit possession than experimental science. In situations of radical alterity, in unknown places, hardly speaking a language, the ethnographer was not only a stranger but also strange, at best amusing, asking obvious or embarrassing questions with the stubbornness of a child, perhaps imitating the behavior of their informants with comical accuracy, rather like young people who have just got their first job and are taking their role too seriously (Berliner 2013: 161). Students would enter this process as "patients," powerless and clueless, and hopefully emerge as "agents," as new people, as anthropologists with a knowledge of the culture they have studied and able to engage in intellectual exchange with their colleagues back home. The field as a trap appears then as a dispositive of building anthropologists as social agents.

The emergence of the figure of the ethnographer in the early twentieth century has many things in common with the avant-garde artist. Like the ethnographer, the modern artist left the workshop and the "Academy" to explore the field: the world outside, in particular the streets of the modern metropolis. This context, as opposed to the workshop, was totally uncontained, uncontrollable, "open-ended," driven by chance and accident. Their end was not to make things, so much as letting themselves be taken by the things they found in their way. This encounter was precisely the result of chance—as Duchamp would say, "the thing chooses you"; avant-garde artists did not just abandon the workshop, but their workmanship, their expertise, to start from scratch. As I mentioned in previous chapters, much has been written about the interest of modern artists in "primitive" cultures (primitivism), but that is not the only factor common to modern artists and anthropologists. There is a much more basic parallelism in the very form of working of the anthropologist and the artist, which hardly could be called a method or a skill, since it is based in the very opposite of informed methodology or technical expertise. More than a shared interest in the primitive, what anthropologists and artists had in common was the aim to break with academic expertise, erudition, authority; to be themselves "primitives," looking at things as if for the first time. Malinowski's "Imagine yourself alone on a remote island" doesn't sound very far away from its contemporary surrealist manifestos, in their striving for encounter and the found object. This search

for the primitive in art should not be understood either as a search for the inner creative genius, or "subjectivity" as opposed to the "objectivism" of science, but the immersion in a living world of objective chance, in what Lévi-Strauss called "bricolage." Experimentation, for avant-garde artists like John Cage, started from the opposite principle to scientific experimentation in the lab. Instead of building a closed environment under the control of the scientist or technician, experimentation in art started from opening up and letting things happen—withdrawing the artist's agency and embracing chance. Anthropological fieldwork was experimental in the same terms: as a work of bricolage, built upon contingency and objective chance. Perhaps one could say that the bricoleur of *The Savage Mind* was, first and foremost, the fieldworker.

By the mid-twentieth century, experimental forms of fieldwork like ethnomethodology developed further the performative potential of the ethnographer and fieldwork as a situation of encounter. Beyond participant observation, ethnomethodology proposed participant actions that would not simply offer an accurate representation of reality, but index its underlying rules. Garfinkel's "breaching" experiments worked from the details of everyday life: the ethnographer, as a performer, would produce contradictory situations, to question the attribution of roles and the rules of social relations. We have already pointed out that breaching experiments had many things in common with situationist practices of *détournement*. And like situationism, they were very polemical—for pushing to the limit the methodological and ethical limits of ethnography, and producing situations of discomfort, embarrassment, or even conflict. As a matter of fact, breaching experiments were violent both for the agents and for the patients of the experiment: students being asked to undertake these experiments would often feel extremely wary of their consequences. But one of the central points of "breaching" experiments, in fact, was precisely to work with the vulnerability and the ambiguity of the figure of the ethnographer.

ENCOUNTER AND PARTICIPATION IN FIELDWORK

More recently, George Marcus (2010) has pointed out that the very Malinowskian scene of encounter does not only or particularly define a method, but the aesthetics of fieldwork—in the sense of the imaginary upon which fieldworkers are trained to see themselves immersed (Marcus 2010: 266). But these aesthetics, he contends, should be reimagined, as the contemporary context of fieldwork has changed. Nowadays, anthropologists find themselves doing fieldwork in a world in which the radical shock of alterity and exoticism, the colonial world of Malinowski, has given place to a "common world," near or far in geographical terms but still sharing

some features of what came to be called "globalization" some years ago. In this context, ethnography inevitably becomes multi-sited, insofar as the people whom anthropologists study circulate between different locales. Secondly, the relationship between the ethnographer and the "natives" today may not take the hierarchical form of colonial ethnography, when ethnographers were very often a superior agent of colonial power, while the natives were their colonial subjects. On the contrary, the "natives" of today may be as, or more, powerful than the ethnographer himself, even more academically literate and cosmopolitan. In these conditions, ethnographers cannot impose themselves from above, rather they have to rely on collaborative forms of work, to which the participants bring their own forms of knowledge and expertise.

The new "aesthetics" of fieldwork that Marcus is proposing are more akin to contemporary art practices of collaboration and participation than to the "encounter model" of detached observation that Malinowski was proposing. This collaborative aesthetics would be an experimental practice, not so opposed to scientific practice, as I described it in the previous section. Following the historian of science Rheinberger, Marcus defines experimentation as a machine for making the future that generates unexpected events (Marcus 2010: 276). The ultimate objective of experimentation is to make concrete "epistemic things" that did not exist as such beforehand. Experiments do not simply aim to represent an already existing reality, but in a way they make their own objects (Rheinberger 1997: 32–3).

Another important point in this argument is that experimentation is defined essentially as participative; from the model of the traditional scientific laboratory as a closed space in which human might controls nature to better understand it, contemporary approaches define experimentation as a social process rather than a knowledge site (Corsín 2013: 2). The new "collective experiments," for Latour, are happening outside the traditional laboratories, on us, with us—we are all participating in them (Latour 2011).

In this context, the borders between scientific and artistic experimentation are becoming more blurred. This expanded model of experimentation would not be based only on scientific research labs, but on open software, design labs, medialabs (Rabinow and Marcus 2008), and artistic collaborative practices at large (Marcus 2010). It would not be the product of individual bricolage, the direct confrontation of individuals with the world, DIY (do it yourself), but DIWO (do it with others): collaborative communities that are not necessarily based on a single site, but are organized as a multi-sited network. Corsín and Estadella underscore the centrality of hospitality in this model, as opposed to the radical strangeness and separation between objects and subjects of the traditional "pure" science lab (Corsín and Estadella 2010).

Marcus is making very interesting points, and yet to a certain extent it could be argued that participation, collaboration, exchange, hospitality have been central elements of fieldwork all along (Candea and De Col 2012). Ethnography has always been essentially relational (Woolgar 1997). Early anthropologists like Boas, Malinowski, and Mauss identified "the gift" as their major question; for them this was central to the cultures which they studied, in opposition to a Western model of society dominated by the market and utilitarianism. But they seemed to pay less attention to the fact that collaboration, hospitality, and gift-giving were also central to their task as ethnographers; they were nothing but guests in a strange place. "Participation" in ethnography is not just the outcome of empathy, but a social exchange. Gift-giving, as Mauss would say, is a form of building personal relations, of building society between fieldworkers and their informants. In Battaglia's terms, "ethnographic dialogues stand as model moments of social exchange" (Battaglia 1999: 120). The progressive engagement of the ethnographer in the everyday life of the field, his progressive transformation from a radical other to a friend, a partner or an associate (if it ever happens) is built upon everyday acts of interpersonal exchange, from chatting to exchanges of information, through shared play and commensality, to giving actual gifts on special occasions, etc. In fact it could be said that the theme of gift emerges out of fieldwork not just because it is prevalent in the fields of study of anthropology, but also because it is consubstantial to fieldwork practice itself.

In this sense, Marcus is quite right in pointing out that anthropological fieldwork can't be seen as the solitary encounter of an ethnographer with an exotic world, but a collaborative endeavor in a common world. Reflexive fieldworkers should be aware of the political dimensions of the process they are undertaking; their work is inevitably participative, ethnographic bricolage is a process of "doing with others." And yet perhaps this is not a totally new thing, and the difference between an aesthetics of encounter and an aesthetics of collaboration in fieldwork is relative. As I just mentioned, fieldwork has always been based on exchange, participation, hospitality, and gift-giving. It is clear that gift-giving in early ethnography probably was much more mediated by colonial hierarchies than it is today, but it would also be naïve to think that there aren't significant power relations in contemporary fieldwork. This is, in any case, a recurrent issue in the gift and hospitality. Personal relations and the communities it builds are not necessarily egalitarian, but hierarchical.

On the other hand, one could say that the aesthetics of participation that Marcus is presenting are also ultimately based on encounter. Contemporary forms of participative art depart from a situation of encounter. And the gift is not just an act of participation and collaboration of pre-existing subjects that remain separated, but an event, a situation through which the people and things assembled become something else in relation to each other. The conditions of this situation

of encounter may change, its collective and participative dimensions have become more obvious to ethnographers in recent decades, but nonetheless, it is this very encounter, the formation of a situation, which puts things in motion.

This understanding of the situation is essential to "the emergent quality" (Rabinow and Marcus 2008: 70) or, in other words, the performativity (Law 2002) of fieldwork as an experimental practice. Fieldworkers always create a situation because of their very presence in the field; they always start a process of social exchange and collaboration; they always generate an intervention. The field doesn't exist as such before the fieldwork, but it is a result of the work process started by the encounter between the ethnographer and the place. One could say that, as in twentieth-century art, we have witnessed a progressive disavowal of agency and engagement with chance, from the encounter with objects, through experimentations with performativity, to collaborative work with communities. As a result, in anthropology there has been a growing awareness of fieldwork not just as a method of representation, but as a social situation of encounter with performative effects.

AFTER METHODS: PROCESS AND PROTOTYPE

Beyond the aesthetics of fieldwork, Marcus has also questioned the very research process of ethnography (Marcus 2013). In its classical Malinowskian model, this process is clearly divided into two phases: fieldwork proper, and the "writing up" of the ethnographic monograph. Traditionally, during fieldwork, anthropologists take field notes, gather documentation and "evidence," which then, at a second stage, will become a coherent narrative, a thesis, a book. This is, as Stocking said, the "magic" of the ethnographer. To operate this magic, graduate students are asked to come back from the field to "write up," to be able to have a "view from afar," and join the intellectual discussion among scholars "back home"; in other words, they are invited to abandon everyday life and return to the world of ideas.

This is still the dominant protocol of research practice in most Anthropology PhD programs. But perhaps this model of division of spaces and times is not so easy to maintain, in a context where the field is not so far from academia—not only geographically, but also in terms of the people, cultures, and practices anthropologists engage with. As I mentioned before, "natives" today may be as scholarly trained, cosmopolitan, and often more powerful than anthropologists themselves; they may share many practices and discourses with anthropologists, from writing papers and books, to organizing conferences or working on research projects, to travelling abroad. It would be difficult today to find a place on earth where there are no representatives of international organizations, multinational corporations,

NGOs, academic institutions, pieces of "Global Assemblages" (Collier and Ong 2005) in which the anthropologist is just one more token. The places where anthropologists do fieldwork may share many things with the places where they will present their "evidence." Once again, we could say that perhaps it has always been a bit like that; but we should recognize that this situation has become much more obvious in the last few decades, and it is becoming very difficult for the anthropologist to maintain a "view from afar." In a contemporary context, where the division between "experience" and "experimentation," the world outside and the world inside the scientific lab, seems to be vanishing (Latour 2011), it is much more difficult for the anthropologists to distinguish between the field and academia, taking field notes and "writing up," fieldwork and its outcomes.

In this context, Marcus and others, such as Ingold (2013), have been proposing to think a bit differently on what constitutes the practice of anthropology, or in other words, how anthropologists work, out of the classical Malinowskian model of academic production. Artistic practice often appears as an alternative. For Ingold, as I mentioned in the Introduction, anthropology should not be circumscribed to the "descriptive accuracy" of ethnography, but it should remain an embodied process, rather than a finished document or text. Art practice as an open-ended process would be a model from which anthropologists could rethink their forms of work.

What "outcomes" these processes would have is, perhaps, less clear in Ingold's argument. The question at stake is not simply to replace the written ethnography with an equivalent object of representation (a film, an album, an exhibit ... a painting?), but to understand the research process differently: these "outcomes" can be relatively underdetermined and open. While the "magic of the ethnographer" transforms the "imponderabilia of everyday life" in a defined output, an ethnography, the outcomes of art practice can be less structured: as we have seen in the last chapter, modern and contemporary art has privileged more open or "raw" forms—from the collage and the ready-made to the archive or the participative event, resisting the building of a coherent narrative. Moreover, these partial, "raw" outcomes are part of the research process itself, rather than being produced after the process, and they can be shared with the "field" and then reshaped and transformed by this very event of sharing.

Marcus has argued this point further, engaging with the notion of the "prototype." The concept of "prototype" was already central to Gell's theory of agency: for Gell the prototype is the model to be reproduced by the index (Gell 1998: 25–6). In a recent text, Corsín (2013) has expanded on this notion, borrowing from free software, where "prototypes" are non-stable versions of programs that can be reprogrammed by their users. In free software there is no model to index: prototype and index are the same thing, always in process, with no final object or finished product

but open to be reused, "hacked." In this sense the prototype is not just some thing to be reproduced, but a machine that generates effects, opens possibilities and futures—more an event than an object.

Taking on Corsín's discussion of the prototype, Marcus draws an analogy with the transformations in fieldwork. For Marcus, there are two types of prototype: type 1 is the model that must result in a successful final version, an actual object that can be reproduced as a product (as in the car prototype). But there is another form of prototyping: "prototyping for its own sake, or for the pleasure of social experimentation itself" (Marcus 2013: 3), not destined for the production of a final marketable product. This is the prototyping done in media labs, design schools, and art collectives. And this is the kind of prototyping that could inform anthropological practice, as a mode of analysis that requires constant reformulation and revision, but without the presumption of a final authoritative form. The difference between fieldwork and ethnography, experience and monograph, in terms of time and place, is cancelled.

In these terms, research is presented as a collaborative process open to revision, not only by the researcher but also by those involved in the research, which may no longer be defined as natives, but co-researchers. The interest of this proposal does not only rely on offering new, more open-ended forms of understanding the work of anthropology, but it also proposes to work in a similar way to many of the collectives that many anthropologists are already working with.

The "results" of these processes are often difficult to define as a detached object, or text separated from the process itself, but they have to be seen precisely as transformations or interventions within the process itself. In other words, these "results" should be defined in terms of the changes that are in operation in the field itself, rather than in the representations of the field through textual or other means. Once again, the emphasis here is on the performative effects of fieldwork as an experimental practice, rather than as a form of representation of an already given reality.

If the distinction between inside and outside of the scientific laboratory, experience and experimentation is being questioned, then ultimately we are also questioning the distinction between "experts" and "lay" people, scientific method and social practice. In these terms, fieldwork would appear not just as a scientific method, but as a form of social practice, a form of life.

ETHNOGRAPHIC CONCEPTUALISM

The recent proposal of an "ethnographic conceptualism" starts from a similar point. Ssorin-Chaikov is putting forward this notion partially as a reversal of Kosuth's

definition of the "Artist as Anthropologist" (1975). Art as anthropology, for Kosuth, does not only depict society, but it also alters it; re-appropriating this notion, ethnographic conceptualism would propose a fieldwork that does not only represent reality but that is also a part of its fabrication. "It explicitly manufactures the social reality that it studies and in doing so goes well beyond a mere acknowledgement that we modify what we depict by the very means of this depiction" (Ssorin-Chaikov 2013: 8).

In other words, ethnographic conceptualism puts the emphasis on fieldwork as a form of social intervention, rather than just the representation of a given reality. One could question if fieldwork hasn't always been a form of social intervention, as we have seen; but the analogy with contemporary art practices may still help in exploring this idea further. By re-appropriating the uses of ethnography in art, anthropologists can rethink and engage critically with the performative aspects of their own work. The question is not just what anthropologists can learn from art practice in itself—as in working with visual methods and techniques, being more aware of the senses, being more creative, etc.—but what they can learn from what artists do when they practice anthropology.

Two recent ethnographies show different possible takes on the "conceptualism" that Ssorin-Chaikov is proposing, while making quite clear analogies with the different forms of participative and social practice art we have been describing all along. Felix Ringel's fieldwork on Hoyerswerda, declared Germany's "fastest shrinking city" (Ringel 2013), focused on its process of urban decline. In this context, Ringel's project seems to respond to the traditional Malinowskian call to study peoples and places "on the brink of extinction." But it also focuses on a very common concern in contemporary social practice art: urban decay. Following the example of the latter, Ringel did not just propose to document this process of decay but to intervene in it. Thus, besides traditional forms of ethnographic fieldwork, like participant observation, Ringel participated in the local public sphere, first by writing a column in the local newspaper. His columns often made reference to the abandonment of the public housing projects, remains of the former German Democratic Republic. This gave him a certain public notoriety and helped to start some debates that eventually became an integral part of his fieldwork, in a process he calls "epistemic collaboration" (Ringel 2013: 44). But this notoriety also made Ringel aware of his vulnerability: he became a public figure clearly identifiable with certain political positions. Ringel considers that his vulnerability was quite productive, since it clarified the terms of the debate with the local population. But on the other hand, he also acknowledges that this public exposure did not really result in any particular influence over the local authorities; in fact they ignored his columns, even if they were explicitly critical of local authority policies.

After the publication of the newspaper columns, Ringel organized an "Anthro-camp" for the local youth, in which they were encouraged to explore their home town. The results were surprising, both in terms of the amount of data quickly gathered and the fact that many of the participants discovered aspects of their own town they were not familiar with. The results were displayed in an ephemeral installation in an abandoned block that was going to be demolished. In that same block, Ringel participated in the organization of the *PaintBlock* project, where the local residents were invited to fill the abandoned building with "art, life, and laughter" (Ringel 2013: 48) before its demolition. The objective of these practices was to generate a "new 'knowledge' [...] to be collaboratively produced about the city's present, but this time in the language of art, affect, and emotion. Through these art practices and the many experiences and affects they fostered, the public discourse on shrinkage was once again made explicit and thereby—if ever so slightly—transformed" (Ringel 2013: 49). This transformation operated also in affective terms: "the experience of having used the block one last time made the demolition process—otherwise experienced as bleak, senseless, inevitable, and disempowering—bearable" (Ringel 2013: 51). The final outcome of these interventions therefore was to create a utopian sense of "hope" (ibid.), a shared space of collective identification beyond the confusion of a fragmented present.

Along the lines of social practice art, Ringel's project was aiming to create a utopian sense of collectivity in reaction to a fragmented, dystopian reality. Like many social practice projects, it also generated loads of data, as a result of a collective process of investigation, which were disseminated during the fieldwork itself, following the work process of an open lab, as proposed by Marcus. Similar criticisms can be made of Ringel's project as of many other social practice art projects. But before going into that, it may be interesting to compare it with another instance of "ethnographic conceptualism."

Michal Murawski's *Palaceology* project (2013) is also focused on an urban setting—in this case, a single, but massive, skyscraper: the Palace of Culture and Science in Warsaw, built during the socialist era. This is a very polemical building, identified with the Stalinist past, and although the city doesn't seem to plan on tearing it down, it certainly plans to surround it with a new cityscape, including skyscrapers of a more "contemporary" style—in particular, a residential skyscraper designed by the American architect Daniel Libeskind: a conscious attempt to "defeat" the palace, in the architect's own terms (Murawski 2013: 65).

Murawski's proposal was not only to do fieldwork in the Palace through participant observation, but to actually intervene in the public debate around it. The Palace, with its overwhelming dimensions, casts a shadow over the city. Murawski's initial idea was precisely to embrace this shadow, instead of containing it. First he

sent a proposal to the Palace, called *Palaceization*, based on the concept that the city should "surrender" to the Palace: all new buildings in the city should make reference to the Palace. This "proposal" had some repercussions in the local media, and Murawski took advantage of his new public status to start a blog—*Palaceology*—that was also published in a local newspaper, on issues related to the Palace, which received plenty of comments.

According to Murawski, *Palaceology* "was meant to function as a space of equality, contestation and in some senses symmetry [...] between anthropologist and informants" (Murawski 2013: 70). In the final period of his fieldwork, he organized a series of public meetings designed to provoke discussion on the Palace. Finally, he organized an online survey through the Museum of Modern Art website, asking if the Palace should be torn down. The hosting website received 590,000 hits and the survey was completed 5,000 times (Murawski 2013: 75).

Murawski justifies his explicitly provocative and public approach as a form of reaching beyond the immediate experience of participant observation, but also as a form of actually generating direct explicit reactions—one could say, as a form of testing a given hegemony. In the public meetings, he explicitly addressed the participants as "my natives," asking them to bolster or object to his research findings before the written ethnography was produced (Murawski 2013: 74).

Murawski's and Ringel's projects have many things in common, and also some important differences. They both start with a strategy to gain public projection through the media. They both justify this strategy as an excellent source of information, but also as a form of provoking immediate reactions—explicitly generating their own field of debate, as it were. On the other hand they also acknowledge the drawbacks of this public exposure: it shows in its fullness the vulnerability of the ethnographer, as an outsider, whose provocations may be perfectly ignored by the local institutions.

Both projects seem inspired by the art practices we have been addressing all along in this book. On the one hand, both have relied on collaborative processes of knowledge production, treating the "natives" as co-researchers, resulting in sometimes massive archives. Following Marcus's figures of the lab and the prototype, these collectively produced archives will inevitably remain open, like many art projects; most of this information cannot be contained by the single, authoritative ethnographic monograph. Both projects use methods that explicitly alter, intervene, and provoke the field to happen as an event; not simply to represent it, but to produce it.

But Ringel's and Murawski's projects also have meaningful differences. Ringel responds more literally to the participatory art model, aiming for the construction of a collective micro-utopia against the bleak prospect of urban fragmentation and

decay. Murawski's methods, on the other hand, seem to be tracing the path of the situationists, proposing acts of *détournement* such as turning Libeskind's building into a replica of the Palace. Murawski doesn't appear to envision any hopeful future for the Palace, or aim to create any sense of community, but his position seems plainly critical of—and playful with—the dominant assumptions on the negative legacy and impact of the building. In fact, his methods test the limits of what we could rightly call "collaboration," they seem to be more interested in generating dissent than in building communities. Perhaps his *Palaceology* could be seen as an example of "Artificial Hell" rather than a relational everyday utopia.

In fact, one could say that Murawski's *Palaceology* does not only have many things in common with situationism, but also with ethnomethodological "breaching." And yet, one could say that these practices clearly go beyond the aesthetics of collaboration, but they are rather an aesthetics (and a politics) of direct confrontation and dissent. Perhaps at this point, we should acknowledge that collaboration and intervention do not mean the same thing. Some forms of intervention may not be "collaborative" at all, but openly conflictual.

By today's standards of practice, "breaching" experiments in Anthropology would appear at the very limits of the ethically tolerable. In fact, some of the projects presented as "ethnographic conceptualism" could also be questioned on ethical grounds. Paradoxically, at the same time that "creative" methods are being promoted, the ethical constraints of anthropological practice have become much more strict. At this point perhaps we should make a general consideration of ethics in these new forms of experimental fieldwork.

ETHICS AND AESTHETICS

The growing ethical control of anthropological research in recent years is the result both of many decades of discussion on the power relations established in fieldwork, and a wider, well-justified concern over experimentation with human subjects in the field of the biological sciences. Nowadays anthropologists are asked to supply informed consent from the subjects they will study—even, as is often the case, they have no idea who these subjects will be before starting their fieldwork. Ethics forms ask for a clear definition of the subjects involved before entering the field—first of all, the ethnographer as a moral subject, an isolated "self" (Pels 2000)—which is contradictory to the very premise of fieldwork: subjects are formed through fieldwork as a process, in which the ethnographer is subsumed.

The justification of "ethics" in current anthropological projects must be defined in wider terms, within the hegemonic "biopolitics of the project" that has seized

scholarly practice in recent decades to a much greater extent than art. Scholars, more than artists, are constantly asked to have projects, to write applications, and to get funding. The clear, explicit justification of the ethics of the project, together with the methodology and its rationale, is crucial to the discourse of the project in these fields. And it defines the researcher in relatively different terms from those we have been using here: as a technician in control of his tools (methods); in possession of the appropriate protocols to deal with his subjects, which are predetermined and separated from him (ethics); and with a clear vision of what the results of the process will be (rationale).

Perhaps it is in reaction to the sometimes asphyxiating pressure of methodological and ethical constraints that anthropologists have started to look at the arts as a domain of relative freedom. Artistic practices are perceived by anthropologists as often deliberately transgressing ethical and methodological boundaries. This transgression, for authors like Schneider, is not entirely negative, but it brings forth an artistic form of working that, according to them, should also inform anthropology (Schneider 2012: 65).

Strohm (2012) has addressed this issue directly by questioning the relation between "ethics" and collaborative ethnography. The notion that a collaborative ethnography has to be based on an "ethical" approach, according to Strohm, is grounded on an assumption of inequality, the anthropologist being in a superior position to the informants; the "ethical" approach of the anthropologist in collaborative ethnography would imply helping the informant rise to the same level as the anthropologist. This assumption of inequality, as Strohm argues convincingly, is at the basis of most of the discussion on the "politics of representation" in recent decades. In this model, the social researcher is committed to defend the issues of the people he or she studies, and in the case of the practicing collaborative ethnography, he or she is committed to provide them with the means of representation. But as such, the "ethical" and "collaborative" approach inevitably leaves the "collaborator" in a secondary position: the anthropologist offering the collaboration, "protecting" the collaborator, inevitably reproduces inequality. This presupposition of inequality reduces politics to ethics, being the "collaborators" secondary agents who are placed in the role of giving their "consent" to the ethnographer. In these terms, alterity and the hierarchy between ethnographer and informant are inevitably reinforced. To escape from this loop, Strohm proposes to start from the opposite: what if instead of presupposing inequality, we presuppose equality? What if we take equality as a gift? This is a point that he borrows from Rancière: in Rancière's terms it is precisely this presupposed equality that allows for politics, defined as nothing else but the capacity of subjects to define themselves in a distribution of the sensible. This "equality" is not to be understood simply in terms of an enlightened theory of the psychic

unity of humanity, but more as a *tabula rasa* outside the social division of labor—a *sensus communis* outside a system of classification that presupposes some subjects are "anthropologists" while others are "informants" or collaborators, in a hierarchy where some subjects have the agency or are entitled to declare others "equal" to and/or "different" from themselves. If collective subjects start by defining themselves, they don't need the anthropologist to represent them or to give them the means of representation. And if collaborative anthropology would start from the presupposition of equality, it would also allow for the possibility of dissent, rather than the need to start asking for "consent."

The very notion of "ethics" in fieldwork starts from the presupposition of inequality: the ethnographer and the "natives" are already politically formed subjects that are objectified in a contract, the ethics consent form, that will predetermine the construction of the field. On the contrary, what Strohm is proposing, following Rancière, is that fieldwork situations should be addressed also in terms of the emergence of particular distributions of the sensible, or—as we have said in this chapter—as having performative effects that transform the agents involved. The "collaboration" of these agents is of a more radical kind: they do not simply "consent" to each other's co-presence, they don't just work together, but they participate in their collective construction as social agents.

Strohm finds an example of this form of more radically "collaborative" anthropology in Schneider and Wright's proposal for a dialogue between contemporary art and anthropology. Schneider and Wright don't use Rancière, or discuss the implications of their proposals in terms of a politics of aesthetics, but Strohm argues that their particular take on the collaboration between anthropologists and artists can inform discussions on collaborative ethnography and the politics of fieldwork in general. Schneider and Wright highlight the fact that art practices can challenge anthropology by providing "new ways of seeing," which Strohm reads in very similar terms to Rancière's "distribution of the sensible." First of all, one shouldn't start from the assumption that the anthropologist is the first "agent" in a process of collaboration, but this collaboration should start by leaving aside distinctions between the professional anthropologist and the amateur outsider, any policing of boundaries (Wright 2010: 72). This questioning of the limits between the professional and the amateur is something that anthropologists could learn from artists.

This questioning in itself, for Strohm and Rancière, has inevitable political implications, since it doesn't only propose to amend unequal access to forms of representation, but questions the very presupposition of the division of social labor upon which this inequality is based. The discussion on "ethics" in anthropology should be framed in these larger terms, as a discussion on the questioning of this social division of labor.

PROTOCOLS AND EXPERTS

The questioning of the social division of labor is also at the center of Latour's argument on the "new collective experiments" that configure the world today, where the division between experts and lay people is disappearing:

> We are all embarked in the same collective experiments mixing humans and non-humans together—and no one is in charge [...] Those experiments made on us, by us, for us, have no protocol. No one is explicitly given the responsibility of monitoring them. Who has the power of saying the last word, of deciding for all of us? (Latour 4: 2011)

But the big question then is which are the limits of experimentation? If experts disappear, the protocols and rules that experts established would disappear with them (Latour 2011: 16). There are no limits.

Latour does not have a clear answer to that question; he acknowledges that a new definition of sovereignty is being called for. This new definition of sovereignty should be the outcome of what Rancière would call new "distributions of the sensible," and Latour, new "cosmograms," "a certain division of roles, functions, agencies to human and non-humans" (Latour 2011: 9).[1] In this sense, the problem of the protocols and rules of the new collective experiments is not just a methodological and ethical problem, but a political one. Social experiments are political experiments.

These arguments on equality, social experimentation, and the cancellation of the distinction between expert (ethnographer) and lay people (native) are central to the discussions on the aesthetics of collaboration in fieldwork and "ethnographic conceptualism." In fact, Murawski explicitly defines his *Palaceology* as a space of equality and contestation (Murawski 2013: 7). But at this point we could ask: if anthropological experiments are like art experiments, and in more general terms, like all the other "new collective experiments" that configure our world, what would be their specificity? Once we have started from the presupposition of equality, we have rejected the social division of labor, we have treated the informants as co-researchers, how are these projects closed, objectified, what comes after? Ssorin-Chaikov explicitly asks the question: "Does ethnographic conceptualism similarly mean the end of the distinct activity of ethnography?" He answers negatively. Just like in the case of art practice, the participative process may be one thing, while the work of art that may come out of it may be a very different thing—in some cases, a thing with a single author. On the side of anthropology, these "ethnographic conceptualism" research projects have not ended with fieldwork, but they have

moved to a second stage, in which both ethnographers have written a dissertation at a very important and prestigious university, a dissertation of their authorship, and which has given or will give them access to a professional career in that field. Just like in the field of art, where there is tension between the autonomy of art as an institution and the dissolution of art in everyday life, or autonomy and heteronomy, so is the case in anthropology: the proposal to subsume fieldwork in processes of collective and participative knowledge does not result in canceling the "autonomy" of anthropology in a second movement; anthropologists still write monographs to obtain their professional degrees, to become integral members of the autonomous realm of their discipline. Replacing the monograph with any other forms of "output" that could be legitimate forms of obtaining recognition—for example, films, exhibitions, etc.—would not substantially challenge this institutional structure, but on the contrary, it would only reinforce it, by making it appear more creative, more innovative, but always within reason.

So in spite of the new collective experiments, the new distributions of the sensible, the claims to the abolition of the division of social labor, there are still separate spheres of practice, domains of expertise and representation. Is the regime of representation, both in art and anthropology, still here with us? What is happening with these "new collective experiments"?

8 ETHNOGRAPHY AND UTOPIA

UTOPIA

Enthusiasm[1] was a collaborative art project between the artist Claudio Zulian, the Bolit art center and the citizens of Salt in Spain, a working-class town mostly inhabited by immigrants (Figure 10). The project resulted in an exhibition, where a film was shown. But the film wasn't a documentary on the social facts of poverty and immigration, as could be expected of a "social practice" art project. Instead, Zulian proposed to write a work of fiction in collaboration with the participants. The script turned out to be something like a science fiction movie, in which people from the future come to the present to explain how things are going to be in a thousand years from now.

And how are things going to be then? To start with, there will be no money; and yet people will live in abundance and luxury, not in scarcity like today. And that is not because of superior technologies or the control of nature, but due to a shift in our understanding of what it means to live in common: their society is not based on need, but on desire; resources are not scarce but plenty, since they are not products of a limited nature, but the outcome of human imagination, which has no limits.

The visitors from the future explained all these things in the closing ceremony of the exhibition, which turned out to be also the closing ceremony of that art center, Bolit. Due to the "crisis," "scarce resources," "inevitable budgetary cuts," the direction of the center was changing. But as in many other cases, these "inevitable budgetary cuts" were clearly a political option: the direction of the center changed following a political change in the local government. Such has been the situation in many art centers, cultural and educational institutions in the last years, not only in Spain. We have already mentioned the case of Can Xalant.

During the summer of 2013, a77, the same team that built We Can Xalant, developed a similar project at MoMA PS1 in New York, the mother of all art production centers. The *Colony*[2] filled PS1's courtyard with caravans inviting artists, architects, scholars, and other cultural agents to live and work communally. *Colony*

Figure 10 *Enthusiasm* (Claudio Zulian 2012).

was not a conventional exhibition, but it stressed process over product, the collective versus the individual; its objective was not the "Colony" itself, but to create a device that generated more questions than answers, questions like: How to find alternatives for future housing and use of public space? Which are the rules of collective life? Or in Bruno Latour's terms (2011), which protocols do the new collective experiments require?

In their authors' words, *Colony* was inspired both by refugee camps and the romantic utopia of the common life. In a way it projects a scenario that is both utopian and post-apocalyptic: how to recompose a common world after the flood, after the crisis. Maybe, its authors say, art centers like PS1 and Can Xalant are the last refuge of utopia.[3]

MICRO-UTOPIA

Is art the last refuge for utopia? This statement has been flying around this book since its first chapters, when I discussed Bourriaud's notion of everyday micro-utopias. What would be a micro-utopia? Let me address this question by making a little detour to classical anthropological theory. According to Viveiros de Castro, Lévi-Strauss once defined art as the ecological reserve of the savage mind in the modern world (Viveiros de Castro 2002: 489). The modern artist would be the bricoleur of our times, a modern "primitive," as opposed to the professional

specialist, the "engineer"; for art makes people out of things, instead of things out of people. Extending on this vision, we could say that art builds social relations through gifts as opposed to commodities; it works through bricolage, playing with the given elements of the world through objective chance, instead of imposing a rational project over the world. This savage mind, some would say, is not just what we once were, but also a promise of what we should be. The aesthetic utopia contains a promise of liberation, a form of life that is not based on work but on play, social relations rather than the material production of commodities.

In *The Savage Mind*, Lévi-Strauss said something more about art. The work of the artist, for Lévi-Strauss, is always a "small-scale model" (Lévi-Strauss 1966: 23), not simply in the sense of size, but in the more general sense of being made in proportion to its maker; "the model being an artifact, it is possible to understand how it is made and this understanding of the method of construction adds a supplementary dimension" (1966: 24). In other words, by making artifacts as reduced models of the world, artists gain a knowledge over it. We could take this notion of the "small-scale model" a bit further, to understand the "micro-utopias" we have been discussing all along. We could understand these micro-utopias, precisely, as small-scale models of a possible society. After all, what is a utopia if not a theory that projects itself onto the future? Or one could say, a prototype (Corsín 2013), a reduced model of a possible world, a research process that proposes to imagine the social in different terms; perhaps still imprecise and unstable, subject to revision, but which still contains the promise of a different future.

But at this point there seems to be a contradiction, which I already pointed out in reference to Bourriaud's vision of relational aesthetics: if utopias take refuge in art spaces, are they still political projects? Wasn't the final objective of the aesthetic utopia to abolish the distinction between art and life, representation and practice, inside and outside? The "new collective experiments" that Latour presented start precisely from that point. Latour emphasized not only the overcoming of the distinction between inside and outside, representation and practice, science (or art) and politics, a realm of experimentation and a realm of experience, but also a questioning of the authority of experts over non-experts. This new reunited reality would take the form of a "technical democracy" (Callon, Lascoumes and Barthe 2011) as opposed to conventional "representative democracy," based on the separation of spheres, and the "representation" between them. For Latour, Europe (the European Union) would be a good example of this new technical democracy, as a "real time experiment" (Latour 2011: 17). The European Union would be the real-time enactment of a utopian project, beyond the autonomous spaces of art and science.

CRISIS

And yet a decade after Latour wrote this (originally in 2002), the European experiment is taking a different form from what he envisioned. After the sovereign debt crisis of 2010, the European "collective experiment" has been clearly taken under the control of experts, who have replaced democratically elected governments with "technical" governments, reinstating the distinction between politics and technique, or worse, reinforcing it by imposing the primacy of the latter over the former. These experts have been experimenting with entire populations, inflicting their models without asking for "informed consent," using the exact arguments that Latour once ironically mentioned:

> [I]f experts and modernists reply that there is "one world" only and that we have "no choice" to live in it or not, if they try to shame us because we are "risk averse", then let them conclude as well that there is no politics left any more. Once there is no choice or alternative, there is no Sovereign. It is as simple as that. (Latour 2011: 17)

Well, exactly—that is the process that Europe has been living through in the last few years, an evacuation of politics and sovereignty, replaced by the rule of experts, who not only test their knowledge but enforce it, in a state of exception justified by the sovereign debt crisis. Their experiment, it is true, is no longer confined to the lab; the whole world outside is their lab. But this has not brought about a leveling between insiders and outsiders, experts and the public, but on the contrary it has just enabled experts to engage in real-time experiments under their direct control but without the need to engage in any democratic process, entrapping the world in their models. This is clearly a dystopia, rather than a utopia.

In direct contrast to the general dystopian experiment of the "crisis" that reinforces the role of experts, in the last few years we have witnessed the emergence of several counter-experiments, which explicitly address Latour's question, proposing new definitions of the sovereign; events or "movements" like Occupy or 15-M in Spain. The 15-M movement took its name after 15 May 2011, a day in which several demonstrations in many Spanish cities ended in the active permanent occupation of central squares. These demonstrations were not led by parties or trade unions, but by horizontal, ad-hoc platforms, like *Democracia real Ya!* (Real Democracy now!). The movement was generally identified by the media as the "Indignados," the "Outraged." The occupations were clearly inspired by Tahrir Square and the Egyptian revolution, and they would yet be very influential on the Occupy movement in the USA some months later. The biggest occupation camps were in

Plaza del Sol, in Madrid, and Plaça Catalunya, in Barcelona. 15-M appeared in the media as a participative, inclusive, peaceful, colorful movement, with slogans for democracy and civil rights, and against corruption, the banks, and partitocracy, which could be shared by many, and it quickly attracted people from all walks of life. It was quite successful on that front: at its height, the sympathy for the movement, according to polls, reached around 70 percent of the Spanish population (Llobera 2012). But the movement didn't have a leadership or program, it wasn't based on any explicit ideology, and it never became organized as a political party. In fact the term that ended up identifying the movement was the acronym of its date of birth: 15-M.

15-M is a clear example of politics in Rancière's sense, a new "distribution of the sensible," "a collective of enunciation" (Hernandez-Navarro 2011; Papastergiadis and Esche 2013), or in Latour's terms, a collective experiment proposing new cosmograms, new definitions of the sovereign (Latour 2011). From their very beginnings, movements/events like 15-M and Occupy had the intention not just to organize a confrontational protest, but to create a space of direct democracy, a "constituent" model of how things could work differently. In other words, they were enactments of a possible utopia, a "prototype" of a projected society based on "real democracy." Many of the forms of organization and participation in the 15-M or Occupy assemblies, from the conscious use of images, to the attention to exchange and deliberation procedures, to the ephemeral architectures built on the squares, had many things in common with the artistic "micro-utopias" that we have been discussing in this book. In fact, the director of the Museum of Modern Art in Madrid (MNCARS), Manuel Borja-Vilell, defined 15-M as the most important work of art of the year 2011 (Borja-Villel 2011).

But it is ridiculous to propose that 15-M or Occupy were simply forms of participative or social practice art. Rather they were made by similar kinds of people (in some cases the same people) sharing similar concerns and ways of understanding politics, and coming from the same culture of activism. 15-M was precisely about the presupposition of equality; canceling the division between experts and lay people, art and life, artists and non-artists. These were not micro-utopias in a protected space, but universal utopias, political projects seeking the transformation of the social as a whole.

POST-CRISIS

What has happened since? At least in Spain, many of the 15-M assemblies abandoned (or were kicked out of) the squares, and dissolved into neighborhood assemblies to

work on specific issues, in particular around housing and real estate, for example by "occupying" local neighborhood spaces. For example, the local Assembly of Eixample, one of the central districts of Barcelona, has occupied the last empty plot in the neighborhood. This occupation, however, has not been imposed on the local authorities, but has been the result of a negotiation with the city council, through the project *Re-creating Crossroads (Recreant Cruïlles)*,[4] which has been given authorization to manage the plot for five years. This project has the support of Idensitat, an art platform that promotes art working on specific territories. In the past few years, one of the focuses of the platform has been to establish partnerships with citizen movements in Barcelona. In this particular case, Idensitat has developed what they have called "Post-devices," artistic interventions and collaborations that propose social models for a future beyond the economic crisis.[5] Idensitat got funding for this project through a European network, Eclectis, "a European cooperation project, aiming at implementing an innovative structuring European process to favor citizens' integration in the urban making, valuing European diversity, intercultural dialogue and new technologies as sources to stimulate creativity and new practices."[6]

Once again, in this case we find a complex assemblage of "projects," communities, and devices, at different levels: from the local neighbors who want to reappropriate the city in their own terms, to artists interested in developing devices of social transformation, to local authorities which may be disposed to share the management of the city, but also take tactical advantage of these participatory movements to manage spaces they can't assume as a result of funding cuts and scarce resources. All this is covered under the general umbrella of a European project, with the objective of stimulating the "creativity" of European citizens to take responsibility for their cities, promoting citizens' agency. Like many of the projects we have seen before, it appears as a multiple "trap," a field of engagement at different levels, with contrasting claims. The different collectives engaged in these processes—or "stakeholders," to use the grim managerial terminology often deployed in European projects—are surely aware of these risks and ambiguities. If we look at these experimental processes as traps or devices, the question is not so much whether they achieve their original objectives, but how these processes will transform the "stakeholders" themselves. As the project evolves, different actors in the local community, which emerged initially as a spontaneous, free, and egalitarian assemblage of neighbors, are becoming more organized, more specialized: some are better at dealing with the authorities, some at working in the garden, some at organizing parties, while others are better at leading demonstrations, and others still at applying for funding. In these terms, a hierarchy of practice is inevitably established, beyond the egalitarian ideals that constituted it.

In fact, these "post-crisis" devices seem to have a lot of things in common with some of the artistic devices we have discussed previously. But what may be interesting

is that these "micro-utopias" are not circumscribed to art spaces or artists. In the last few years, new transversal networks between different collectives have been formed, going much further than the closed spaces of art. *Recreant Cruïlles* is a good example of that: it is also an art project, but not just, or not mainly; mostly, it is a citizenship project.

On the other hand, the discourse of "participation" is also actively used by the institutions that these very practices are questioning. "Participation" hasn't been abandoned by governments after the crisis; on the contrary, it has become a general model of governmentality. The political discourses of a "participation society" or the "Big Society" seem to dominate Europe today, at least in theory defending the empowerment and participation of citizens in society. In any case, after the crisis, it has become clear that this "participation society" has come to replace previous forms of governmentality based on the welfare state; it's only bringing forward a radicalization of the neoliberal policies that were already in place before. The term "participation" is only used as a euphemism to justify the primacy of something very different from what it used to mean—perhaps it means, simply to be a part of society as a market.

In these terms, is there any possible middle ground, any room for negotiation between the ground-up, local communities that have emerged from the crisis and the new forms of "participation society" imposed from above? It seems difficult, but it is still too early to say. But the overarching machinery of our big collective experiment, "Europe," with its "European projects," seems to work in this direction.

In the same terms, the "lab" as a metaphor for the new forms of the social hasn't disappeared either; on the contrary, it is still growing: fabrication (fab) labs, citizen labs, living labs, keep on appearing, replicating, and networking throughout. Barcelona, as a whole city, has been designed as a "living lab,"[7] an open innovation ecosystem. At the basis of all these "labs" there is a common aim to foster user-centered open innovation by empowering citizens to contribute with their "creativity" and "innovation." Rather than art, these participative processes seem inspired by IT and design. Still, the question one could pose concerning this multiplication of labs is to what extent the "collective experiments" they undertake are really at the service of the public, or if the public is at their service: in other words, if they are really collective, or if they are designed to extract "creativity" and "innovation"—whatever that means—from everyday life and turn it into a marketable product. The omnipresent "transparent lab" looks like an extended version of the "transparent factory" we mentioned in previous chapters, where work is taken beyond the walls of the space of production to transform everyday life in productive and marketable activity. Its new incarnation, the "transparent lab" turns everyone into a collaborator in a collective experiment that ultimately will generate products and outcomes beyond their control. If everything is a "lab," if the lab is everywhere, are we all

experts, are we all equals engaging in a democratic process, or are some of us just experimental subjects? Are these experiments really "with us" or simply "on us"? That is not so clear. Perhaps we should leave room for hope, and expect that all the energy that has emerged from the collective counter-experiments of the last few years is not reabsorbed by the new devices of the "participation society."

In the end, where is anthropology left in this landscape? The last chapter has given some hints in answer to this question, but to conclude the book, we should make it a bit clearer.

ANTHROPOLOGY AND UTOPIA

Ethnographies, like artworks, could also be seen as reduced models, which resize a world to a human scale. These reduced models sometimes can take the form of a micro-utopia. For David Graeber (2004: 12), there is always a utopian component to anthropology, a call to think beyond or alternatively to our immediate here-and-now. How to think a society not based upon utilitarianism and profit? How to think the person in different terms from the bourgeois individual? How to think our relation with the world besides the dichotomy between nature and culture? etc. ...

The commonality between art and anthropology does not start simply from a common interest in "other cultures," but from a common interest in rethinking its own reality from a different point of view. Searching for this different perspective, avant-garde artists and anthropologists left their studios in academia to encounter the "field" of social practice, both in faraway places and in everyday life. In both cases, the encounter with the field came with a rejection of previously acquired forms of academic knowledge and techniques in order to start from scratch, letting oneself "be taken" by the field. Anthropology, like art, can be seen as the "ecological reserve of the savage mind." And the field of social practice emerges as an event of encounter, a dispositive that does not only represent a preexisting reality but performs a new, possible world.

Fieldwork in anthropology and art inevitably led to the (re)-discovery of the "gift": a form of exchange dedicated to the construction of social relations instead of the production of objects, making people out of things instead of things out of people. In the gift, artists and anthropologists have encountered the proof and promise of a different form of life. The potlatch, in particular, was for the situationists a prototype of the society to come, the future affluent society. The utopian promise of art and anthropology seems to remain always suspended at the level of possibility; but as Rancière says, it is precisely by imagining possibilities, alternatives, new distributions of the sensible, or we could say, by building devices and prototypes, that politics begins.

But these utopias sometimes run the risk of turning upside down, and becoming dystopias. Anthropologists have also found the dark side to the gift: hierarchy and obligation. Many artists have used participatory practices and everyday life in general as "form," one more resource, a source of raising their fame and reputation in the art world, rather than turning art into everyday life. Further than that, many of these practices have been actively reappropriated by the very society and institutions they were questioning: surrealist and situationist practices were reappropriated by the culture industries. Participatory art practices have become tools to manage communities, collective political experiments have been used to transform citizens into economic assets. In the same terms, anthropology has been actively used as a tool to research markets, and in the current landscape, it runs the risk of becoming a factory of "experts" in identifying field sites as "ecosystems of innovation," populations with "creative" potential to be integrated into "collective experiments," and then open the path to other "experts" who harvest the "creativity" and "innovation" of these fields. Alternatively, if the situationist revolution finally comes to be, anthropology, like art, will disappear as a discipline, along with its experts, and it would become just one of the things that everyone can do in their daily life—as, in fact, it has always been. In any event, we are in the middle of a process of creative destruction, as marketing gurus like to say. Its outcomes are still difficult to foresee.

NOTES

1 INTRODUCTION: AFTER THE ETHNOGRAPHIC TURN

1 http://www.fundaciotapies.org/site/spip.php?rubrique488 [last accessed 21/7/2013].

2 http://todaslasplantasdelbarrio.wordpress.com/ [last accessed 21/7/2013].

3 http://psumuseummuseum.blogspot.com.es/2010/03/felix-González-Torres.html/ [last accessed 7/7/2013].

4 http://www.artandculture.com/users/5-rirkrit-tiravanija [last accessed 2/2/2013].

5 http://www.brooklynrail.org/2004/02/art/rirkrit-tiravanija) [last accessed 2/2/2013].

2 ART AS ANTHROPOLOGY

1 For an interesting and comprehensive selection of readings on this relation, see Enwezor (2012).

2 To define Bataille and *Documents* as surrealist is contentious, both for the surrealist orthodoxy led by André Breton and for Bataille himself, who would define his approach as "low-materialist." Bataille was certainly taking a much more radical approach than Breton on a range of issues, not least sexuality (Deliss 1992). Bataille was also more clearly interested in history and the social sciences than the visual arts, and he was more influenced by ethnology than psychoanalysis. Still here, following Clifford (1988), we take "surrealism" as a general umbrella term that defines the spirit of theorists and artists at that time and place, including Bataille, Breton and even Benjamin. The objective of this book is not to point out the differences between authors and cliques; here we are just interested in how the work of several of them can be read alongside anthropology.

3 Duchamp 1961; see also De Duve 1994: 72.

4 "I'm not responsible. It was made, I wasn't the one who made it. There is a defense: I object to responsibility" (Cabanne 1971: 48).

5 Interview with Jean-Jacques Lebel, http://vimeo.com/7728449 [last accessed 28/5/2014].

6 "The bitter victory of surrealism," *Situationist International* 1, 1958, http://www.cddc. vt.edu/sionline/si/bitter.html [last accessed 2/1/2014].

7 Situationist Manifesto, *Internationale Situationniste* #4 (June 1960), http://www.cddc. vt.edu/sionline/si/manifesto.html [last accessed 4/1/2014].

8 *Theses on the Cultural Revolution*, 2, http://www.bopsecrets.org/SI/1.cultural-revolution.

htm [last accessed September 2011].

9 Jorn, Asger (1960), "The end of the economy and the realization of art," *Internationale Situationniste* #4 (June 1960) http://www.cddc.vt.edu/sionline/si/economy.html

10 See Debord, Guy, "The role of potlatch, then and now," in *Potlatch* #30 (July 15, 1959) http://www.cddc.vt.edu/sionline/si/potlatch.html

11 See Debord, Guy, "A user's guide to détournement" at http://www.bopsecrets.org/SI/detourn.htm [last accessed 14/7/2013].

12 Debord, Guy (1955), "Introduction to a critique of urban geography," in http://library.nothingness.org/articles/SI/en/display/2 [last accessed 10/7/2013].

13 Abdelhafid Khatib, "Attempt at a psycho-geographical description of Les Halles," *Internationale Situationniste* #2 (December 1958). http://www.cddc.vt.edu/sionline/si/leshalles.html [last accessed 2/1/2014]. Many years later, Rumney published *The Leaning Tower of Venice* as an art book "photonovel" (Rumney 2002).

14 "Venice has vanquished Ralph Rumney," *Internationale Situationniste* #1 (June 1958) http://www.cddc.vt.edu/sionline/si/venice.html [last accessed 14/1/2014].

15 See www.francisalys.com

3 TRAPS AND DEVICES

1 Post in the Memetro Facebook page, 27 January 2014.

2 http://a-desk.org/highlights/En-Santa-Monica-el-dilema-es-otro.html [last accessed 6/7/2014].

5 PARTICIPATION AND THE GIFT

1 Besides Bourriaud's influential work, some exhibits and publications of the period made a very significant contribution to this debate, as we will see throughout this chapter: essentially Marianello, Risaliti, Somaini (eds) (2001) and Purves (ed.) (2004).

2 www.wochenklausur.at/ [last accessed 31/5/2013].

3 http://www.santiago-sierra.com/200709_1024.php [last accesed 10/2/2104].

4 Daniel B. Smith (2008), "What is Art For?" *New York Times Magazine*, November 16, 38.

5 Besides the authors I will make reference to in this section, some of the main readings of Mauss's work are Godelier 1999, Hart and James 2013, Laidlaw 2000, Lévi-Strauss 1987, Parry 1986, Sahlins 1972, Skyes 2005.

6 WORK AND LIFE

1 'L'art moderne [] refuse de considérer comme séparés le produit fini et l'existence à mener. Praxis égale *poiesis*. Créer, c'est se créer" (Bourriaud 1999 : 13).

2 Personal interview, June 2012.

3 Idem.

4 Idem.

5 Personal interview, June 2012.

6 http://www.disonancias.com/es/ [last accessed 27/3/2014].

7 http://vimeo.com/32586846 [last accessed 19/7/2013].

8 See http://www.capgros.com/opinio/detall.asp?id=3966 [last visited 19/7/2013].

7 FIELDS AND LABS

1 Granted that there is a fundamental difference between the two; Rancière, as we have seen before, would not include non-humans into the equation.

8 ETHNOGRAPHY AND UTOPIA

1 http://www.acteon.es/contenido.php?catid=2&conid=96 [last accessed 6/7/2014].

2 http://estudioa77.com.ar/?portfolio=colony; see also http://www.momaps1.org/expo1/module/colony/, www.domusweb.it/en/architecture/2013/06/26/constructive_action.html [all last accessed 19/7/2012].

3 http://estudioa77.com.ar/?portfolio=colony [last accessed 19/7/2012].

4 http://recreantcruilles.wordpress.com/ [last accessed 17/3/2014].

5 http://www.idensitat.net [last accessed 17/3/2014].

6 http://www.eclectis.eu/ [last accessed 17/3/2014].

7 http://barcelonalab.cat/ [last accessed 18/3/2014].

BIBLIOGRAPHY

Agamben, G. (2009), "What Is an Apparatus?," in *What Is an Apparatus? And Other Essays*. Stanford: Stanford University Press.

Alliez, E. (2010), "Capitalism and Schizophrenia and Consensus: Of Relational Aesthetics," in S. Zepke, and S. O'Sullivan (eds), *Deleuze and Contemporary Art*. Edinburgh: Edinburgh University Press, pp. 85–99.

Althusser, L. (1971), *Lenin and Philosophy and Other Essays*, Monthly Review Press.

Appadurai, A. (1988), *The Social Life of Things*. Cambridge: Cambridge University Press.

Ardenne, P. (2002), *Un Art Contextuel*. Paris: Flammarion.

Arnaut, K. (2001), "A pragmatic impulse in the anthropology of art? Gell and semiotics," *Journal des africanistes*, Vol. 71, Numéro 2 pp. 191–208.

Arnold, M. (1869), *Culture and Anarchy: An Essay in Political and Social Criticism*. Cambridge: Cambridge University Press.

Barbrook, R. (1999 [1998]), "The High-Tech Gift Economy," in J. Bosma (ed.), *Readme! Filtered by Nettime. ASCII Culture and the Revenge of Knowledge*, New York: Autonomedia.

Bataille, G. (1993 [1949]), *The Accursed Share (La Part Maudite)*. New York: Zone Books.

Bataille, G., Waldberg, I., and White, I. (1995), *Encyclopaedia Acephalica: Comprising the Critical Dictionary & Related Texts*. London: Atlas Press.

Battaglia, D. (1999), "Towards an Ethics of the Open Subject: Writing Culture in Good Conscience," in H. Moore (ed.), *Anthropological Theory Today*. Cambridge: Polity Press.

Baumgarten, A. (1954), *Reflections on Poetry: Alexander Gottlieb Baumgarten's Meditationes Philosophicae de Nonnullis ad Poema Pertinentibus*. Berkeley: University of California Press.

Belting, H. (2011), *An Anthropology of Images: Picture, Medium, Body*. Princeton: Princeton University Press.

Bennett, J. (2005), "In Parliament with Things," in L. Tonder and L. Thomassen, *Radical Democracy. Politics Between Abundance and Lack*. Manchester: Manchester University Press, pp. 133–48.

Bergquist, M. and Ljungberg, J. (2001), "The power of gifts: organizing social relationships in open source communities," *Information Systems Journal* (11)4: 305–20.

Berliner, D. (2013), "Le désir de participation ou comment jouer à être un autre," *L'Homme* 206: 151–70.

Bertolino, G. (2002), "Realisez Potlatch," in G. Marianello, S. Risaliti, and A. Somaini (eds), *The Gift, Generous Offerings Threatening Hospitality*. Milan: Charta.

Beuscart, J.-S. and Peerbaye, A. (2006), "Dispositifs," *Terrains & Travaux*, No. 11.

Bishop, C. (2004), "Antagonism and relational esthetics," *October* 110 (Fall): 51–79.

—(ed.) (2006), *Participation*. Cambridge, MA: MIT Press.

—(2006), "The social turn: collaboration and its discontents," *Artforum* (February): 178–83.

—(2012), *Artificial Hells: Participatory Art and the Politics of Spectatorship*. London and New York: Verso.

Boileau, N. (2008), *The Art of Poetry*. Richmond: London House.

Boltanski, L. and Chiapello, E. (2005), *The New Spirit of Capitalism*. London: Verso.

Boltanski, L. and Thevenot, L. (1991), *De la justification. Les économies de la grandeur*. Paris: Gallimard.

Borja-Villel, M. (2011), "Puerta del Sol Madrid," *Artforum* (December).

Bourdieu, P. (1984), *Distinction: A Social Critique of Judgement*. Cambridge, MA: Harvard University Press.

—(1993), *The Field of Cultural Production*. New York: Columbia University Press.

—(1996), *The Rules of Art: Genesis and Structure of the Literary Field*. Cambridge: Polity Press.

Bourriaud, N. (1999), *Formes de Vie. L'art moderne et l'invention de soi*. Paris: Denoel.

—(2002), *Relational aesthetics*. Dijon: Les Presses du reel.

—(2005), *Postproduction*. London: Lukas & Sternberg.

—(2009), "Precarious constructions," *Open* 17.

Breton, A. (1937), *L'amour Fou*. Paris: Gallimard.

Buck-Morss, S. (1992), "Aesthetics and Anaesthetics: Walter Benjamin's Artwork essay reconsidered," *October* 62, pp. 3–41.

Burch, N. (1986), "Primitivism and the Avant-Gardes: A Dialectical Approach," in P. Rosen (ed.), *Narrative-Apparatus-Ideology*. New York: Columbia University Press, p. 491.

Buskirk, M. (2003), *The Contingent Object of Contemporary Art*. Cambridge, MA: MIT Press.

Cabanne, P. (1971), *Dialogues with Marcel Duchamp*. London: Thames and Hudson.

Caillé, A. and Godbout, J. (2000), *The World of the Gift*. Montreal: McGill University Press.

Calle, S. (2007), *Double Game*. New York: D.A.P. Violette editions.

Callon, M. (2006), "What does it mean to say that economics is performative?," *CSI Working Papers*, series no. 5. Ecole de Mines, Paris.

Callon, M., Lascoumes, P., and Barthe, Y. (2011), *Acting in an Uncertain World: An Essay on Technical Democracy*. Cambridge, MA: MIT Press.

Candea, M. and De Col, G. (2012), "The return to hospitality: strangers, guests, and ambiguous encounters," *Journal of the Royal Anthropological Institute*, Vol. 18, No. Supplement s1: Siii–Siv, S1–S217.

Carrier, J. (1995), *Gifts and Commodities. Exchange and Western capitalism since 1700*. London: Routledge.

Clark T. J. and Nicholson-Smith, D. (1997), "Why art can't kill the situationist international," *October* 79 (Winter): 15–31.

Clifford, J. (1988), *The Predicament of Culture. Twentieth Century Ethnography, Literature, and Art*. Cambridge, MA: Harvard University Press.

Coles, A. (ed.) (2000), *Site-Specificity: The Ethnographic Turn*. London: Blackdog Publications.

Collier, S. J. and Ong, A. (eds) (2005), *Global Assemblages: Technology, Politics and Ethics as Anthropological Problems*. Oxford: Blackwell.

Coote J. and Shelton, A. (1992), "Introduction," in *Anthropology, Art and Aesthetics*. Oxford: Oxford University Press, pp. 1–11.

Corsín Jiménez, A. (2013), "Introduction: The prototype: more than many and less than one," *Journal of Cultural Economy*, (forthcoming): 1–18.

Corsín Jiménez, A. and Estalella, A. (2010), "The prototype: a sociology of abeyance," available from http://limn.it/issue/00/ (accessed).

Corsín Jiménez, A. and Lafuente, A. (2010), "Comunidades de afectados, procomun y don expandido," *Fractal* No 57 (April–June): 17–42.

Cox, G. (2010), *Antithesis: The Dialectics of Software Art*. Aarhus: Digital Aesthetics Research Center.

Crear, K. (2012), "The Material Lives and Deaths of Contemporary Artworks." Doctoral thesis, Goldsmiths University of London.

Crehan, K. (2012), *Community Art: An Anthropological Perspective*. Oxford: Berg.

Crow, T. (1998), *Modern Art in the Common Culture*. New Haven: Yale University Press.

Danto, A. (1988), "Artefact and Art," in *Art/Artefact: African Art in Anthropological Collections*. Exhibition Catalogue: New York, Center for African Art & Prestel Verlag.

Dardanyà, P. (2013) "Artes de pesca: Apropósito de la muestra 'Un dilema. El arte contemporáneo y la inversión en la incertidumbre.'" http://blog.transit.es/artes-de-pesca/ (last accessed July 6, 2014).

Davies, W. (2007), "Abducing the Agency of Art," in R. Osborne and J. Tanner, *Art's Agency and Art History*. Oxford: Blackwell, 199–219.

Debord, G. (1958 [2006]), "Report on the Construction of Situations and on the International Situationist Tendency's Conditions of Organization and Action," in K. Knabb (ed.) *Situationist International Anthology*. Bureau of Public Secrets.

—(1970), *Society of the Spectacle*. Detroit: Black And Red.

Deliss, C. (été 1992), "Notes pour *Documents*. Quelques réflexions sur l'exotisme et l'érotisme en France pendant les années trente," *Gradhiva*, No. 2: 933–54.

Duchamp, M. (1961), *Entretiens inédits avec Georges Charbonnier*. RTF.

—(1973), *Salt-Seller: The Writings of Marcel Duchamp*. New York: Oxford University Press.

Duve, T. de (1994), "Echoes of the readymade: critique of pure modernism," *October*, Vol. 70, The Duchamp Effect (Autumn): 60–97.

Enwezor, O. (ed.) (2012), *Intense Proximity: An Anthology of the Near and the Far*. Paris: Centre National des arts plastiques Tour Atlantique.

Evans-Pritchard, E. E. (1937), *Witchcraft, Oracles, and Magic Among the Azande*. Oxford: Oxford University Press.

Faris, J. (1988), "Art/artefact: on the museum and anthropology," in *Current Anthropology* 29(5): 775–9.

Faus, P. (2014), "Historia de una rulot" http://artscoming.com/Articulo/historia-de-una-rulot/ (last accessed July 6, 2014).

Flam, J. and Deutch, M. (eds) (2003), *Primitivism and Twentieth-century Art: A Documentary History*. Berkeley: University of California Press.

Florida, R. (2004), *The Rise of the Creative Class*. New York: Basic Books.

Fontdevila, O. et al. (2012), *Catàleg Sala d' Art Jove*. Barcelona: Generalitat de Catalunya.

Foster, H. (1985), "The 'primitive', the unconscious of modern art, or White skin, black masks," in *Recordings: Art, Spectacle, Cultural Politics*. Seattle: Bay Press.

—(1995) "The Artist as Ethnographer?," in G. Marcus and F. Myer (eds), *The Traffic in Culture: Refiguring Art and Anthropology*. Berkeley: University of California Press.

Foucault, M. (1995), *Discipline and Punish: The Birth of the Prison*. New York: Vintage Books.

Fowle, K. and Bang Larsen, L. (2005), "Lunch Hour: Art, Community, Adminis-trated Space, and Unproductive Activity," in T. Purves (ed.), *What we Want is Free. Generosity and Exchange in Recent Art*. Albany: State University of New York Press, pp. 17–27.

Freud, S. (2003 [1919]), *The Uncanny*. New York: Penguin.

Friedman, K. (1998), *The Fluxus Reader*. New York: Wiley, John & Sons.

Garfinkel, H. (1967), *Studies in Ethnomethodology*. New Jersey: Prentice Hall.

Gell, A. (1996), "Vogel's net: traps as artworks and artworks as traps," *Journal of Material Culture* 1(1): 15–38. [Also in *The Art of Anthropology*. London: Athlone.]

—(1998), *Art and Agency*. London: Clarendon Press.

—(1999), *The Art of Anthropology*. London: LSE.

Godelier, M. (1999), *The Enigma of the Gift*. London: Polity Press.

Graeber, D. (2004), *Fragments of an Anarchist Anthropology*. Chicago: Prickly Paradigm Press (distributed by University of Chicago Press).

—(2011), *Revolutions in Reverse: Essays on Politics, Violence, Art, and Imagination*. Brooklyn, NY: Autonomedia.

—(2013), "On the moral grounds of economic relations: a Maussian approach," *Journal of Classical Sociology*, Vol. 4.

Gratton, J. and Sheringham, M. (eds) (2005), *The Art of the Project*. Oxford: Berg.

Groys, B. (2002), "The Loneliness of the Project." The New York Magazine of Contemporary Art and Theory. http://www.ny-magzine.org (last accessed July 6, 2014).

—(2008), *Art Power*. Cambridge, MA: MIT Press.

Hardt, M. and Negri, A. (2000), *Empire*. Cambridge, MA: Harvard University Press.

Hart, K. and James, W. (2013), "Marcel Mauss: a living inspiration," *Journal of Classical Sociology Special Issue*, Vol. 4.

Heidegger, M. (1971), "The Thing," in *Poetry, Language, Thought*. New York: Harper & Row, pp. 163–86.

—(1979), *Nietzsche. Volume I: The Will to Power as Art*. New York: Harper & Row.

Heinich, N. (1998), *Ce que l'art fait à la sociologie*. Paris: Éditions de Minuit.

Hernández-Navarro, M. Á. (2011), "Visualizar la revolución: baja fidelidad y estéticas relacionales," June 19, available from http://salonkritik.net (accessed).

Hiller, S. (ed.) (1991), *The Myth of Primitivism: Perspectives on Art*. London: Routledge.

Holbraad, M., (2011), "Can the Thing Speak?," Open Anthropology Cooperative Press, available from www.openanthcoop.net/press (accessed).

Holbraad, M. and Pedersen, M. A. (2009), "Planet M: the intense abstraction of Marilyn Strathern," *Anthropological Theory* 9: 371.

Hollier, D. (1992), "The use value of the impossible," *October* 60: 3–24.

—(1995), *Le Collège de Sociologie*. Paris: Gallimard.

Holmes, B. (2006), "The Artistic Device, or the Articulation of Collective Speech". Ephemera volume 6(4): 411–32.

Hyde, L. (2009 [1983]), *The Gift. Creativity and the Artist in the Modern World*. New York: Vintage Books.

Ingold, T. (2011a), *Being Alive: Essays on Movement, Knowledge and Description*. London: Routledge.

—(2011b), *Redrawing Anthropology, Materials, Movements, Lines*. London: Ashgate.

—(2013), *Making: Anthropology, Archeology, Art, and Architecture*. New York: Routledge.

Ingold, T. and Hallam, E. (eds) (2007), *Creativity and Cultural Improvisation*. Oxford: Berg.

Jackson, S. (2011), *Social Works: Performing Art, Supporting Publics*. New York: Routledge.

Johnstone, S. (ed.) (2008), *The Everyday*. London: Whitechapel.

Jorn, A. (1957), "Notes on the formation of an imaginist Bauhaus," in *Bureau of Public Secrets*, http://www.bopsecrets.org/SI/bauhaus.htm (last accessed September 2011).

Kant, I. (1951 [1790]), *Critique of Judgment*. New York: Hafner.

Kaprow, A. (1993), *Essays on the Blurring of Art and Life*. Berkeley: University of California Press.

Kauffmann, S. and Cage, J. (1966), "The Changing Audience for the Changing Arts (Panel)," in *The Arts: Planning for Change*. New York: Associated Councils of the Arts, pp. 23–52.

Keane, W. (2003), "Semiotics and the social analysis of material things," *Language & Communication* 23 (2003): 409–25.

Kelty, C. (2008), *Two Bits. The Cultural Significance of Free Software*. Durham: Duke University Press.

Kennedy, R. (2013), "Outside the Citadel, Social Practice Art is Intended to Nurture," *New York Times*, March 20.

Kester, G. (2011), *The One and the Many: Contemporary Collaborative Art in a Global Context*. Durham: Duke University Press.

Klimke, M. and Scharloth, J. (2009), "Utopia in Practice: The Discovery of Performativity in Sixties' Protest, Arts and Sciences," in A. Dialla, V. Karamanolakis, and K. Kornetis (eds), *Historicizing 1968 and the Long Sixties*. Athens, Historein, Vol. 9: 46–56.

Kuchler, S. (2000), "The Art of Ethnography: The Case of Sophie Calle," in Alex Coles (ed.), *The Ethnography Turn*. London: Black Dog Publishing Limited. 94–114. 2001.

Kwon, M. (2002), *One Place after Another: Site-Specific Art and Locational Identity*. Cambridge, MA: MIT Press.

Laidlaw J. (2000), "A free gift makes no friends," *The Journal of the Royal Anthropological Institute*, Vol. 6, No. 4: 617–34.

Latour, B. (1999), *Pandora's Hope*. Cambridge, MA: Harvard University Press.

—(2004), "Why Has Critique Run out of Steam? From Matters of Fact to Matters of Concern," *Critical Inquiry*, Vol. 30, No. 2. (Winter): 225–48.

—(2005), *Making Things Public: Atmospheres of Democracy*. Cambridge, MA: MIT Press.

—(2011), "From multiculturalism to multinaturalism: what rules of method for the new socio-scientific experiments," in *Nature and Culture*, Vol. 6, No. 1: 1–17.

Lautreamont, Le Comte de (2011), *The Songs of Maldoror*. New York: Solar Books.

Layton, R. (2003), "Art and agency: a reassessment," *The Journal of the Royal Anthropological Institute*, Vol. 9, No. 3: 447–64.

Law, J. (2004), *After Method: Mess in Social Science Research*. New York: Routledge.

Law, J. and Ruppert, E. (2013), "The social life of Methods: Devices" *Journal of Cultural Economy*, 2013, Vol. 6, Issue 3, 229–40.

Lazzarato, M. (1997), *Lavoro Inmateriale. Forme di vita e produzione di soggetività*. Verona: Ed. Ombre Corte.

—(2006 [2002]), "From biopower to biopolitics," *Tailoring Biotechnologies*, Vol. 2, No. 2 (Summer–Fall): 11–20.

Lefevre, H. (1953), *Contribution à l'esthétique*. Paris: Editions Sociales.

—(2002 [1961]), *Critique of Everyday Life 2: Foundations of a Sociology of the Everyday*. London and New York: Verso.

Leibniz, G. W. (1969), *Philosophical Papers and Letters*, L. E. Loemker (trans. and ed.), 2nd edn. Dordrecht: D. Reidel.

Leiris, M. (1993 [1939]) *L'Age d' Homme*. Paris: Gallimard.

—(1996), *Miroir de L' Afrique*. Paris: Gallimard.

Lessig, L. (2004), *Free Culture*. New York: Penguin Press.

Lévi-Strauss, C. (1966), *The Savage Mind*. London: The Garden City Press.

—(1986), *Introduction to the Work of Marcel Mauss*. London: Routledge.

Llobera, J. (2012), "El 15-M aumenta su apoyo ciudadano. Tras la movilización, el 68% expresa su simpatía, más que hace un año." *El Pais*, May 20.

Lütticken, S. (2010), "Art and thingness, Part I: Breton's ball and Duchamp's carrot," *E-flux Journal* #13 (February). Available from http://www.e-flux.com/issues/13-february-2010/ (last accessed July 11, 2014).

Malinowski, B. (1978 [1922]), *Argonauts of the Western Pacific*. Illinois: Waveland Press [New York: Routledge].

Marcel, J.-C. (1999), "Bataille et Mauss: un dialogue de sourds?," *Les Temps Modernes*, No. 602: 92–108.

Marcus, G. (2010), "Contemporary fieldwork aesthetics in art and anthropology: experiments in collaboration and intervention," *Visual Anthropology* 23: 263–77.

—(2013), Prototyping and Contemporary Anthopological Experiments with Ethnographic Method. *Journal of Cultural Economy* (forthcoming).

Marcus, G. and Fischer, M. (eds) (1986), *Anthropology as Cultural Critique*. Chicago: The University of Chicago Press.

Marcus, G. and Myers, F. (eds) (1995), *The Traffic in Culture*. Berkeley: University of California Press.

Marianello, G., Risaliti, S., and Somaini, A. (eds) (2001), *The Gift, Generous Offerings Threatening Hospitality*. Milan: Charta.

Martin, S. (2007), "Critique of Relational Esthetics," *Third Text*, Vol. 21, No. 4 (July): 369–86.

Mauss, M. (1985 [1938]), "A Category of the Human Mind: The Notion of the Person; the Notion of Self," in M. Charriters, S. Collins, and S. Lukes (eds), *The Category of the Person. Anthropology, Philosophy, History.* Cambridge. Cambridge University Press, pp. 1–25.

—(1990 [1925]), *The Gift. The Form and Reason for Exchange in Archaic Societies.* London and New York: Routledge.

—(2002), "Techniques of the Body," in J. Crary and S. Kwinter (eds), *Incorporations.* Cambridge, MA: Zone Books [MIT Press].

—(2003 [1925]), "Essay sur le Don. Forme et raison de l'échange dans les sociétés archaïques," available from http://www.uqac.uquebec.ca/zone30/Classiques_des_sciences_sociales/index.html (accessed).

McClancy, J. (2005), "The literary image of anthropologists," *Journal of the Royal Anthropological Institute* 11 (3): 549–75.

McDonough, T. (2007), "Calling from the inside: filmic topologies of the everyday," *Grey Room,* No. 26, pp. 6–29. http://www.mitpressjournals.org/toc/grey/-/26 (last accessed July 11, 2014).

McEvilley, T. (1984), "Doctor, Lawyer, Indian Chief," *Artforum* (November): 54–60.

Medina, C., Buck-Morss, S., Alÿs, F., and Diserenes, C. (2005), *Francis Alÿs: When Faith Moves Mountains.* Madrid: Turner Publications.

Miessen, M. (2011), *The Nightmare of Participation.* Berlin: Sternberg Press.

Miller, D. (1987), *Material Culture and Mass Consumption.* Oxford: Blackwell.

Mitchell, W. J. T. (1996), "What do pictures really want?," *October* 77 (Summer): 71–82.

—(2005), *What do Pictures Want? The Lives and Loves of Images.* Chicago: The University of Chicago Press.

Munn, N. (1986), *The Fame of Gawa, A Symbolic Study of Value Transformation in Massim Exchange.* Durham: Duke University Press.

Murawski, M. (2013), "Palaceology, or Palace-as-methodology: ethnographic conceptualism, total urbanism, and a stalinist skyscraper in Warsaw." *Laboratorium,* 5(2)56–83.

Myers, F. (2001), "Introduction," in *The Empire of Things: Regimes of Value and Material Culture.* Oxford: James Currey, pp. 3–61.

—(2006), "'Primitivism', Anthropology and the Category of 'Primitive Art'," in C. Tilley et al., *Handbook of Material Culture.* London: Sage, pp. 267–84.

Negri, A. (2011), *Art and Multitude.* Cambridge: Polity Press.

Obrist, H.-U. and Vanderlinden, B. (2001), *Laboratorium.* Köln: DuMont.

Oliver, J. and Badham, M. (2013), "Re-presenting the everyday: Situational practice and ethnographic conceptualism." *Laboratorium,* 5(2): 149–65.

Ortner, S. B. (1984), "Theory in anthropology since the sixties," *Comparative Studies in Society and History*, Vol. 26, No. 1 (January): 126–66.

Papastergiadis, N. and Esche, C. (2013), "Assemblies in art and politics: an interview with Jacques Rancière," *Theory, Culture & Society*, 0263276413476559.

Parry, J. (1986), "The gift, the Indian gift and the 'Indian gift'," *Man New Series*, Vol. 21, No. 3 (September): 453–73.

Peirce, C. S. (1998 [1992]), *The Essential Peirce, Selected Philosophical Writings, Volume 2 (1893–1913)*. Bloomington and Indianapolis, IN: Indiana University Press.

Pels, P. (2000), "The Trickster's Dilemma: Ethics and the Technologies of the Anthropological Self," in M. Strathern (ed.), *Audit Cultures: Anthropological Studies in Accountability, Ethics and the Academy*. London and New York: Routledge.

Phillips, R. and Steiner, C. (1999), *Unpacking Culture: Art and Commodity in the Colonial and Post-Colonial World*. Berkeley: University of California Press.

Pietz, W. (1985), "The problem of the fetish, I," *Res, Anthropology and Esthetics* (Spring): 5–17.

Pinney, C. (2011), *Photography and Anthropology*. London: Reaktion.

Pinney, C. and Thomas, N. (eds) (2001), *Beyond Esthetics: Art and the Technologies of Enchantment*. Oxford: Bloomsbury academic.

Plant, S. (1992), *The Most Radical Gesture: The Situationist International*. New York: Taylor & Francis.

Price, S. (1986), "Primitivism in the 20th century," *American Ethnologist*, Vol. 13, No. 3: 578a–80.

—(1989), *Primitive Art in Civilized Places*. Chicago: The University of Chicago Press.

Purves, T. (ed.) (2005), *What we Want is Free. Generosity and Exchange in Recent Art*. Albany: State University of New York Press.

Rabinow, P., Marcus, G. E., with Faubion, J. D., and Rees, T. (2008), *Designs for an Anthropology of the Contemporary*. Durham: Duke University Press.

Rancière, J. (1991), *The Ignorant Schoolmaster*. Stanford: Stanford University Press.

—(2002), "The Aesthetic révolution and its outcomes," *New Left review*, April 14.

—(2004), *The Politics of Aesthetics. The Distribution of the Sensible*. New York: Continuum.

—(2009a), *Aesthetics and its Discontents*. Cambridge: Polity Press.

—(2009b), "Contemporary Art and the Politics of Aesthetics," in B. Hinderliter, W. Kaizen, V. Maimon, J. Mansoor, and S. McCormick (eds), *Communities of Sense: Rethinking Aesthetics and Politics*. Durham: Duke University Press, pp. 31–50.

Raunig, G., Ray, G., and Wuggenig, U. (eds) (2011), *Critique of Creativity: Precarity, Subjectivity and Resistance in the 'Creative Industries'*. London: MayFly.

Rheinberger, H.-J. (1997), *Towards a History of Epistemic Things*. Stanford: Stanford University Press.

Rhodes, C. (1994), *Primitivism and Modern Art*. London: Thames and Hudson.

Ringel, F. (2013), " Epistemic collaborations in context of change: on conceptual fieldwork and the timing of anthropogical Knowledge," *Laboratorium* 5(2): 36–55.

Risaliti, F. (2001), "Donare l'eccedente, ospitare l'inospitabile," in G. Marraniello, S. Risaliti, and A. Somaini (eds), *The Gift, Generous Offerings Threatening Hospitality*. Milan: Charta.

Rivoal, I. and Salazar, N. B. (2013), "Contemporary ethnographic practice and the value of serendipity," *Social Anthropology*, Vol. 21, No. 2: 178–85.

Roberts, J. (2007), *The Intangibilities of Form: Skill and Deskilling After the Readymade.* London: Verso.

—(2010), "Art After Deskilling," *Historical Materialism* 18: 77–96.

Rofes, O. (2006), "Objectes distribuits i consciència discontinua: l'obra d'art com a mediació transtemporal i transcultural," *Quaderns de l' Institut Catala d' Antropologia* 21: 107–22.

Rollins, T. (1996), "Felix González-Torres, (interview)," in L. Barnes, M. Barosh, W. S. Bartman, and R. Sappington (eds), *Between Artists: Twelve Contemporary American Artists Interview Twelve Contemporary American Artists.* Los Angeles: ART Press, pp. 82–101.

Ross, A. (2009), *Nice Work if You Can Get It: Life and Labour in Precarious Times.* New York: New York University Press.

Rubin, W. (ed.) (1984), *Primitivism in 20th Century Art: Affinity of the Tribal and the Modern.* New York: Museum of Modern Art.

Rumney, R. (2002), *The Leaning Tower of Venice.* London: Royal Book Lodge.

Sahlins, M. (1972), *Stone Age Economics.* New York: Aldine de Gruyter.

—(1981), *Historical Metaphors and Mythical Realities: Structure in the Early History of the Sandwich Islands Kingdom.* Ann Arbor: University of Michigan Press.

—(1993), "Cery Cery fuckabede," *American Ethnologist* 20, No. 4: 848–67.

Sansi, R. (2005a), "The hidden life of stones: historicity, materiality and the value of candomblé objects," *Journal of Material Culture*, 10(2): 139–56.

—(2005b), "Making do: agency and objective chance in the psychogenetic portraits of Jaume Xifra," *Quaderns de l'Institut Català d'Antropologia* 21: 91–106.

—(2007), *Fetishes and Monuments. Afro-Brazilian Art and Culture in the 20th Century.* Oxford: Berg.

Schechner, R. (1985), *Between Theater and Anthropology.* Philadelphia: Pennsilvanyia University Press.

—(1988), *Performance Theory.* London: Routledge.

Schiller, F. (1982 [1794]), *On the Aesthetic Education of Man in a Series of Letters.* Oxford: Oxford University Press.

Schneider, A. (2005), "Chapter 2: Appropriation," in A. Schneider and C. Wright, *Contemporary Art and Anthropology.* Oxford: Berg, pp. 39–51.

—(2006), *Appropriation as Practice. Art and Identity in Argentina.* Oxford: Palgrave Macmillan.

—(2012), "Art and Anthropology," in R. Fardon et al., *The Sage Handbook of Social Anthropology*, Vol. 1. London: Sage, p. 65.

Schneider, A. and Wright, C. (eds) (2005), *Contemporary Art and Anthropology.* Oxford: Berg.

—(2010), *Between Art and Anthropology: Contemporary Ethnographic Practice.* Oxford: Berg.

—(2013), *Anthropology and Art Practice.* London: Bloomsbury.

Scholte, B. (1987), "Review article: the literary turn in contemporary anthropology: writing culture: the poetics and politics of ethnography," *Critique of Anthropology* 7 (July): 33–47.

Sierra, S. (2004), *300 Tons and Previous Works.* New York: König.

Silverstein, M. (1976), "Shifters, Linguistic Categories, and Cultural Description," in K. H.

Basso and H. A. Selby (eds), *Meaning in Anthropology*. Albuquerque: University of New Mexico, pp. 11–55.

Ssorin Chaikov, N. (2013), "Ethnographic conceptualism: an introduction," *Laboratorium* 5(2): 5–18.

Steiner, C. (1994), *African Art in Transit*. Cambridge: Cambridge University Press.

Stengers, I. (2010), *Cosmopolitics I*. Minneapolis: University of Minnesota Press.

—(2011), *Cosmopolitics II*. Minneapolis: University of Minnesota Press.

Stocking, G. (1992), *The Ethnographer's Magic and Other Essays*. Madison: University of Wisconsin Press.

Stoller, P. (1992), *The Cinematic Griot*. Chicago: The University of Chicago Press.

Strathern, M. (1988), *The Gender of the Gift. Problems with Women and Problems with Society in Melanesia*. Berkeley: University of California Press.

—(1991), "Partners and consumers: making relations visible," *New Literary History*, Vol. 22, No. 3, Undermining Subjects (Summer): 581–601.

—(1995), *The Relation: Issues in Complexity and Scale*. Cambridge: Prickly Pear.

—(2000), *Audit Cultures: Anthropological Studies in Accountability, Ethics and the Academy*. London and New York: Routledge.

Strohm, K. (2012), "When anthropology meets contemporary art notes for a politics of collaboration," *Collaborative Anthropologie*, Vol. 5.

Subiros, P. (2002), *En el corazón de la confusión*. El País, July 12.

Svansek, M. (2007), *Anthropology, Art and Cultural Production*. London: Pluto Press.

Sykes, K. M. (2005), *Arguing with Anthropology: An Introduction to Critical Theories of the Gift*. London: Routledge.

Taussig, M. (1984), "History as sorcery," *Representations*, No. 7: 87–109.

—(1991), *Shamanism, Colonialism and the Wild Man: A Study of Terror and Healing*. Chicago: The University of Chicago Press.

—(1993), *Mimesis and Alterity: A Particular History of the Senses*. London: Routledge.

Terranova, T. (2000), "Free labor: producing culture for the digital economy," *Social Text*, 63, Vol. 18, No. 2: 33–58.

Thomas, N. (1991), *Entangled Objects: Exchange, Material Culture, and Colonialism in the Pacific*. London and New York: Harvard University Press.

—(1999), *Possessions: Indigenous Art, Colonial Culture*. London: Thames and Hudson.

Thomson, N. (ed.) (2012), *Living as Form: Socially Engaged art from 1991–2011*. Cambridge Mass. MIT Press.

Tomkins, C. (1997), *Duchamp: A Biography*. New York: Chatto & Windus.

Vaneigem, R. (2009 [1967]), *The Revolution of Everyday Life*, available from www.library.nothingness.org (accessed May 14, 2009).

Virno, P. and Hardt, M. (1997), *Radical Thought in Italy: A Potential Politics*. Minneapolis: University of Minnesota Press.

Viveiros de Castro, E. B. (2002), *A Inconstancia da Alma Selvagem*. São Paulo: Cosac & Naify.

Ward, O. (2007), "Santiago Sierra: Interview," *Time out* London, December 3rd.

Whelan A. (2009) "Leeching Bataille: Peer-to-peer polatch and the acephalic response," in

K. Prada (ed.) *4th Inclusiva-net Meeting: P2P networks and processes* (pp. 1–15). Madrid: Medialab Prado.

Weiner, J. (ed.) (1994), "Aesthetics is a cross-cultural category". Manchester: Groups for Debates in Anthropological Theory.

Woolgar, S. (1997), "Accountability and Identity in the Age of UABs", CRICT (Centre for Research into Innovation, Culture and Technology, Brunel University) Discussion Paper no. 6.

Wright, C. (2010), "In the Thick of it: Notes on Observation and Context," in *Between Art and Anthropology: Contemporary Ethnographic Practice*, (eds) Arnd Schneider and Christopher Wright, 67–74. Oxford Berg.

Yves, A.-B. (2012), "Rosalind Krauss with Yves Alain-Bois," *The Brooklyn Rail*.

Zeitlyn, D. (2003), *Gift economies in the development of open source software: Anthropological reflections*, Research Policy 32 (7), pp. 1287–91

INDEX